THE SHORTER CONNE

A J WILKINSON ◆ CLARICE CLIFF ◆ CROWN DEVON

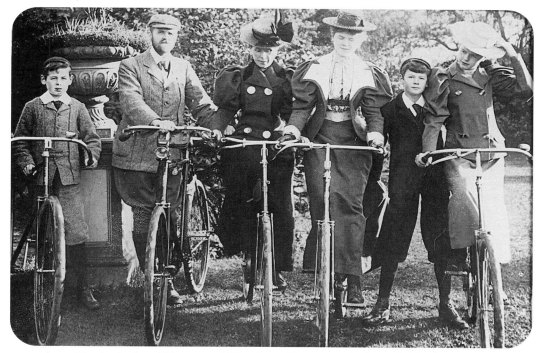

Fig. 1 Arthur Shorter and Henrietta Shorter with their children Guy, Mabel, Colley and Nora (October 1896).

by Irene and Gordon Hopwood

A FAMILY POTTERY 1874 - 1974

THIS BOOK IS DEDICATED TO MABEL LEIGH

"The pleasures of friendship are exquisite,
How pleasant to go to a friend on a visit!
I go to my friend, we walk on the grass,
And the hours and the moments like minutes pass."

Stevie Smith
(Collected Poems - Published by Allen Lane)

ACKNOWLEDGEMENTS

Illustrations from the Pottery Gazette by courtesy of Tableware International; illustrations from the Wilkinson archives by courtesy of the City Central Library, Hanley, Stoke-on-Trent; illustrations from the Shorter and Crown Devon archives by courtesy of the Staffordshire County Record Office.

Photographs by courtesy of The Public Record Office, Royal Doulton Ltd., Thomas Goode and Co. Ltd. (present owners of Crown Devon), Sentinel Newspapers, Stoke-on-Trent, and Millers Publications.

Photographs kindly loaned by Mr and Mrs J.B. Shorter, Mabel Leigh, Mrs Phyllis Dale, Mrs G. Dale, Mrs Edwards, Mrs G. Jackson, Mrs V. Keaveney, Mrs B. Lodey, Mrs. M Machin, Mr E. Walklate, Mr and Mrs E. Wood, Mr L. Griffin, Mr D. Jones, Miss M. Parr, Mr G. Parry Thomas, Mr V. Schuler and others taken by Mr. John Fisher. The Shorter mould-maker's notebook kindly donated by Mr L. Ewin.

Print Design and Reproduction by Flaydemouse, Yeovil, England
Photography by Mike Bruce at Gate Studios
Production by Wendy Wort
Published in 1992 by Richard Dennis, The Old Chapel, Shepton Beauchamp, Ilminster, Somerset TA19 OLE, England Reprinted 2002
© 1992 Richard Dennis, Irene and Gordon Hopwood

ISBN 0 903685 31 0

Illustrations to front cover: "Samarkand" Period Pottery plaque by Mabel Leigh and "Pooh Bah" Gilbert and Sullivan figurine from "The Mikado".

Illustrations to back cover: Period Pottery originated by Mabel Leigh.

CONTENTS

FOREWORD

Four years ago my 'phone rang and a voice asked if I was the John Shorter who had been connected with the Shorter pottery in Stoke-on-Trent. Gordon Hopwood was, of course, the caller and we both remarked on the coincidence that we lived only a few a miles apart.

Gordon and his wife Irene told me that they were writing a book about the Shorter family, its factories and productions. They subsequently showed me the ware they had collected and I was most interested to see the pottery made before I joined the firm in 1950. In fact, I can safely say that I found some of the ware produced then had real artistic appeal. In 1950 Shorters were successfully recovering from World War II and producing ware that compared favourably with that of its competitors. I am glad to learn that much of that ware is still popular with pottery collectors today.

I am pleased to have been able to help the Hopwoods with their research about Shorter and Son Limited. Their book puts the factory firmly into perspective as a traditional Staffordshire family pottery. It truthfully portrays what I feel was my family's significant contribution to the history of British pottery and I am happy to write this foreword to their book.

John Brereton Shorter.

Fig. 2 John Brereton Shorter.

INTRODUCTION

Although we had been inveterate collectors for many years, the decision to collect and then research Shorter pottery occurred almost by accident. It was as if benign forces were redirecting our lives from the disciplines and strictures of teaching and the civil service into the world of ceramics research and antique dealing. The first piece of Shorter pottery we acquired was an inexpensive Christmas "stocking-filler", chosen solely because of its colourful, rustic charm. By coincidence — and the Shorter story is full of such coincidences — the next piece of pottery that we found irresistible, was a floral cheese dish of completely different design, which bore the same backstamp, "Shorter and Son Ltd., Stoke on Trent".

Subsequently, we began to seek out pieces by this firm because, not only did we find them attractive, they were also comparatively inexpensive. Our attempts to find any information about Shorters in reference books met with limited success and, as we acquired more pieces, the great variety of styles, shapes and glazes became evident. This meant that not only was collecting made more difficult, albeit more interesting, but researching the pottery was rather like attempting a huge jigsaw puzzle with both hands tied behind our backs. We had no idea what the final picture should look like, and we had very few of the pieces. Such pieces that we did have appeared to lack the homogeneity which would confirm a common origin.

So intrigued were we by the challenge that we decided that it was necessary to go to the source of the pottery, Copeland Street, Stoke-on-Trent, only to find that the factory that had once existed there had been completely obliterated by an arid stretch of tarmac ring-road. However, if the site of the factory presented a blank face to us, the people of Stoke-on-Trent certainly did not. Their kindness proved to be one of the most rewarding features of the whole of our research. Although we had set out on a journey to investigate Shorter pottery, it seems that, en route, we were to learn just as much about the people involved.

In the Hanley Library and Museum we encountered nothing but friendly patience and expertise based on local pride in the pottery industry. The library staff provided us with a rich source of research material and even located a photograph of the factory from the depth of their archives. From the Museum, Kathy Niblett in particular, guided our enquiries and gave us hours of her time.

Stoke-on-Trent's local newspaper, the "Sentinel", was equally co-operative, printing our letters in full and publishing an interview with their columnist, Virginia Heath. This brought in a sheaf of invaluable information and enabled us to trace people who had worked for Shorters. Only two of the people thus traced declined to be interviewed, all the others could not have been more kind and helpful. We still remember their warmth and friendliness and recall with pleasure the innumerable cups of tea, always served in Stoke's finest bone china. Our many questions were answered with patience and we were entrusted with precious photographs and documents.

Information from one of the ladies whom we interviewed eventually led us to none other than John Brereton Shorter, the grandson of Arthur Shorter, the founder of the firm. It was mentioned in a letter to us that it was believed that "Mister John" had retired to live in Gloucestershire. Our very first telephone call to the first "J. Shorter" in our local directory revealed that he and his wife were now living three miles from our

home; another coincidence. Since that time, Mr John Shorter and his wife Charlotte have been generous in allowing us access to family papers and memorabilia and in answering hundreds of questions. To Mr Shorter we are indebted for the gift of an album containing photographs of Shorter pottery that was sold during his time with the firm, and for a "family tree" that he had researched. To Mrs Shorter we are grateful for the way in which she has preserved so many of the family documents and photographs.

A vital piece of the Shorter jigsaw fell into place when, from a response to an article in the "Sentinel", we were directed to a couple whose friendship has enriched our lives, the Shorter designer Mabel Leigh and her husband John. Our first, tentative, telephone conversation with Mabel was disconcerting because she could not understand our enthusiasm for the work she had designed for Shorters. For her, life had moved on. She now lives in a remote part of the country pursuing a rural life and continuing with her painting. She showed us some beautiful pieces of her early work and the notebook she had used at Shorters in which she had listed her Period Pottery designs. When Mabel Leigh first agreed to see us we thought that we had found the end of the Shorter rainbow; we had indeed, but the crock of gold turned out to be not the pottery but Mabel Leigh herself. It is her wide-ranging intelligence, her vitality, her sense of fun, her warm generous personality and the rapport that has developed between us that we value most highly.

Unlike the Shorter factory in Copeland Street, the building in which the firm spent its last days still existed in 1987 when we first visited the old Crown Devon site off the Whieldon Road. Here we met Jeffery Parry Thomas who was working in his own small pottery there and looking after the half-empty factory. From his encyclopaedic knowledge of both Stoke-on-Trent and the pottery industry, Mr Parry Thomas provided us with a wealth of background information. He showed us around the old factory just before it was demolished and whilst it still contained many of the old Shorter moulds. He had personally preserved some of the Shorter records that might otherwise have been lost and had prevented many of the old moulds from being destroyed. (Fig. 40)

The Shorter moulds that were preserved are now in the possession of pottery manufacturers who recognise their unique quality and the appeal they could have for the contemporary market.

Anthony Roper of Thomas Goode Ltd. who bought Crown Devon in 1984/85 played a significant part in "The Shorter Connection" by giving us his support and much useful information. With foresight he retained for his company the moulds for Shorters' famous Fish Ware together with a comprehensive range of their character jugs.

Another far-sighted manufacturer, Larry Ewin of Sherwood China, revived the name of Shorter and Son Ltd and bought many of their moulds. His enthusiasm for the pottery is equal to ours and together we have studied and sorted many of the old moulds. Larry encouraged us to talk to his staff who were producing Shorter shapes from the original moulds. Following in the hundred year old tradition established by Shorters, the early shapes, some of which had been used for majolica ware, were skilfully hand-painted, sometimes using the original colours and sometimes in an entirely different colour combination, chosen specifically to appeal to the modern market. Once again, there was a happy family atmosphere at Shorter and Son. The quality of the "new" Shorter pottery has been recognised by prestigious stores such as Liberty of London.

In 1988 we had the good fortune to attend a convention of the Clarice Cliff Collectors Club in Stoke-on-Trent. Although we owned a few pieces of Clarice Cliff's work, we freely confessed that our main reason for attending the convention was to pursue any possible links between Clarice Cliff and Shorter pottery. Here we must pay tribute to Leonard Griffin, the Chairman of the Club who provided us with such valuable background information about Clarice and Colley Shorter in his club notes and in his scholarly work "The Bizarre Affair". It was from the latter that we learned of the influence of French designers on Clarice Cliff's art deco shapes and went on to investigate the similarities between these and the

Shorter art deco shapes from the same period. The depth of Leonard Griffin's knowledge, the incredible memory of Eric Grindley who had worked with Clarice, and the infectious enthusiasm of the members of the Clarice Cliff Collectors Club have proved to be a real source of inspiration.

Another collector whose assistance we have valued is Judy Thorpe. Judy had already done some research about Mabel Leigh and generously allowed us to see her notes and to photograph a Sherborne plaque and Joan Shorter pieces from her magnificent collection. We thank Bob Lynn for permission to photograph his Toltec vase and Gardiniere bowl.

We owe much to the expertise of so many antique dealers that it is impossible to list them all. However, we would like to mention in particular our good friends Mary Parris and John Fisher who found so many unusual pieces for us — from the Mikado to Mecca, from Daisy Bell to Samarkand. Our thanks, also, go to Jean and Mike Gotts, Katherine and Dennis Dixon, George and Betty Flett, Helen Smith and Paddy Bateman, Martha and John Flynn, "David Lindsay", Michael Poole and Peter Savill and Albert Black who, with his colleague Gerry, took time off to show us some of the sights, as well as the antique markets, of his beloved Glasgow.

On many of our expeditions we were accompanied by our friends Tony and Wendy Hawkins who soon adapted the skills they have acquired when building up their fine collection of carnival and pressed glass to the discovery of Shorter pottery.

A summer school of the Northern Ceramics Society also provided us with a great deal of valuable background knowledge about ceramics that threw a new light on much of our research. It also introduced us to many fellow pottery enthusiasts and to experts such as Geoffrey Godden, Terence Lockett and Victoria Bergesen who were generous with both information and advice.

Although we may sometimes have been daunted by the research needed to prepare a book such as this, we have been helped and inspired by the example of our friends Sarah Levitt, the author of "Pountneys, the Bristol Pottery", Howard and Pat Watson, "Collecting Clarice Cliff", and Susan Verbeek who wrote "The Sylvac Story".

Finally, we must thank Richard de Peyer, the Deputy Director of the South West Area Museum Council for his encouragement in arranging a touring exhibition for us, and Mary Greensted, a consultant acting for Mr de Peyer, who, after an enthusiastic visit to our collection, succinctly put Shorter pottery into its historical context.

ARTHUR SHORTER — HIS FAMILY & HIS POTTERY

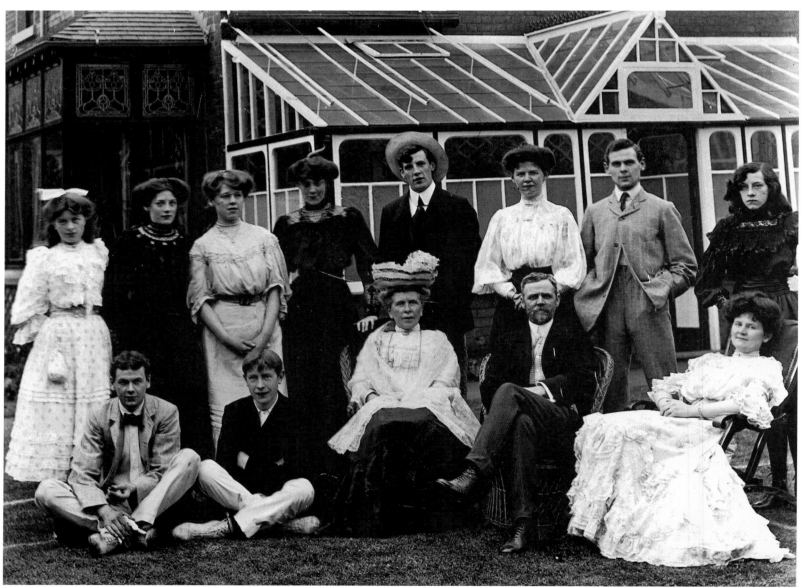

Fig. 3 Family and friends Wolstanton c 1900.
Back row : Laurie Crawford, Jessie Shorter, Annie Crawford, Hughie Crawford, Louise Shorter, Guy Shorter, Daisy Crawford.
Front : Colley Shorter, A friend, Henrietta Shorter, Arthur Shorter, Mabel Shorter.

Chapter One

EARLY YEARS

Atypical Staffordshire family pottery business, the Shorter firm was founded in the 1870s and produced pottery continuously for the next hundred years.

ARTHUR SHORTER'S BACKGROUND

The founder was Arthur Shorter who was born in Willenhall, near Wolverhampton, on 18th May, 1850. He did not come

Fig. 4
Charlotte Shorter — Arthur's mother.

from a traditional pottery family but his father, Jabez, who was a station-master, had an interest in a little pottery in Longton that produced terracotta with Moorish designs. It was, however, no more than "an interest". Although he had started his working life in the grocery trade, Jabez Shorter must have seen the promise of the booming new railways and had joined what was the Grand Junction Company, before Arthur was born. Arthur's mother, Charlotte Austin, who had married Jabez in 1840, is understood to have had some connection with the Wilkinson pottery family.

Jabez and Charlotte had seven children. Minnie, Martha, William, Sarah and Lucy were born before Arthur and they do not feature in "the Shorter story". However, brother John, who was born when Arthur was three, played a strong supporting role. At first it was thought that John might not survive; he was a delicate child and this caused his worried father to apply for a transfer to the countryside station at Whitmore, near Newcastle-under-Lyme, away from the urban smog of Willenhall. As it was, John outlived Arthur by many years, although he had to go to Australia to recover completely.

Inter-City trains speed past the village now and the station buildings are deserted. In the 1850s, however, Whitmore was the only rail outlet for the North Staffordshire pottery industry. Horse-drawn carts laden with casks and crates of pottery would converge on the station from the six towns of Stoke-on-Trent. Consequently, Jabez Shorter played a key role in the distribution of pottery and that, together with his interest in the little Longton factory, must have made him a well-known figure in the pottery community. Manufacturers would visit his home and this undoubtedly aroused young Arthur and John's interest in the trade.

FORMATIVE YEARS

Arthur was educated at the Hill Chorlton School near Maerfield Gate, with his brothers and sisters. When he left school he worked with his father as a railway clerk but he had an artistic temperament and a talent that can be judged from the few specimens of his work still in existence. He was also a talented photographer and examples of his work can be seen in these pages. After a difference of opinion with his father, Arthur left the railways to become an apprentice decorator with Hope and

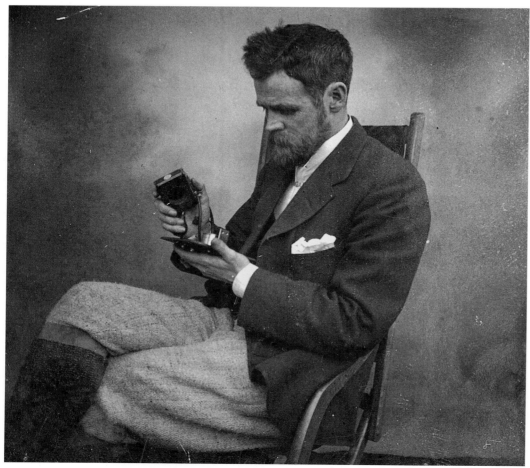

Fig. 5 Arthur Shorter, the photographer.

these to Albert Wenger, the Swiss born founder of the Helvitia Works, a ceramic colour firm and one of the largest manufacturers of majolica glaze. According to the ceramics historian Geoffrey Godden, the first reference to Shorter relates to the 1870s when there is a reference to the partnership of Shorter, Bethelley, Millward and Co., also known as Shorter and Co., which was dissolved on 9th November 1878. From that date, Arthur Shorter and James Boulton carried on the business of producing earthenware and majolica at the Batavia Works in Copeland Street under the name of Shorter and Boulton. No other reference to Bethelley and Millward has been found.

ARTHUR SHORTER'S FAMILY

It was during the 1870s that Arthur married Henrietta Elizabeth Wilkinson, a strong-minded woman, three years his senior, who was the daughter of a teacher and the sister of A.J. Wilkinson, who was shortly to set up an earthenware factory in Burslem. Their first daughter, Lucy, was born in 1876, followed by Mabel in 1878, Nora in 1880, Arthur Colley in 1882 and John Guy in 1884. Their sixth child, Jessie, was born four years later.

Carter in Burslem. From there, he went on to work as an artist at the prestigious firm of Mintons in Stoke-on-Trent where he was undoubtedly influenced by the artistic director, Leon Arnoux, who introduced majolica to Great Britain. Following his apprenticeship, Arthur joined Bodley's China works in Burslem as a journeyman painter and the work of that firm too is reflected in his later products.

THE FIRST SHORTER POTTERY

It was not long before Arthur decided to set up in business on his own account as a decorator of pottery. An example of his artistic work is still owned by his grandson, John Brereton Shorter. This takes the form of a christening mug that he made for his first daughter, Lucy, in 1876. He acquired premises in Hanley in or about 1874, but after a short time sold

THE SHORTER AND BOULTON YEARS (1878-1905)

THE JAMES BOULTON CONNECTION

With the proceeds of the sale of his Hanley establishment, Arthur bought a small factory on the site of an ancient church in Copeland Street, Stoke upon Trent. According to the contemporary historian Llewellyn Jewitt, the factory was previously owned by Billington and Company. It was this factory, with its small frontage and only two bottle ovens, that served the Shorter family from about 1878 until 1964. At one time the factory housed over a hundred workers. Its situation could hardly have been more convenient; it was on the bank of the canal for the delivery of clay and other materials and around the corner from the main Stoke-on-Trent railway station which eventually replaced Whitmore as the rail distribution point for the pottery industry. Much of the pottery was despatched by road, and Copeland Street is near to the main trunk roads.

Shortly before setting up his factory, Arthur had lost his father, Jabez, who died intestate on the 1st February, 1875.

Arthur Shorter joined forces with James Boulton to form his new company for the manufacture of majolica ware. James was an experienced biscuit fireman from the famous Wedgwood factory and his skills would have combined effectively with Arthur's expertise in design, glazing and decoration. Little is known about James Boulton but he must have been confident that the venture would succeed. He is said to have told Arthur's family that they would soon all be driving a coach and pair, the nineteenth century equivalent of a Rolls Royce. The first advertisement from the firm of Shorter and Boulton appears in the Pottery Gazette in 1879. It offers a wide variety of products in majolica and green glaze, from table ware to spittoons.

THE AUSTRALIAN CONNECTION

Shorter and Boulton were soon able to export their products to Australia where Arthur's "delicate" brother John had been able to set up a successful agency in 1881 because of his connections in the pottery industry. Shorter House, the headquarters of his agency still exists in Sydney and is managed by his grandson John Shorter, C.B.E., assisted by his wife Adeline. Shorter and Boulton's arrangement with John Shorter senior ended in 1889 when he obtained the valuable Doulton agency for Australia.

Shorter and Boulton continued to trade in that country through the firm of South and Cowan.

Ever since the 1880s, a large proportion of the firm's output was exported to what was then the British Empire and to the American continents. Shorter and Boulton were referred to in the American "Crockery and Glass Journal" on 20th October, 1881, which mentioned their new goods in majolica, reporting that, "....a pair of vases with ducks in high relief against a blue ground are very striking".

Fig. 6 John Shorter (Australia) 1895.

Fig. 7 Doulton face-mask modelled by Noke in the likeness of the Australian Arthur Shorter (John's son).

Fig. 8 Doulton character jug of Australian John Shorter CBE, (grandson of Arthur's brother John).

Arthur Shorter and, later, his son Colley travelled all over the Americas selling their pottery, and the family archives contain many fascinating letters they wrote home from hotels in such cities as Chicago, New York and Buenos Aires.

THE A.J. WILKINSON CONNECTION

Whilst his brother John was developing his agency in Australia, Arthur's brother-in-law, Arthur J. Wilkinson, was setting up another earthenware factory in Burslem which opened in 1885. At that time, the two factories operated independently; Arthur Shorter's majolica firm in Copeland Street, Stoke upon Trent, and A.J. Wilkinson's in Burslem. A sad event six years later, however, strengthened the links between the two firms. Whilst on holiday in Switzerland, Arthur J. Wilkinson sustained a fatal fall from a hotel balcony. One can imagine that a family conference must have decided that Arthur Shorter should be appointed to manage the Burslem factory, leaving James Boulton in charge of Copeland Street. In the same year, Arthur's mother Charlotte, died at the age of 78.

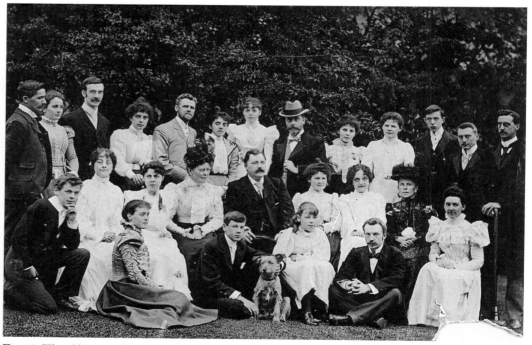

Fig. 9 The Shorter family and friends, including Edmund Leigh (centre of back row with hat), their American agent, Mr Slimmon (middle of centre row with moustache) and Harold Hales (second from right, front row, "The Card" of Arnold Bennett's novel).
Arthur Shorter — back row, fifth from left, Guy, kneeling at left, Colley seated centre.

Three years later, in 1894, Arthur Shorter consolidated his position by buying the firm of A.J. Wilkinson in collaboration with Edmund Leigh (Fig. 9). During this period, although James Boulton managed the Shorter and Boulton factory in Copeland Street, Arthur maintained overall control of both firms. In 1897, James Boulton retired, to be succeeded for three years by his son William. Arthur's sons, Colley and Guy, were growing up and he had clear plans for their future.

THE SECOND SHORTER GENERATION

The young Shorter brothers were educated at the village school near their home in Maerfield Gate (Plate I) and went on to the High School in Newcastle-under-Lyme. They were both enthusiastic sportsmen, and Guy went on to play hockey for his county and cricket for a local club. Later in life, he captained the local golf club. Characteristically, Colley took up the more flamboyant "sport" of fox hunting.

Little is known about the brothers' academic achievements but they were good enough for them to help their father to run his factories when they left school at the age of 16. In 1898 Colley joined his father at A.J. Wilkinson's as a traveller and soon had his own area that was advertised in the Pottery Gazette. In the following year, his second wife, Clarice Cliff, was born in a terraced house in Tunstall, Stoke-on-Trent.

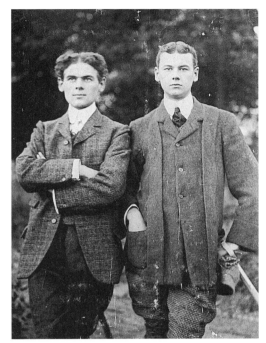

Fig. 10 Guy and Colley Shorter c. 1902.

After leaving school in 1900, Guy Shorter was appointed as manager of the original Shorter factory in Copeland Street, taking over from William Boulton. The firm continued to be known as Shorter and Boulton, but the Shorter family was now firmly in charge of both factories, with Arthur keeping a fatherly eye on both establishments.

If little mention is made of Arthur's daughters, it is because they played no part in the work of Shorter and Sons. Mabel and Nora married (Mabel to John Walker, who worked at Wilkinsons) but Lucy and Jessie remained unmarried and lived at home until their parents died.

In 1905, when Guy was 21, he joined his father and Colley at Wilkinsons leaving Arthur Holdcroft as manager in Copeland Street. He still visited the Shorter and Boulton factory nearly every day, but his main responsibility was the administration of Wilkinsons. A showroom in London was set up in 1907. When a reporter from the Pottery Gazette visited it two years later he found that the firm was still producing flower pots and similar popular florist's ware of "medium class".

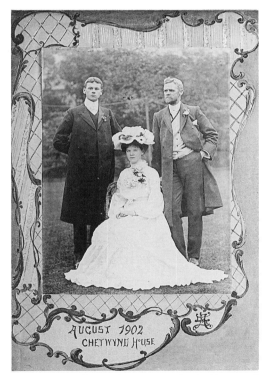

Fig. 11 Arthur Shorter with Colley and Nora. Frontispiece of family album by Arthur Shorter — Note Monogram.

Chapter Three

SHORTER AND SON (1906-1932)

The firm was described as "Shorter and Son" for the first time in 1906. It was shortly after this that Colley married his first wife, Nancy Beech. Their first child, Margaret, was born in 1912. As World War I approached, Shorters main customers continued to be the florists whom they supplied with majolica flower pots and vases.

THE GREAT WAR (1914-1918)

The outbreak of the War in 1914 found Guy Shorter on holiday near the German border. After a series of adventures behind enemy lines, he made his way to Lucerne in Switzerland but could not get back to England for another month. When he did, he immediately enlisted and was commissioned into the North Staffordshire Regiment. He was later appointed as a Staff Captain and Brigade Machine Gun Officer of the 147 Brigade.

The company continued to trade whilst Guy was in the trenches. Colley had not enlisted and continued to run the companies with his father. Shorters adopted the "Batavia" trade mark in 1914. Colley and Guy were made directors of Wilkinsons in 1916; Arthur was by then 66 and thinking of retirement. There were few changes in Shorters products but the report of a trade show in 1917 refers to the introduction of Toby jugs as a sideline to their regular trade. Wilkinsons, with whom they shared a stand, was still the more prestigious firm exhibiting such items as the lustrous Oriflamme, Thibetan and Rubiyat ware. Clarice Cliff, who joined the firm in 1916, later helped to decorate this ware.

Guy Shorter was posted to Ireland when the "Troubles" broke out. It was there he met Elsie Hincks Lett whom he married on 21st March, 1918. Their son, John Brereton Shorter, was born in the following year on 1st December.

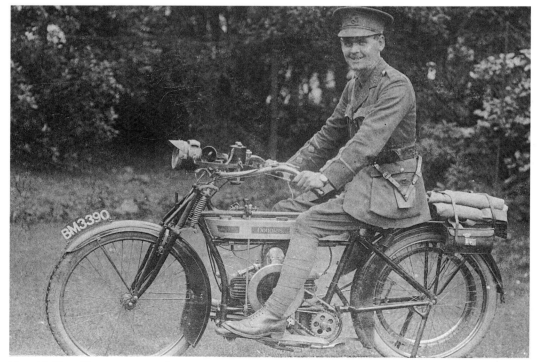

Fig. 12 Guy Shorter c. 1915.

Fig. 13 Colley takes his parents for a family outing.

THE SECOND GENERATION TAKES OVER

With the end of the Great War, Arthur Shorter retired, leaving his sons in charge of both factories. He and Henrietta went with their two unmarried daughters to live in Llandudno, a popular holiday resort for the Staffordshire middle class. Throughout his life he had been a pillar of the Methodist church, having held every position available to a lay person. When he retired he continued to serve the church as a circuit steward.

At the end of the war there was a boom in the pottery industry. There was a large market for inexpensive, functional earthenware, and the Shorter brothers saw to it that their factories took advantage of the opportunities that presented themselves. Each factory had its own special niche in the market and they worked in close co-operation, advertising and exhibiting jointly.

As business improved, the brothers acquired another factory at Burslem in 1920. This was the Newport Pottery, which later became the base for Clarice Cliff's "Bizarre" ware. This company had capital of £25,000 and its secretary was John Guy.

In the same year, Nancy Shorter gave birth to her second daughter, Joan. At that time, she and Colley were living in Chetwynd House in Wolstanton. That house is now a working man's club, but in the 1920s the garden was full of swings and slides where Colley arranged parties for his daughters and their young friends. Unfortunately, Nancy's health was worsening and she is said to have rarely attended these events.

Because of the smoke that belched from its hundreds of bottle ovens, Stoke-on-Trent was a most unhealthy city between the wars. Unfortunately, the pottery workers had no alternative but to endure the smog, whilst the factory owners and managers made their homes in the healthier neighbouring towns, such as Newcastle-under-Lyme. Guy lived in Alsager in Cheshire, but eventually moved to Newcastle, with a summer home in Ashley Heath. Colley moved from Wolstanton in 1925 to a beautiful house built in the Arts and Crafts style by Barry Parker and Raymond Unwin. This was also named "Chetwynd" but was further out in the Staffordshire countryside. Colley hoped that the fresh air and a pure water well in its garden

Fig. 14 "Chetwynd" (No 2).

would help to improve Nancy's health. Unfortunately these measures were unsuccessful and her health continued to deteriorate.

In the same year, 1925, Clarice Cliff also moved home, from her parents house to her own flat. Her close association with Colley was developing and she was given her own studio next to his office. 1925 was also the year of the Exposition des Arts Decoratifs et Industriels Modernes in Paris that was to launch the Art Deco movement.

During this period, the products of Shorter and Son hardly varied. Their range included coloured majolica wares of every description, and the trade press of the time felt that they had "found their niche and (were) evidently intent upon continuing to occupy it". What the trade papers had not realised was that the Exposition in Paris was beginning to have its effect even on this small majolica house in Copeland Street.

Arthur Shorter died in Llandudno on 18th September, 1926, the year of the General Strike. Although he had retired eight years previously, his sons made few significant policy changes whilst he was alive. Nevertheless, changes were in course of preparation that would dramatically affect the products of both Shorters and Wilkinsons.

THE TRANSITIONAL YEARS
(1927-1932)

It was the progress of Clarice Cliff's career and her relationship with Colley Shorter that was to significantly affect the three factories. Even before Arthur's death, the collaboration between Clarice and Colley was developing, with her move from the family home and the acquisition of her new studio next to Colley's office. By this time, Colley's wife was a virtual recluse because of her ill-health and he spent more and more of his time at the factory and in his clubs. His involvement as a prominent Freemason, together with his business and social activities meant that he spent much less time at Chetwynd. Whatever the truth of his relationship with Clarice during this period, his mere close association with a young, attractive, single woman was enough to cause gossip on the shop floor. His relatives who worked at Wilkinsons, including brother Guy and brother-in-law Jack Walker, distanced themselves from Clarice, much to her distress.

Even today, former employees have been heard to denigrate Clarice's work and attribute her success to her liaison with Colley. However, although Colley may have had a reputation as a "ladies man", he also had an astute business brain. He recognised that the art deco designs that Clarice was producing were in tune with the contemporary "Jazz Age" and would appeal to young people bored with traditional designs. Consequently, he arranged for her to attend a concentrated course in modern design to develop her inherent talent. A two month course at the Royal College of Art, followed by a trip to Paris to absorb the new art deco culture prepared Clarice for the design of the "Bizarre" ware for which she is now renowned.

At first Clarice was encouraged to experiment by decorating some of the old shapes from the Newport Pottery, which she did with colourful geometric designs. Clarice used some Shorter shapes in this way; in fact examples of the Oceanic jug decorated with Delicia and other designs have been seen and a publicity photograph actually shows Clarice decorating a plaque whilst a Shorter Dragon jug, already decorated, stands in the foreground. There were also innovations, which included typical art deco shapes, that undoubtedly involved the three factories. Simultaneously, experiments were taking place with glaze effects. These may be what were referred to when the Pottery Gazette, whilst praising Shorters majolica jugs, wrote about "interesting lines in mottled and splashed glazed effects".

This was an exciting time, artistically and emotionally, for Colley Shorter. He was the supreme salesman, having toured the world selling the firm's products with great success. Returning from a trip abroad, he would march into the factory wearing a white suit and a Stetson hat. Often, after a few lunch-time drinks at his club, he would take his friends for hair-raising rides in his Rolls Royce

Fig. 15 "Keltique" Jardiniére signed "Colley Shorter".

Silver Cloud. In keeping with his flamboyant life-style he generated a spectacular, but carefully planned, publicity campaign for the ware that he and Clarice had developed.

In 1924 Grays had successfully used Susie Cooper's name on her designs and this personal publicity appealed to the extrovert Colley. At first he experimented with a few pieces signed "Colley Shorter" but these now only have scarcity and novelty value. Some were inscribed "Keltique", others "Santoy". However, when Colley arranged for Clarice Cliff's facsimile signature to appear on her "Bizarre Ware", it proved to be a significant factor in the success of her designs, a success that was totally unexpected by the conservative Wilkinson sales-force.

Colley had prepared the ground with some careful consumer research, followed by brilliant publicity involving show-business personalities. Teams of "Bizarre Girls" toured the big department stores, dressed in "artistic" costumes and decorated the ware in public, often in the stores' display windows.

Later, when Shorters' new designer Mabel Leigh, created her ethnic-based Period Pottery designs, it was decided that this ware too should be personalized. Consequently, each piece bore her signature, and the name of the individual pattern.

Another idea from Colley's fertile brain also put the family name on Wilkinson's pottery. When his daughter Joan was eight she produced some childish drawings which her proud father took to work to show his colleagues. In consultation with Clarice it occurred to him that children's pottery bearing such designs might be popular. Once again, his instinct was right, and pottery bearing the message "From a child to a child, by Joan Shorter, aged 8" produced with a fanfare of publicity, was a success, particularly in Australia.

During this period, Guy Shorter was carefully administering the business side of the factories and, no doubt, exerting a steadying influence over the headstrong Colley. Former employees describe Guy as "a perfect gentleman", whereas it has been said of Colley, "If you can work with him, you can work with anyone". The Copeland Street factory was being managed by a Mr A. Lovatt who had taken over from Arthur Holdcroft. However, the brothers spent time at both factories and the three factories, Shorters, Wilkinsons and Newport, operated as sections of a united group. Sharing the same directors, the factories undoubtedly had a co-ordinated policy and output. For instance, when one factory was creating excessive profits the output would be diverted to another in the group, for tax purposes. Staff were also moved from one factory to another if necessary. Even some of the famous "Bizarre" girls occasionally spent some time in Copeland Street.

By 1927 Shorters were coming to the end of the period during which they had produced majolica and associated products almost exclusively. They were, by then, one of the few factories specializing in this Victorian ware. It was becoming less and less fashionable and they must have become aware of the need to diversify their output. When the press reviewed their exhibition in 1928, they noticed, ".... a still newer line of goods a range of matt glazed ware some wonderfully good effects, many of them quite original in type". These could have been the art deco shapes that may well have been designed by Clarice Cliff. Unfortunately the article was not illustrated. During this time the Fish Ware series, for which Shorters is famous, was introduced in a matt glaze. It was widely publicised, in a way that indicates Colley Shorter's influence, and its design has also been attributed to Clarice Cliff.

In an exhibition in 1931, Shorters are categorically reported to have exhibited some of "Miss Clarice Cliff's latest designs" alongside some of their reproduction, old Toft-style jugs, glazed with old majolica colours. It seems quite feasible that the designs in question were the Shorter art deco matt glazed vases. The old and the new styles were being marketed side by side, but the new was in the ascendency.

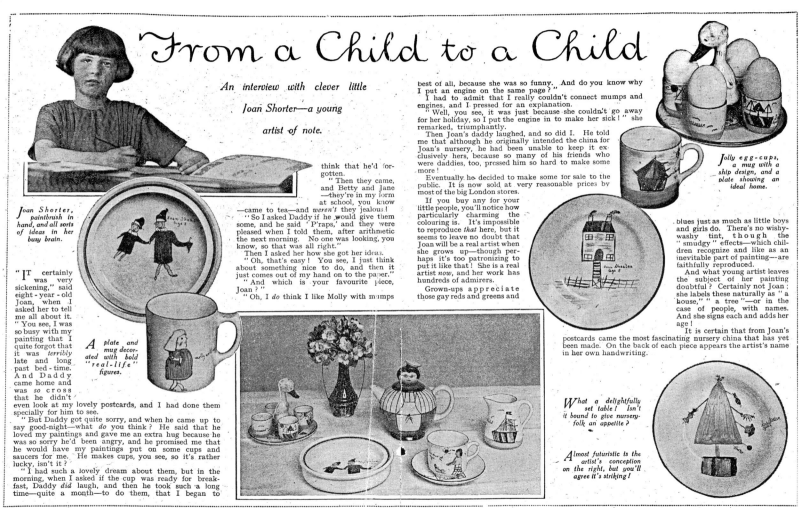

From a Child to a Child

An interview with clever little Joan Shorter—a young artist of note.

Joan Shorter, paintbrush in hand, and all sorts of ideas in her busy brain.

"It certainly was very sickening," said eight - year - old Joan, when I asked her to tell me all about it. "You see, I was so busy with my painting that I quite forgot that it was *terribly* late and long past bed - time. And Daddy came home and was *so cross* that he didn't even look at my lovely postcards, and I had done them specially for him to see.

"But Daddy got quite sorry, and when he came up to say good-night—what *do* you think? He said that he loved my paintings and gave me an extra hug because he was so sorry he'd been angry, and he promised me that he would have my paintings put on some cups and saucers for me. He makes cups, you see, so it's rather lucky, isn't it?

"I had such a lovely dream about them, but in the morning, when I asked if the cup was ready for breakfast, Daddy *did* laugh, and then he took such a long time—quite a month—to do them, that I began to think that he'd forgotten.

"Then they came, and Betty and Jane—they're in my form—came to tea—and *weren't* they jealous!

"So I asked Daddy if he would give them some, and he said ' P'raps,' and they were pleased when I told them, after arithmetic the next morning. No one was looking, you know, so that was all right."

Then I asked her how she got her ideas.

"Oh, that's easy! You see, I just think about something nice to do, and then it just comes out of my hand on to the paper."

"And which is your favourite piece, Joan?"

"Oh, I *do* think I like Molly with mumps best of all, because she was so funny. And do you know why I put an engine on the same page?"

I had to admit that I really couldn't connect mumps and engines, and I pressed for an explanation.

"Well, you see, it was just because she couldn't go away for her holiday, so I put the engine in to make her sick!" she remarked, triumphantly.

Then Joan's daddy laughed, and so did I. He told me that although he originally intended the china for Joan's nursery, he had been unable to keep it exclusively hers, because so many of his friends who were daddies, too, pressed him so hard to make some more!

Eventually he decided to make some for sale to the public. It is now sold at very reasonable prices by most of the big London stores.

If you buy any for your little people, you'll notice how particularly charming the colouring is. It's impossible to reproduce *that* here, but it seems to leave no doubt that Joan will be a real artist when she grows up—though perhaps it's too patronizing to put it like that! She is a real artist *now*, and her work has hundreds of admirers.

Grown-ups appreciate those gay reds and greens and blues just as much as little boys and girls do. There's no wishy-washy tint, though the "smudgy" effects—which children recognize and like as an inevitable part of painting—are faithfully reproduced.

And what young artist leaves the subject of her painting doubtful? Certainly not Joan; she labels these naturally as "a house," "a tree"—or in the case of people, with names. And she signs each and adds her age!

It is certain that from Joan's postcards came the most fascinating nursery china that has yet been made. On the back of each piece appears the artist's name in her own handwriting.

A plate and mug decorated with bold "real-life" figures.

Jolly egg-cups, a mug with a ship design, and a plate showing an ideal home.

What a delightfully set table! Isn't it bound to give nursery-folk an appetite?

Almost futuristic is the artist's conception on the right, but you'll agree it's striking!

Fig. 16 Article from *Womans Life*, 4th May 1929.

SHORTER AND SON LIMITED (1933-1974)

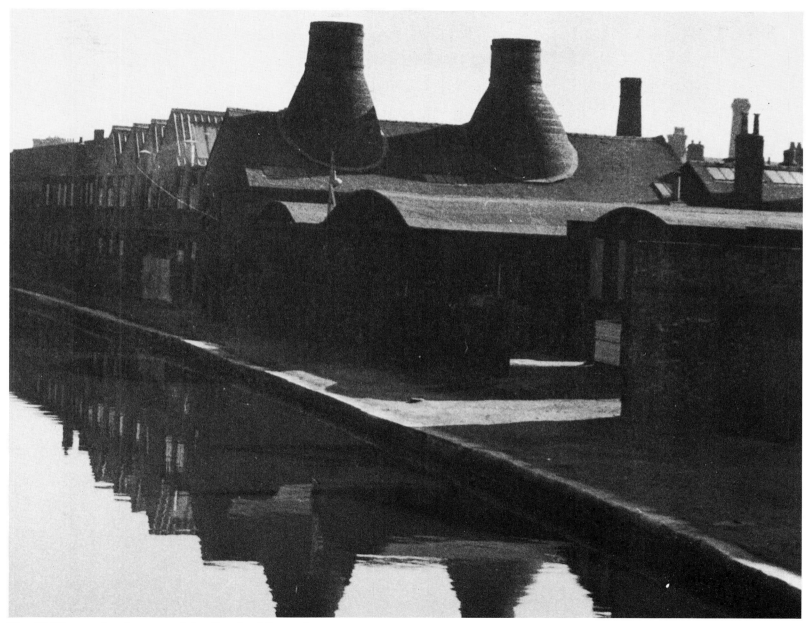

Fig. 17 The two bottle ovens of the Copeland Street factory.

Chapter Four

THE THIRTIES RENAISSANCE

HARRY STEELE –
THE MANAGER (1932-1964)

A turning point in Shorters' development came in 1932 when Harry Lawrence Steele took over from Mr Lovatt as the manager at Copeland Street. The firm was beginning to escape from the domination of majolica that had served it well for more than fifty years. The experiments that Clarice Cliff was making in Burslem were having repercussions in the Shorter factory. These exciting, new "Bizarre" developments at the Newport/Wilkinson complex may have been pre-occupying the Shorter brothers, somewhat to the neglect of the small Copeland Street factory. A former senior employee at Wilkinsons has suggested that the company's bank manager had advised that energetic new management was

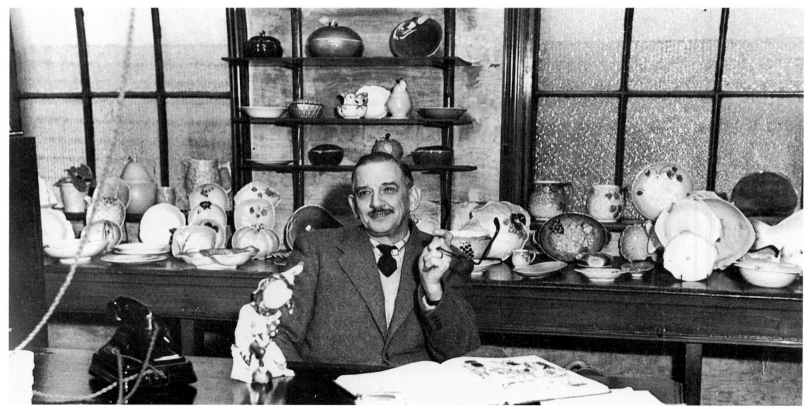

Fig. 18 Harry Steele in the showroom (c. 1950).

needed at Shorters. This eventually took the form of Harry Steele who was recruited from a firm in Scotland.

Harry Steele's brief was to bring Shorters into the "Jazz Age" of the Thirties and update its rather Victorian image. There is always a market for nostalgia and although Shorters were not prepared to discard their best-selling lines in this area, an injection of vitality was clearly needed. The rather down-at-heel old pot bank in Copeland Street must have seemed a daunting prospect, but Harry Steele was a dynamic young manager with enough experience and technical expertise to meet the challenge. Contemporary photographs show a handsome, rather swarthy man with a hair-line moustache reminiscent of the Thirties film idol, Clark Gable. One can imagine the frisson of excitement that his appearance must have generated amongst the mainly female workforce when he took over that little factory. Some elderly ladies still smile wistfully as they recall dancing with him at the firm's Christmas ball in the Rialto ballrooms in Stoke-on-Trent.

Although he was capable of "striking the fear of God" into his employees, as one of them recalls, he could certainly command obedience and respect. He had a cynical rule about not selling Shorter pottery to his workers. He would say, "If I sell it to you, it will never get broken" (in other words, they would replace any breakages from stock). Despite this rule, some retired workers are still proud possessors of examples of their work.

However intimidating he might have been, he ran a happy factory that most retired workers remember with pleasure. He introduced new, more systematic measures, for instance in the numbering and recording of pottery shapes. The pattern book also dates from his arrival. In general, however, he did not believe in keeping superfluous records. A former traveller recalls how the firm was run "on a shoe-string" compared with contemporary establishments.

Harry Steele inspired many of the designs which were changed frequently to keep abreast of fashionable trends. His motto is said to have been "Variety is the spice of life" and he was constantly on the look-out for designs that his travellers could sell. He was assisted by skilled modellers, designers and decorators. One modeller in particular, Leon Potts, kept pace with Harry Steele's imaginative suggestions and produced new lines for him year after year, probably assisted only by the vaguest of ideas or rough sketches.

Shorters became a limited company in 1933. With a registered capital of only £3,000 in £1 shares and three directors, the Shorter brothers and Harry Steele, this registration marked their progress in a turbulent decade. Harry Steele shared Colley Shorter's flair for publicity, and made sure that the pottery press knew about the developments in Copeland Street. In 1933 their attention was drawn to the new glazes that had been developed, and they were urged to tell retailers of these exclusive effects. Interesting new table ware attracted the attention of the Royal family and ".... Distinct evidence of progress and development", was reported in an article which commended the new harder bodied earthenware that Harry Steele had introduced.

In the same year, Harry Steele recruited a talented young designer called Mabel Leigh whose Period Pottery based on ethnic designs gave Shorters the prestige they had been seeking. Period Pottery was a deliberate "design opposite" to Clarice Cliff's art deco innovations, as the press quickly realised. It was further evidence of the joint thinking of the three company directors. At the same time, Shorters continued to make inexpensive but attractive novelties and reproduce some of their previously successful lines. "No longer does one hear the 'tick-tock' of the majolica glazes as they craze in the warehouse," remarked the Pottery Gazette. The designs were good and the glazes were reported to be "virtually indestructible".

A new traveller, Mr T.G. Roberts, had to be employed to specialize in Period Pottery. The existing travellers, Mr S. Sidon and Mr Eric Lane, who had been with the firm since 1924, must have experienced a surge of interest from their customers when they produced Mabel Leigh's table-ware designs, SHANTEE and PAGODA, as well as the art deco matt glazed items. Unfortunately, Mabel Leigh left Shorters in 1935 and although they continued to use many of her designs, her unique skills and inspiration were lost to the firm.

THE HALCYON YEARS
(1933-1939)

Throughout the Thirties, Shorters continued to progress. Their ornamental earthenware was said to be "capable of selling in every leading retail establishment". There was little room for expansion in Copeland Street but in 1936 Harry Steele instructed the works joiner to convert an available warehouse into a showroom and invited the pottery press to admire this new venture. Even after Mabel Leigh had left the firm in 1935 her designs and their successors continued to sell well. The vibrant Period Pottery plaques became fashionable as wall decorations and the new "Sunray" trade mark, adopted about that time, epitomised the firm's new, bright image. It had long since ceased to produce the ".... plain, self-coloured majolica glazes of a former regime" and specialized in what the pottery trade describes as "fancies". Harry Steele preserved the moulds of the magnificent majolica pieces and re-used them whenever the public seemed particularly receptive to nostalgia.

Shorters' anonymous designers and modellers brought out countless attractive ranges in decorative table ware and "fancies" during this creative decade to keep this small firm flourishing where others crashed in the slump. An enthusiastic review in the Pottery Gazette of September 1936 reported that the Group's productions had been lifted out of "the ordinary rut" and placed them on "a plane of their own". The article went on to say, "There are probably few firms in the pottery industry which are so consistently engaged practically all the year round in trying out new ideas, with a view to fostering interest in pottery and stimulating a demand for it." The review goes on at some length to commend the Shorter group for their innovation and their courage in developing new lines.

Unfortunately, this was not a happy period at "Chetwynd", Colley's home. In 1935 his elder daughter, Margaret, married a man of whom he did not approve. She left the family home and was cut out of Colley's will without the proverbial penny. Nancy's health was becoming so poor that she had to be admitted to a hospital in nearby Market Drayton. Soon afterwards, Colley's younger daughter Joan, started work in the offices of A.J. Wilkinson Ltd. and, like other members of her family there, was reluctant to associate with Clarice Cliff.

At Wilkinsons, the design impetus generated by Clarice appeared to have diminished. The balance of original ideas, design and production was moving in favour of Shorters. Mabel Leigh's Period Pottery, so different in style from Clarice Cliff's "Bizarre" Ware, was in the ascendency with the series extended by many imaginative and finely executed new designs. Harry Steele's motto that "Variety is the spice of life" was put into effect when Shorters presented the public with an unprecedented choice of new decorative wares.

Despite the approach of World War II, Harry Steele was full of confidence at Shorters. He opened new showrooms and told trade reporters that the firm was "stronger and more powerful than ever".

Chapter Five

MABEL LEIGH

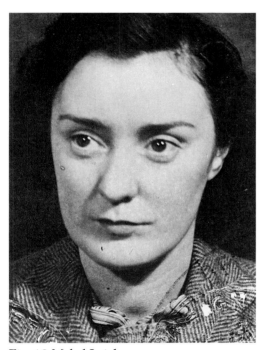

Fig. 19 Mabel Leigh.

In her brief spell at Shorters' factory in Copeland Street, Mabel Leigh made such an impact that her name can now be put alongside those of Charlotte Rhead, Clarice Cliff and Susie Cooper, although it is only recently that her talent has been fully recognised. Surprisingly, Mabel feels that this was not her best work but, undoubtedly, her Period Pottery with its unique, vibrant quality has ensured that she will be remembered. As was the case with most designers of that period, her name was not acknowledged on her later work for other factories and it will take more research to identify the pottery she designed later.

Incredibly, Mabel Leigh was still in her teens when she produced some of the designs described in this book. Born on 5th January 1915, her childhood was disciplined and somewhat spartan because of her father's well-meaning but strict Victorian attitudes. A compulsive reader from a very early age, her knowledge of history is reflected in her designs.

THE GORDON FORSYTH INFLUENCE

The records of the prestigious Burslem School of Art, the training ground for so many ceramic artists, show that by the time she was twelve, in 1927, she had been awarded a scholarship. The legendary Gordon Forsyth, who was the principal of the School at that time, helped to develop Mabel's innate ability. Not only did she attend for the normal day school hours, but as soon as she could, she also attended evening classes.

Mabel's skill in modelling can be seen from the shapes she designed for Shorters and other pieces of her work still in existence. She was offered a scholarship to the South Kensington School of Art, but her father would not agree to her leaving home. However, if she had gone to South Kensington she may never have met a man who was to influence her life and work fundamentally, Mr J.F. Price.

THE JACK PRICE INFLUENCE

Coincidence plays a large part in our lives and it was pure coincidence that introduced Mabel to Jack Price. After she had left the Burslem School of Art and was looking for work, her father decided to learn to drive. In the course of his lessons, the instructor introduced him to another pupil, Jack Price, the Art Director at the Royal Cauldon Pottery. When Mabel's father told Mr Price about his talented daughter who wanted to work as a pottery designer, Jack Price immediately suggested that she should be brought to see him at Royal Cauldon on the following Monday.

Mabel succeeded in persuading Gordon Forsyth to allow her to take her portfolio of designs from Burslem School of Art even though this was not customary. She

also decided to take a vase she had modelled depicting the ballet Petroushka. Russian ballet has always been one of Mabel's passions and she must have poured all her feelings for it into that vase. Jack Price was a formidable man who, Mabel thought, looked rather like Henry VIII. He completely overawed her, and even put her redoubtable father in his place. However, when Mr Price asked to see the portfolio, Mabel found the courage to ask him to look at the vase first. After studying it for some minutes, Jack Price asked, "What does a little girl like you know about Petroushka?" She recounted the plot of the ballet and Mr Price had to admit that the vase told it all. Could she start work at 9 a.m. the following Monday?

When Mabel arrived promptly at 9 a.m. as instructed, Jack Price had forgotten about her and did not call in his office until about 4 p.m. After apologising for her long wait, he proceeded to lecture her about what he expected from his staff: "Never tell a lie; never be selfish, and always do good work". This was his first step towards influencing her artistic and political life. He trained her thoroughly as a designer and eventually she would visit his home at weekends to talk about music, art and politics. Jack Price was a committed socialist and carried his socialism into his relationships with those who worked with him. He recognised the worth of all the workers in the industry and his deep social conscience made a lasting impression on the young Mabel.

Unfortunately, Royal Cauldon ran into financial difficulties and had to close. Jack Price was offered a consultancy at Poultney's of Bristol and wanted Mabel to work with him there. Once again, her father stood in the way of her progress and she had to stay at home in Stoke-on-Trent, working at Mason's (Ashworth's).

An incident during Mabel's time with Jack Price gives some indication of this young woman's strength of character. During 1933 she attended a meeting arranged by the Society of Industrial Artists with Jack Price and Gordon Forsyth. After a lecture about modern art there was some discussion amongst the audience, which included the young Susie Cooper, about the attitude of the pottery industry to modern art. Mabel muttered her disagreement to her companions and they forced her to her feet where she made the following statement: "There are a lot of young artists producing modern stuff, but when they show it to the boss he says 'It is new, and I have never seen anything like it before; but I dare not give it to my travellers.' The stuff is admitted to be very nice, but all the same it is never taken up, and I don't think it is giving young artists their chance" (Pottery Gazette, January 1933).

THE SHORTER YEARS

Soon after this incident, Mabel got a chance to express herself more freely in her work. After leaving Royal Cauldon she worked in her own studio, experimenting in various ways of decorating pottery and developing designs based on ethnic cultures. Coincidence struck once again when Harry Steele, the Manager of Shorter and Son, called to see her father about a nurse who had been looking after Mabel's grandmother. In the course of his visit, Harry Steele noticed some pots that Mabel had left drying on a tray. He was immediately impressed and suggested that she should call at his factory the following day to discuss working there.

Mabel was disinclined to leave her experimental work in her small "Geirig" studio, but there was no question of disobeying her father and she turned up at Shorters' factory in Copeland Street on a snowy Saturday morning, probably in late February 1933. Harry Steele was surprised that she had made her way through the snow but immediately offered her work as a designer with a comparatively free hand. She could have a room of her own and "play around" for a while.

Used to the more up-market Royal Cauldon Pottery, Mabel found conditions at Shorters positively Dickensian. Jack Price had sharpened her social conscience and she was appalled at the environment in which Harry Steele's employees spent their days. Many floor boards were rotten and she was forced to protest when a woman carrying a heavy trayload of pots fell through the boards, scratching her legs. Sagger makers worked on earth floors and dippers ate their snacks from boards stained by

poisonous lead oxide. Pay was extremely low and this was reflected in the inadequate clothes of some of the unskilled workforce.

MABEL LEIGH'S PERIOD POTTERY

In her new post, Mabel flung herself into a torrent of creative work. She had conceived the idea of a series of peasant pottery based on designs from the Middle East, Africa and Central America. Harry Steele appreciated the quality of her original work. On one occasion he even exerted pressure on her to hand over one of her own experimental pieces, saying, "We have bought your mind!" Because of its derivation Mabel would have preferred to call the series "Peasant Pottery" but the consensus of opinion was that "Period Pottery" would be a more appropriate name for what was intended to be a new and prestigious range.

She recruited four young girls, school leavers, who enjoyed drawing but who were not formally trained, to work in her Period Pottery studio. She did not want the comparatively sophisticated students of the Burslem School of Art because she required her trainees to paint and decorate in the unaffected manner of native artists.

Mabel designed the shapes in her studio at Shorters and trained her small team to decorate them with sgraffito and free-hand painting. Some pieces, and all the traveller's samples, were decorated by

Mabel herself. She endeavoured to maintain high standards despite Harry Steele's pressure for greater output. Her original team consisted of Marie Procter, Ena Wright, Ann Penson and Marjorie Chatfield (or Cartwright?).

Mabel recalls that Ena, Marjorie and, occasionally, another decorator called Elsie, did the sgraffito designs using a metal skewer, whilst Marie and Ann painted the pottery. To ensure that her team was kept fully employed, Mabel designed some pieces that required only a

Fig. 20 Leaflet designed by Mabel Leigh for 1933 exhibition.

painted pattern, for example, the multi-coloured, spiralling, ESPANOL. The pottery was launched at an exhibition in the London showroom that Shorters used and was publicised with a leaflet designed by Mabel herself. The pottery press was enthusiastic about Shorters new Period Pottery. In the December 1933 issue of the Pottery Gazette a reviewer describes "a splendid range of ornamental wares in bold, fearless, colourful style" and in 1935 Mabel Leigh's Period Pottery was judged to be "qualitatively excellent".

Mabel Leigh's designs had given Shorters products the qualitative boost that Harry Steele was seeking and provided the Group of potteries with a range of ware that complemented and contrasted with the extravagantly modernistic designs produced by Clarice Cliff for the Newport Pottery.

THE PRODUCTION OF PERIOD POTTERY – AN ACCOUNT BY MRS PHYLLIS DALE

Mrs Phyllis Dale, a contemporary of Mabel Leigh who played a major role in the running of the factory, gives a first-hand account of the production process involved:

"The manufacture of Mabel Leigh pottery or 'Period Ware' as it was then generally known, was a rather specialised line which was decorated etc. in an entirely different manner from our usual run of goods. Whereas our other lines were embossed from the clay biscuit state, fired then painted and refired, this particular pottery was actually

worked on in its clay form, so that you can possibly imagine it had to be rather a careful and slow process they are all of a scratched pattern, the patterns were actually scratched in the clay by metal skewers, no two pieces being identical of course Then fired to biscuit, painted in by hand, glazed, then refired. All had what is called in the trade a Patina background mainly in browns, fawns and greens the most popular ones were Medina/Brown, Mendoza/Green, Aztec/Green and Aswan, I think a fawnish background (and Khimara). Very few of the others proved popular so were eventually discontinued. The demand was very limited, because in the first place they were fairly expensive in those days, and secondly usually only specialised shops purchased them"

COTTAGE WARE

In Mabel's words, she worked "like a robot" whilst at Shorters, designing hundred of shapes in one year. Her work was not confined to Period Pottery. Cottage ware was fashionable at the time and Harry Steele asked her to design a cottage series. At first Mabel demurred on the grounds that they had become rather clichéd. When Mr Steele persisted, she struck a bargain with him. If she did his cottages, could she experiment with a series based on pagodas? He agreed, and the result was the highly original Shantee series of cottage designs and the exotic Pagoda ware.

By 1935, however, Mabel Leigh was becoming increasingly unhappy about her association with Shorters. Although she was fond of her young team she wished to develop her artistic and creative ideas but Harry Steele was reluctant to provide the necessary resources. Consequently, after just over two creative years, Mabel left Shorters.

THE POST-SHORTER PERIOD

After leaving Shorters Mabel continued her work in the pottery industry, specialising in design and decoration at Crown Ducal where she worked with Charlotte Rhead.

During the War she used her skills in draughtsmanship to produce maps for the War Office. Just before the end of the War, the Government realised that it would be necessary to raise foreign currency if the country was to recover from the catastrophic effects of the global conflict. A pottery export drive was initiated and Gordon Forsyth was asked to bring together a team of skilled designers, one of whom was his talented former pupil Mabel Leigh. Her release from the Intelligence Service was secured and she resumed her career in pottery design. With Gordon Forsyth, Gilbert Sergeant and Eric Tunstall she worked at the Royal Winton factory.

RETIREMENT

Mabel continued to work as a designer at Royal Winton until her retirement which was hastened by a spinal injury in 1964. She still remembers with great affection her colleagues at Royal Winton Pottery. She and John renovated a small school-house in Wales and retired there in 1968. Mabel wanted to set up a pottery workshop but could not obtain planning permission. She did some freelance work, painting and designing tiles for H. and G. Thynne, but mainly concentrated on enjoying her retirement with John.

Together, they have transformed the rough grounds of the old school house into an idyllic Japanese garden with snow lanterns and ornamental pools which provides a sanctuary for local wild life. She still reads voraciously and their home is filled with books, paintings and pottery, some commemorating John's early interest in motor-cycling. Although this remarkable woman regards herself as something of a recluse, she still maintains a wide circle of friends.

It came as a complete surprise for her in the 1980s when the authors sought her out as the Mabel Leigh who had designed that, almost forgotten, Period Pottery.

Chapter Six

THE NINETEEN FORTIES

WAR TIME (1940-1945)

Shorter and Son Ltd. survived the War remarkably well. They and Wilkinsons were happy to be able to sell off all their surplus pottery to the War Office at the beginning of the war. Most of the male, and some of the female work force, joined the Armed Forces. Production for the home market was restricted to undecorated ware and the "Bizarre" shop was closed. Shorters were one of the fortunate firms permitted to export. Patriotic and nostalgically British pieces, such as John Bull character jugs, were sent to the Commonwealth and Allied countries. The sgraffito skills, developed to produce Period Ware, enabled them to replace much of the sgraffito ware previously imported from Italy, and they continued to develop new lines and glazes.

Although the decorated ware was supposed to be restricted to the export market, some pieces, known as "export rejects" (which we would now call "seconds") and "frustrated exports" found their way on to the home market.

The Shorter family played its part in the war. Guy's son, John Brereton, was the only one who saw active service. After secondary education at Denstone College he had gone to the London School of Economics and was still there when war broke out. Like his father before him, he immediately enlisted. As a major in the crack Parachute Regiment he served throughout the Italian campaign and later, in Palestine. A parachute accident injured his back but he continued to serve in the Middle East until July, 1946. During the War, John met his second cousin Charlotte who had come to England from Argentina to help in the war effort. They married on 28th March, 1947.

Colley Shorter's war started on a sad note. After years of illness, his wife Nancy died on 22nd November, 1939. Characteristically, he delegated the arrangements for the funeral to one of his managers, Gerald Pearson. Nancy's death left Colley free to associate more openly with Clarice Cliff and, after a year and one month, they married quietly in Stafford Registry Office. The marriage was not made public until the following year when the couple went on a belated honeymoon, to North Wales, where Clarice was introduced to Colley's mother and sisters in Llandudno. They did not stay with the family because Colley enjoyed a drink and his mother kept a strictly Methodist home.

Colley, who had always been rather envious of Guy's First World War record, took the opportunity to try to emulate it by joining the Home Guard. His friend Arthur Wenger, whose family had bought Arthur Shorter's first factory, helped him to obtain a commission and he was soon an enthusiastic Lieutenant Colonel, even buying a full officer's uniform to wear on duty. The military authorities frowned on this ostentation but one can imagine Colley riding to his factory in full uniform on one of his hunters when petrol for his Rolls Royce was not available.

Guy Shorter had probably had his share of military excitement in the Great War and did not join Colley in uniform. Instead he concentrated on keeping the factories going despite wartime difficulties. Colley's daughter, Joan, appreciated the new independence that she had gained during the war. Although her father had obtained a reserved job for her in a munitions factory she joined the Women's Auxiliary Air Force against his wishes. Whilst in the services she met and married a Canadian Medical Officer, Raymond Purkis. Colley relented sufficiently to attend the wedding, accompanied by Clarice.

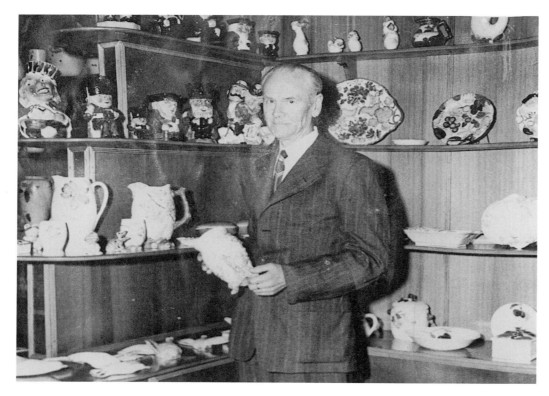

Fig. 21 Colley Shorter
with a display of
Shorter pottery.

POST-WAR REVIVAL (1946-1949)

After the war there was a tremendous drive to build up Britain's shattered economy by exporting as much as possible to obtain foreign currency. The Shorter factories already had contacts all over the world and enthusiastically joined the export drive. Colley was assigned to the Advisory Committee of the Export Earthenware Manufacturers' Association and he , Clarice and Guy travelled abroad extensively to boost their businesses. Fortunately, all the male staff of Shorters had survived the War and now returned to help to increase production.

The creative upsurge experienced after the war was reflected in Copeland Street where Harry Steele's designers and modellers produced some remarkable new lines for Colley and Guy to export. Stylish vases that epitomised new design trends, cheerfully original children's ware, a new generation of character jugs and a profusion of floral designs poured from the old bottle ovens. Confident as always, Harry Steele told the press, as he had told them in 1939, that the firm was again, ".... stronger and more powerful than ever".

In Canada and the United States, Colley and Clarice became celebrities, giving interviews and broadcasts about their firms' creations. Colley used his Home Guard rank and was described by the press as "Colonel Shorter" whilst Clarice was described as the Artistic Director of the Shorter Group of Factories. In reports of these interviews, a series of figurines based on the Gilbert and Sullivan operas is attributed to Clarice Cliff-Shorter. This series was marketed by Shorters in 1949 with all the publicity for which Colley was noted. During the same visit, Clarice claimed to have designed Fruit Ware.

Whilst in Canada they took the opportunity to visit Colley's daughter Joan and her husband in Victoria.

Chapter Seven

THE NINETEEN FIFTIES

Although "austerity" may have been the watchword in a Britain struggling to recover from the War, the exporting potteries were able to express themselves in colourful decorative terms. Shorters reproduced many of their most successful lines and at the same time developed delightful new ranges of floral table ware and attractive fancy goods. Many of these items were for export until the mid-Fifties but some found their way into British homes and others appeared on the market as "export rejects".

To keep their products in the public eye, Shorters organised spectacular publicity campaigns. The Gilbert and Sullivan figurines, which represented a peak in their artistic development, were distributed to the casts of D'Oyly Carte productions by prominent Shorter representatives such as their Australian agent, Geoffrey Cowan. To publicize the magnificent Neptune character jug, Shorters organised a transatlantic campaign. Metro-Goldwyn Mayer's international film star, David Niven presented a Shorter Neptune to the winner of an all-Britain beauty contest who, in turn, took examples to the Mayors of the main cities in the United States. The whole enterprise was

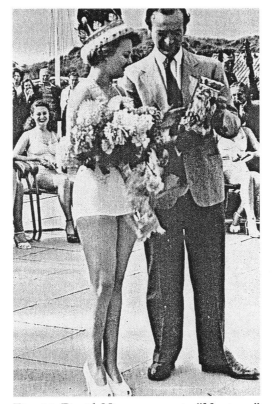

Fig. 22 David Niven presents "Neptune" character jug to winner of "Neptune's daughter" beauty contest (1950).

endorsed by the Mayor of Stoke-on-Trent, Alderman Henry Hopwood, who sent an accompanying letter to his transatlantic counterparts.

In 1950, Guy Shorter partly retired but could not resist visiting the factories frequently. Eventually he went to live in Rhos-on-Sea, North Wales but, unable to settle down there, soon returned to the more familiar Ashley Heath, near Market Drayton.

Although he was older than Guy, Colley did not retire. He and Clarice were actively involved in promoting the latest Shorter designs in Canada and the United States.

They amassed an impressive collection of antiques of every description. Both smoked heavily and by the end of the decade this and increasing rheumatism gradually affected Colley's health. Although he would always manage to straighten his back as he strode across the factory floor, his visits became less frequent.

THE THIRD GENERATION

By 1950, Guy Shorter's son John had settled down to civilian life with his wife Charlotte. After a spell with the Commercial Metal Company in the City of London he joined the Bank of England and seemed destined to a career in banking. Uncle Colley Shorter, however, had other plans. Eric Lane, who had

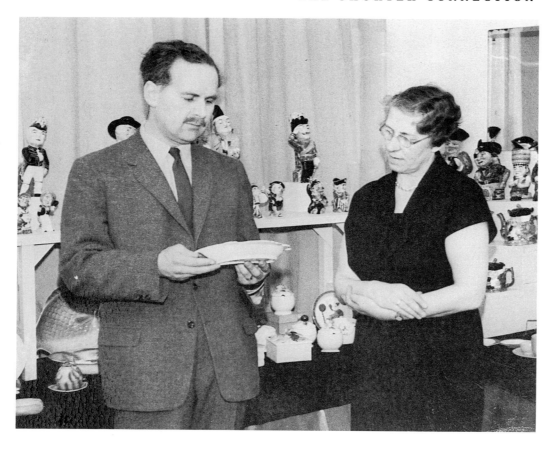

Fig. 23 John B. Shorter and Phyllis Dale at a Blackpool Trade Fair in the early 1950s.

their creation. This white matt glazed series was sold on the home market. It was not until 1952 that a limited number of decorated wares could be sold to the British public and Shorters took full advantage of the new freedom with an avalanche of colourful designs that John B. Shorter and Mr N. Reid sold throughout the United Kingdom.

The quality of the firm's press publicity also improved during this period. Although occasionally, in the Thirties, Clarice Cliff had personally designed striking and unmistakable full-page advertisements, (Fig. 50), the usual joint Shorter/Wilkinson advertisements in the Pottery Gazette had been uninspired. In the Fifties, however, Shorters began to advertise independently and employed a professional commercial artist who illustrated their new lines to great advantage. During this period, Shorter and Son Ltd. was undoubtedly the most creative firm of the group.

Novelties and fancies were still strong sellers and a "whistling bird mug" attracted favourable headlines at the 1957 Trade Production Series Fair in Blackpool. Harry Steele continued to exude confidence whenever interviewed.

worked for the company since 1924 must have felt that his career was not progressing. He had the opportunity of a better job and wanted to leave. This placed Colley in something of a dilemma and he suggested to Guy that he might invite his son John to take Eric's place.

With some misgivings, John agreed to Colley's suggestion, and in 1950 he and his wife moved to Newcastle-under-Lyme so that he could take over as Sales Manager, and later as a director, of Shorter and Son Limited.

THE FESTIVAL OF BRITAIN

The Festival was organised in 1951, the centenary of the Great Exhibition, to boost the morale of a nation that was wearying of austerity. The design changes inspired by the Festival were reflected by Shorters in a striking series of white matt glaze vases and bowls that were ahead of their time in design terms; so much so that when the Australian John Shorter Jnr saw examples in the authors' collection, he expressed the opinion that Clarice Cliff must have had a hand in

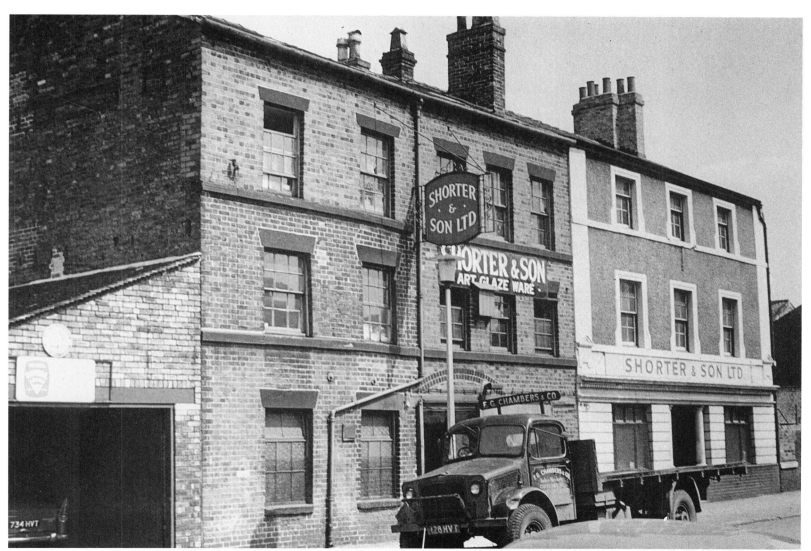

Fig. 24 The factory in Copeland Street extended in 1962 to include new premises.

THE LAST YEARS AT COPELAND STREET (1960-1964)

The 1960 Trade Fair in Blackpool produced ".... the best results yet", according to Harry Steele, but foreign competition was becoming more fierce every year. New floral designs, a new white matt glaze series and up-to-the-minute, oven-to-table ware kept alive the Shorter tradition of constant development. Best-selling ranges were re-introduced and Harry Steele and John B. Shorter planned to expand the factory.

Adjoining premises in Copeland Street were acquired in 1962 and the company was able to use them for a new office and showroom, making room in the old factory for bigger production departments. It was hoped that this would improve output and delivery schedules. A Clean Air Act had been passed in 1956 and implemented in a transitional form in 1958. Although final implementation was not planned until 1963, this meant the end of the traditional bottle ovens on which Shorters, and hundreds of other firms in Stoke-on-Trent, depended. Undaunted, the firm planned to introduce up-to-date, electric intermittent kilns.

Despite these optimistic plans, the directors were worried about competition from the European Economic Community. Harry Steele felt that some form of protection would be necessary if small firms such as Shorters were to survive. Nevertheless, the company planned to develop the factory to give

them the capacity to maintain and strengthen their business. The art of flower arranging was developing and Harry Steele felt that this would present more openings for their products. From John B. Shorter we learn that the firm's best selling vase from the 1930s onwards was the classical Grecian urn shape No. 446 (Fig. 70).

Unfortunately, whilst the firm was planning its developments in 1962, it could not have been aware that the local authority was planning a ring road which would obliterate the whole of the side of Copeland Street that ran alongside the canal. The news of this plan must have severely shocked the directors, particularly after the expense that had been incurred in taking over the adjacent premises. There was obviously no point in converting the ovens in the face of this shattering news.

Colley Shorter, his health worsening, decided to retire in 1961. Seriously ill, he spent two years in and out of hospital before he died on 13th December 1963. Most of his estate went to Clarice Cliff but he left a small legacy to his daughter Joan, in Canada. True to his threat, however, his elder daughter, Margaret, was disinherited. Clarice continued to live quietly at Chetwynd. She disposed of their shares in the Group's factories, passing control of the Wilkinson /Newport factories to the Midwinter company.

THE CROWN DEVON CONNECTION (1964-1974)

The loss of the family's control of the associated factories must have had a further, serious effect on the situation at

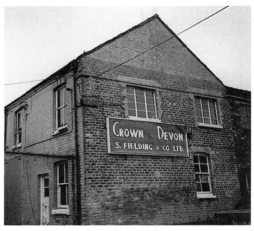

Fig. 25 The Crown Devon factory in 1988.

Copeland Street. Foreign competition was indeed beginning to bite, as Harry Steele had forecast, and in 1964 the company took the decision to merge with Fieldings (Crown Devon) and move its operations to that company's site in Whieldon Road. Although there must have been some compensation for the destruction of the Copeland Street factory, the overall situation meant that a merger with a stronger firm was the only viable alternative.

The Crown Devon factory had been founded at almost the same time as Shorters in the 1870s and had developed as a similar family firm along parallel lines. This single factory became much larger than the Shorter factory but the

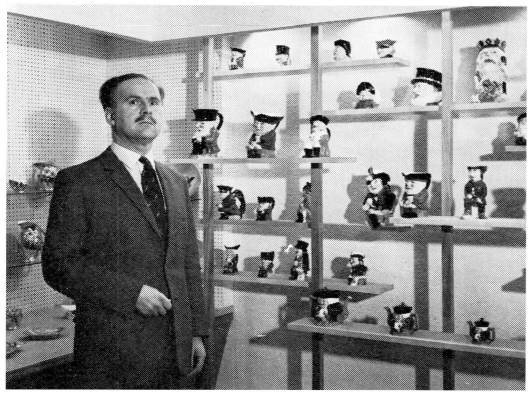

Fig. 26 John Brereton Shorter in the Crown Devon Showroom.

Shorter group of potteries consisted of three separate establishments, each catering for a different section of the pottery market. Although Crown Devon was founded by Simon Fielding, it was his son Abraham, a contemporary of Arthur Shorter, who played the leading role in the early years.

Crown Devon started as a majolica factory but ceased to manufacture this type of ware at the turn of the century. It developed first the "Vellum" range and, subsequently, their characteristic red

lustre series and musical novelties. Technically more progressive than Shorters, Crown Devon introduced gas fired kilns as early as 1913 and, throughout its existence, maintained a policy of modernising its equipment. Abraham Fielding was succeeded by his son Ross in 1932.

Crown Devon underwent a comprehensive reconstruction after the Second World War but Ross Fielding died in 1947 before he was able to appreciate the full benefits. His son,

Reginald, took over. After four years the factory was almost destroyed in a disastrous fire but by 1952, they were back in production and by 1964, were strong enough to take Shorter and Son under their aegis.

The staff at Copeland Street was stunned to be given only two weeks notice of the closure of their factory. Most of them were made redundant, and a mere handful of workers was transferred to the Crown Devon site. This was before Redundancy Payments became payable by law. Harry Steele did not take part in the move; he was in his sixties and must have decided that this was a convenient time to retire. Many of the skilled workers had to find jobs in other factories and some have sad and bitter memories of the sudden loss of their jobs.

At Crown Devon, John Shorter bravely created a separate identity for Shorters, commissioning a new logo and arranging for new showrooms to be built. The nucleus of Shorter staff shared facilities with the Crown Devon workers in an uneasy union that led some of them to leave after a short time. They continued to produce popular Shorter lines with only a few new ranges being created. When they moved, the owner of Fieldings was Reginald Fielding, one of the old school of pottery owners. He and John Shorter got on well, but when he died, soon after the move, the firm was taken over by Douglas Bailey whose management style was completely different.

After a few years at Whieldon Road, it became clear that the new arrangement was unsatisfactory. In 1971 John Shorter decided to take a year's sabbatical to consider his position. The following year, on 22nd February, 1972, John's father, Guy Shorter, died, and John and his wife Charlotte decided to take over a picturesque country post office in the West Country. Later in that year, on 23rd October, Clarice Cliff-Shorter also died. Crown Devon continued to use some Shorter moulds, particularly the character jugs, which bear either the Shorter impression or the Crown Devon backstamp or, occasionally, both.

Fig. 27 John B. Shorter's country Post Office.

Fig. 28 End of an era — blocks and moulds for sale at Crown Devon.

So ended a century of pottery making by the Shorter family. It was to be some years before the quality of their work achieved recognition amongst collectors of ceramics. Such collectors are now beginning to appreciate the richness of Shorters majolica jugs, the pioneering style of their art deco matt glaze, the sheer exuberance of their fancies and floral table ware and, above all, the enduring quality of Mabel Leigh's Period Pottery.

Chapter Nine

THE WORKFORCE

Most of the former employees we met were in their seventies and even eighties, but despite years of hard work their minds were alert and their memories sharp. Almost without exception, they enjoyed their days with Shorters, despite less than ideal working conditions. Most of them remembered the little old factory with affection, one even referred to it as a "home from home". Industrial relations appear to have been good; nobody interviewed recalls any serious industrial action.

MANAGEMENT

The factory was managed successively by James Boulton, his son William, Guy Shorter, Arthur Holdcroft, Mr Lovatt and for over thirty years by Harry Steele. Other people in the management organisation, such as Mr Yeomans and Hilda Dodds are little more than names recalled by older members of the workforce.

Although Harry Steele was the manager, he spent half of his time at the Wilkinson factory, leaving Mrs Phyllis Dale with much of the day to day running of Shorters (Fig. 23). This means that some of the firm's success should also be attributed to Mrs Dale, who dealt with every aspect of management, from keeping the accounts to illustrating the Pattern Book. Mrs Dale obviously worked very closely with Harry Steele and gives him credit for inspiring many of the designs that were produced. When the factory was closed so suddenly in 1964,

Fig. 29 Dinner dance at the 'Rialto', Stoke - on -Trent in the 1950s. Seated, from the right are Mrs Charlotte Shorter, Mrs Guy Shorter, Mrs & Mr Harry Steele and Mrs Phyllis Dale with three other ladies. Standing from the right are Mrs Gladys Copestoke, (Glost warehouse manageress), Mr John Shorter, Mrs Beryl Lodey, Mr Guy Shorter, Mrs Ethel Palmer.

the effect on Mrs Dale must have been traumatic, so closely did she identify herself with the firm. John B. Shorter was sales manager from 1950. He took over complete control following the merger with Crown Devon.

DESIGNERS

The only designer referred to by name is the incredibly talented Mabel Leigh whose work is now so highly collectable. As Mrs Dale records, many of the other designs were inspired by Harry Steele, but the firm must have employed some anonymous, free-lance designers and some from the sister firms of Wilkinsons and Newport. Free-lance designers whose names have been mentioned, but who have not been traced, are Frank Garbutt and Mr Coxon.

MODELLERS

A key figure who, sadly, declined to be interviewed at length was the modeller Leon Potts who modelled many of the

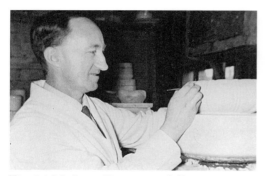

Fig. 30 Mr Leon Potts – modeller.

pieces that were so popular for nearly thirty years. Colleagues who worked closely with him recall with admiration that he produced new ranges every year, mentioning in particular, Anemone, Dahlia, Petal and Wild Rose. Mr Walklate, a former apprentice who joined the firm in 1959 describes how the modellers were responsible for:

Fig. 31 Mr Walklate – modeller.

".... putting the idea into clay and also adding some elaboration. When everyone was satisfied with the original model we then had to make up further pieces which were basically our design". The modellers had no say in the colouring of their creations. John Shorter also suggested several designs.

It is quite possible that Mr Potts initiated some designs himself because one of his colleagues recalls seeing him sketching patterns. Mr Potts was another of the long-serving members of the staff who suddenly became redundant in 1964. He had joined the staff in the early 1930s and, not surprisingly, was embittered to be given two weeks' notice, after thirty

years service. At the age of 49, he thought he might have difficulty in obtaining another job, but clerical qualifications he had gained in his youth helped him to find work in an office. After a lifetime of creative modelling he found this uncongenial and eventually was able to return to his trade at the Howard Factory.

Mr Walklate, was responsible for modelling the Cavalier character jug, as well as the "Countryside" series of decorative table ware.

Harry Steele employed some free-lance designers and according to the former mould maker, "Ernie" Wood, some modellers from A.J. Wilkinsons produced work for Shorters. Amongst them was Betty Silvester, who designed the "Teepee" teapot, for Clarice Cliff and the "Daisy Bell" figures for Shorters.

TRAVELLING SALESMEN

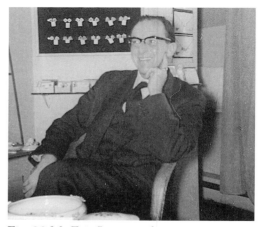

Fig. 32 Mr Eric Lane – salesman.

A vital worker who has declined to be interviewed at all is Mr Eric Lane who travelled for Shorters from 1924 until 1950 when he moved to another firm and was replaced by John B. Shorter. His energetic salesmanship throughout the South of England undoubtedly contributed to the survival and success of Shorters.

Mr T.G. Roberts, a traveller who only spent two or three years with the company, specialized in selling Mabel Leigh's Period Pottery in the 1930s. Mr Roberts co-operated closely with Mabel Leigh who gave him a booklet, that she had illustrated by hand, to show his potential customers and supplied him with samples which she had decorated personally. This was supplemented by the leaflet that Mabel had designed for the launch of Period Pottery. Mr Roberts would tour all the likely outlets, and return on the following Saturday with a list of orders. He recalls that Harry Steele ran Shorters "on a shoestring" keeping paper work to the minimum. He would be paid in cash on the Saturday morning and given a fresh batch of samples if necessary. Although the whole operation was simple in the extreme it sold so much pottery that the firm was kept going when others were bankrupted by the Thirties depression.

DECORATORS

Most Shorter pottery was decorated by hand, and we were fortunate enough to meet several of the skilled paintresses who decorated the hundreds of different designs. One of these artists who remembers the early days, before Harry Steele took over, was Mrs W. Moran, who was born in 1909. Mrs Moran is rather critical of some of the work produced in those days which, she claims, was sold in fairgrounds. She told us that, "the glaze was majolica with plenty of lead in it", which was why it had lasted so well. The manager in the 1920s was Mr Lovatt and Mrs Moran recalls that the staff then consisted of a "maker, a dipper, a warehouseman, a kiln-man and five paintresses", one of whom was Mrs Moran's mother. Some of the staff had been transferred from A.J. Wilkinsons. As a paintress who worked for Shorters only occasionally, Mrs Moran found herself painting countless fish. She remembers that Hilda Dodds, "a Mormon", ran the biscuit oven and the glost oven and was known as "the Missus". In later years, Mrs Dodds was said to have enjoyed a nap in the afternoon. This was, surprisingly, tolerated by Harry Steele who told her staff not to waken her.

Mrs Ethel Cartlidge, a slightly younger paintress, born in 1915, worked there in the 1930s. She recalls Toby jugs and cottages, the rather heavy pottery, and the majolica style of decoration used. She remembered with pleasure the annual dinner dance held in the Rialto Ballroom in Stoke-on-Trent.

One of her contemporaries, born in 1918, was Mrs M. Edwards, a paintress for 17 or 18 years. She recalled working on the top floor of the rather cramped factory, with the aerographers in cubicles in the same "shop". Cherry Ripe, and Strawberry Fair were amongst the many patterns she decorated in the majolica style. She too enjoyed the Rialto dinners and wistfully recalls dancing with the debonaire Harry Steele. Mrs Edwards still treasures a Christmas card she had received from Colley Shorter and Clarice Cliff-Shorter enclosing a 10/- note.

ACAPULCO *"Happy Days!"*

Fig. 33 Christmas card from Colley Shorter and Clarice Cliff Shorter to Mrs Edwards.

The young John B. Shorter was a visitor to the factory and Mrs Edwards recollects that he was "a little dinger" and that he used to play with her paints.

One of the younger generation of paintresses was Teresa Lindop who joined Shorters from school in 1949. Her

mother had been a skilled pottery decorator and Teresa inherited her talents. Sgraffito was then still an important decorative technique and Teresa inscribed many of the pieces such as Medina and Mendoza. She had drawn them so often that she was still able to produce a free-hand example, skilfully and quickly, when interviewed. The Gilbert and Sullivan figures were introduced at about the time Teresa started at Copeland Street and she painted many of these intricately decorated figures.

AEROGRAPHING

Aerographing was another of Shorters decorative techniques. This involves spraying colour on to the ware from a pressure gun with which a skilled operator can produce beautiful shaded effects. One such operator was Minnie Machin who worked for Shorters from before the Second World War. She was one of the few who moved to Fieldings, together with one other aerographer, four paintresses and a mould maker. She decorated hundreds of popular Fish dishes. According to a Crown Devon aerographer, Mrs Carvil, the large Fish ware "Pike" dish was too big to fit in the aerographer's booth and, despite regulations, had to be surreptitiously manoeuvred outside the booth before it could be fully sprayed.

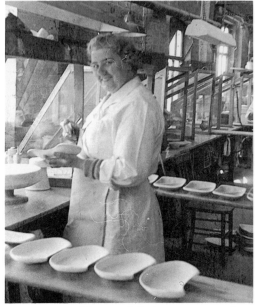
Fig. 34 Mrs "Minnie" Machin – aerographer.

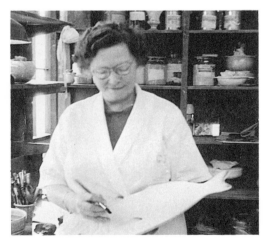
Fig. 35 Mrs "Gertie" Jackson – mottler.

MOTTLING

One of Minnie Machin's older colleagues was "Gertie" Jackson who did not join the firm until 1946. Her trade was "mottling" – dabbing coloured glazes on to aerographed or dipped ware using a sponge. There was a dusty atmosphere, Mrs Jackson recalls, and the workers had to wear protective overalls and hats. They drank milk at 11 a.m. each day, to help to counteract the dust. One of her specialities was painting the eyes in the Fish ware and she claims to be able to recognise "her" fish even now because the pupil of the eye was always painted in the exact centre. Although paid only £4.50 a week for this heavy work, "Gertie" was very happy in the friendly, "comfortable atmosphere". She recalls that the workers were stunned to be given only two weeks' notice of the closure in 1964.

CASTERS

One of the firm's 12 slip casters, Mrs Keaveney, who has provided valuable information for our research, found her days at Shorters, "the happiest of her life". She worked there from 1950 until 1964. Her job was to mould the ware, some of which was intricately shaped. It required great care, especially when delicate pieces had to be removed from

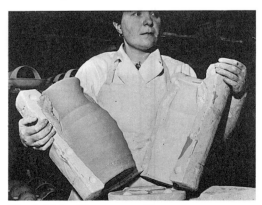
Fig. 36 Mrs Keaveny – slip caster.

the moulds. She worked closely with the modeller Leon Potts, and greatly respected his skill. At the same time, she acted as the union shop steward and represented her colleagues in negotiations with the management about pay and conditions. They usually reached an amicable agreement.

Another caster, Lily Dingwall, had worked with Harry Steele at the Britannia factory in Glasgow. He was glad to employ her and her husband when they moved to Stoke-on-Trent in 1932 because he needed more skilled staff.

THE BISCUIT DEPARTMENT

This was the domain of Mrs G. Dale who worked there for 30 years controlling the flow of fired pots. Mrs Dale was occasionally responsible for the backstamping and recalls that buyers from a few department stores asked that the Shorter name should be omitted. Mrs Dale has been a most helpful source of general information about the factory.

MOULD MAKING

Another long-serving employee was "Ernie" Wood, who started work at Shorters at the age of 17 in 1932. He was employed in many capacities but mainly as a "maker" and "jolleyer". His wife worked with him, and they found the factory a "home from home", despite the rather primitive conditions in those early days. They would make their own

Fig. 37 Mr "Ernie" Wood (right) – mould maker and colleague.

Fig. 38 Mrs Wood with packing cask.

"saggers" in a little old shed and in winter would often have to break the ice to obtain water. There were only about 80 staff in those early days. "Ernie" would often stay at the factory all night to stoke the ovens and earn seven shillings (35p) overtime. At first he took home only 15/- (75p) a week but when he went on to piece work he could earn £5, an above average wage in those days. When business was slack, Mr Woods was even called upon to whitewash the factory walls. "Ernie" recalled the rather make-shift methods of the thirties when he sometimes had to nail an old mould

together to stop it falling apart. The china clay would arrive by canal and the fuel would be delivered by horse and cart. On one occasion a cart fell into the canal. "Ernie" remembers Harry Steele very well and claims that his motto, "variety is the spice of life" was again quoted.

"THE CLAY END"

This is the Potteries term for the part of the factory where the pots are actually fired. Sylvia Thomas was responsible for

Fig. 39 'Tea break'.

sorting the undecorated ware from 1949 until 1956. She earned only £2 a week and explained that because of the hierarchical structure in the industry, "paintresses didn't speak to the clay end".

OFFICE STAFF

Mrs Joyce Barrow started in 1954 and dealt with sales invoices and wages for the 100 or so staff. She recalled that much of the ware was exported to Australia and that some pieces were sold as "seconds" in the United Kingdom.

Mrs Beryl Lodey worked in the office at a slightly earlier date and remembers being told how Clarice Cliff had visited the D'Oyly Carte productions to study the Gilbert and Sullivan costumes in order to design the remarkable figures that were issued in 1949. The offices were on the ground floor, behind the showroom, but were moved when the firm took over the public house next door, "The Copeland Arms", known to the locals as "The Glass Barrel".

CROWN DEVON STAFF

A descriptive letter was received from Mrs Carvil who worked as an aerographer on Shorter ware after 1964. She was employed by Fieldings when Shorters were taken over and twenty years later she still recalled "her beautiful fish". She remembers feeling sorry for the small group of Shorter workers who were so isolated in the Fielding factory.

In meeting this delightful group of Shorter workers we have gradually assembled the image of a busy, small factory on the canal bank, with two bottle ovens and a small frontage. Before the Clean Air Act and surrounded by many other similar establishments it was, of course, rather dingy and dusty, but so were nearly all the other hundreds of potteries in the City. The workforce emerges as a small, happy group of mainly skilled, industrious people who took great pride in their work and thus gained satisfaction from their daily lives. They would sing, joke and even dance on the factory floor and there must have been a great atmosphere of friendship that is missing from some of the more regimented modern work-places.

Fig. 40 Jeffrey Parry Thomas and Gordon Hopwood rescuing the Copeland Street factory sign (1988).

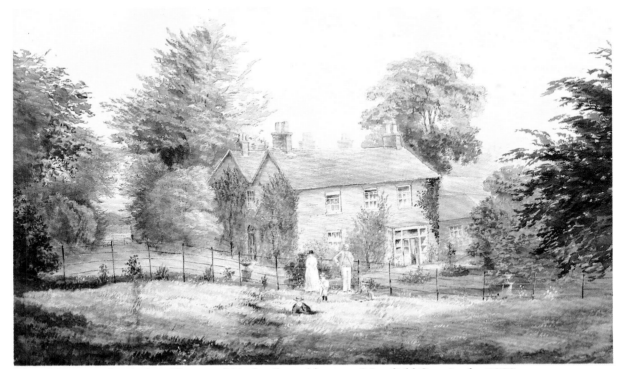

Plate I Painting by Arthur Shorter of his family and home at Maerfield Gate in the 1880s
(77 x 52 cm., 30.5 x 20.5 in.)

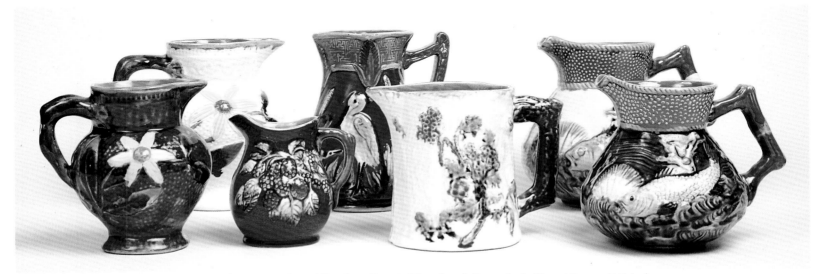

Plate II Majolica jugs: Dragon, Blackberry, Stork and Rushes, Rustic Floral and Oceanic (tallest 19 cm., 7.5 in.)

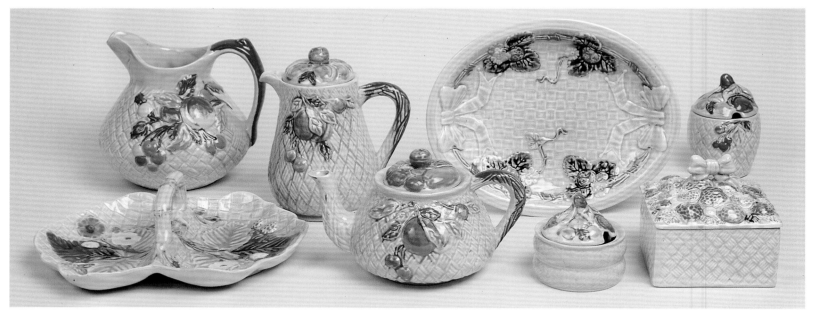

Plate III Majolica tableware: Floral basket, Cherry Ripe and Strawberry and Bow (height of jug with lid 18.5 cm., 7.25 in.)

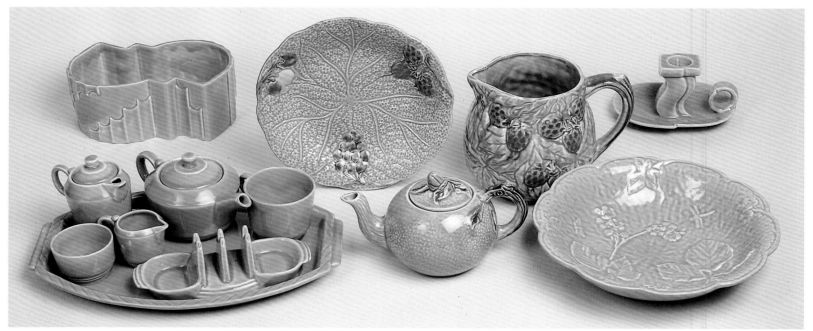

Plate IV Green glazed ware in art deco and majolica styles with Strawberry Fair jug (height of jug 13.5 cm., 5.25 in.)

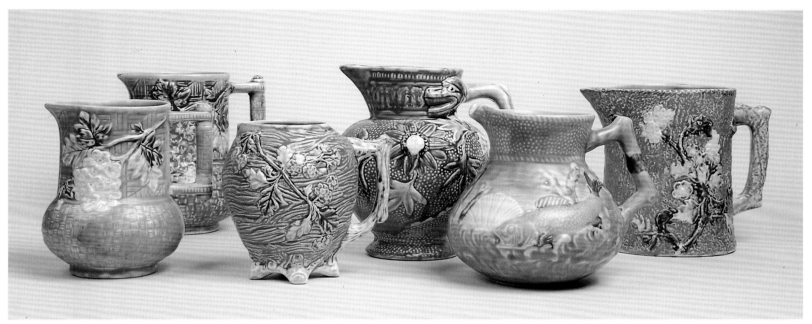

Plate V Matt glazed majolica-style jugs: Blossom, Rustic Floral, Dragon, Oceanic and Floral Tree Trunk (tallest 21 cm., 8.25 in.)

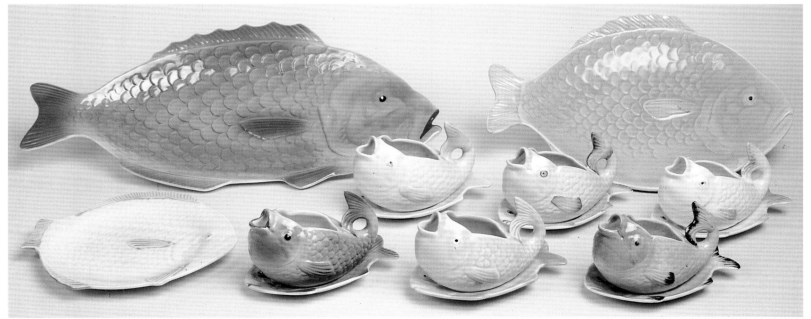

Plate VI Fish tableware (large fish dish 52 cm., 20.5 in.)

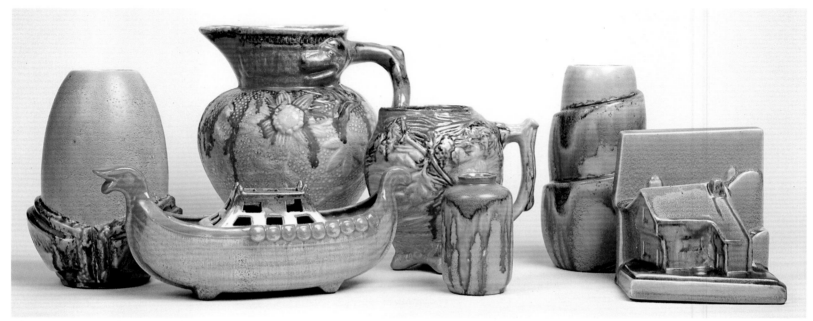

Plate VII 'Aura' glaze on art deco and majolica style ware (tallest jug 23 cm., 9 in.)

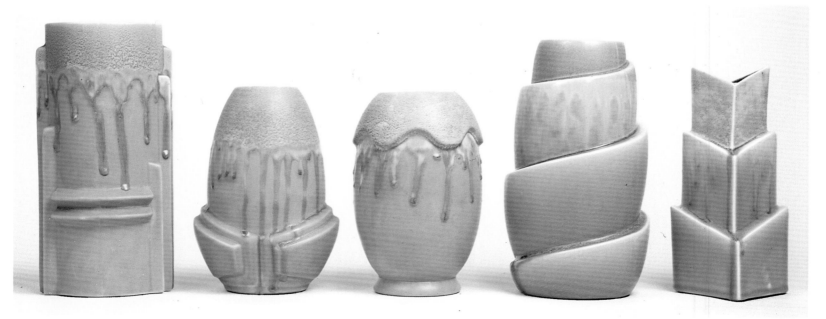

Plate VIII Matt glazed art deco style vases: Pyramus, Olwen, Noni, Thisbe and Rhomboid (tallest 25 cm., 9.75 in.)

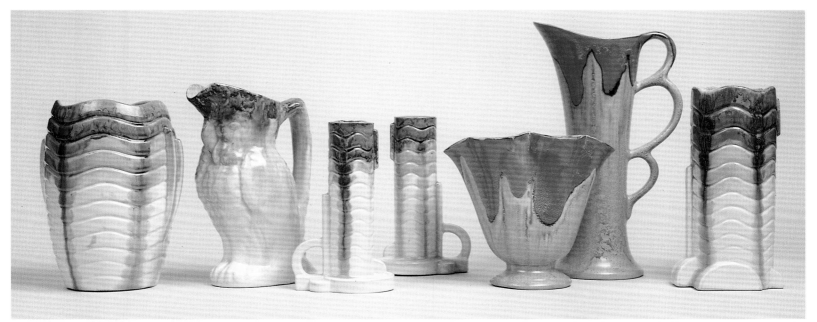

Plate IX Running art glazes on 'Wave' art deco style vases and candlesticks, contemporary shapes and Cockatoo jug (tallest 30 cm., 11.75 in.)

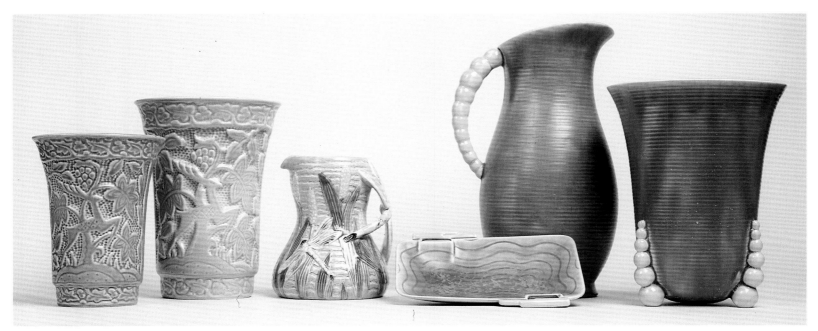

Plate X Matt glazed Stag vases, Dragonfly jug, 'Wave' and 'Beaded' art deco style shapes (tallest 32 cm., 12.5 in.)

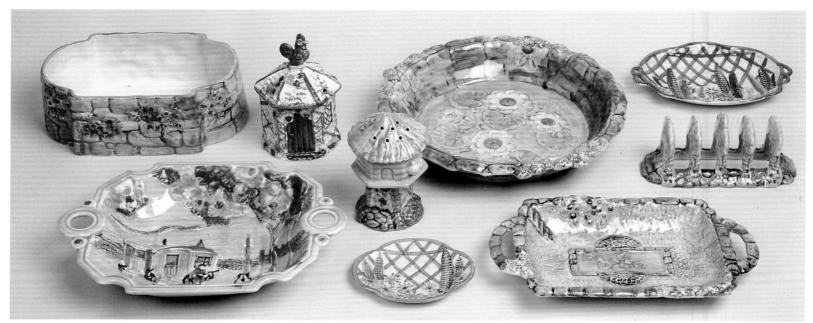

Plate XI Rock Garden and Lupin tableware with Caravan dish (longest dish 29 cm., 11.5 in.)

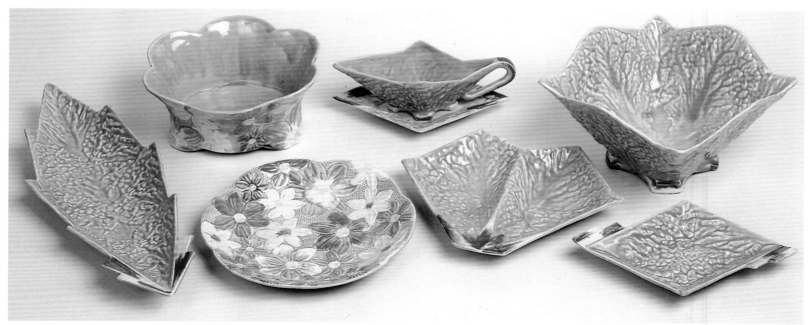

Plate XII Modern Salad and Narcissus tableware (longest dish 40 cm., 15.75 in.)

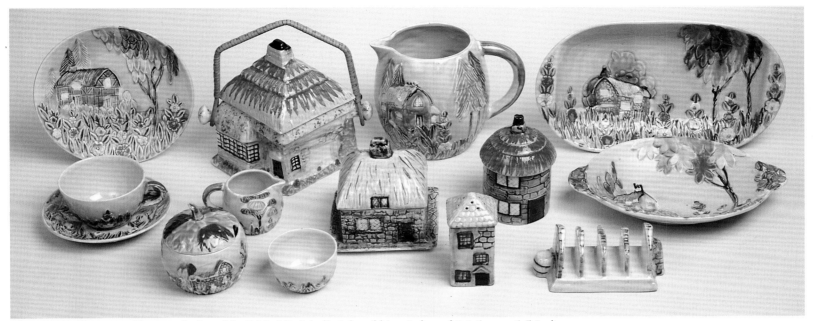

Plate XIII Shantee tableware designed by Mabel Leigh (height of biscuit barrel 16.5 cm., 6.5 in.)

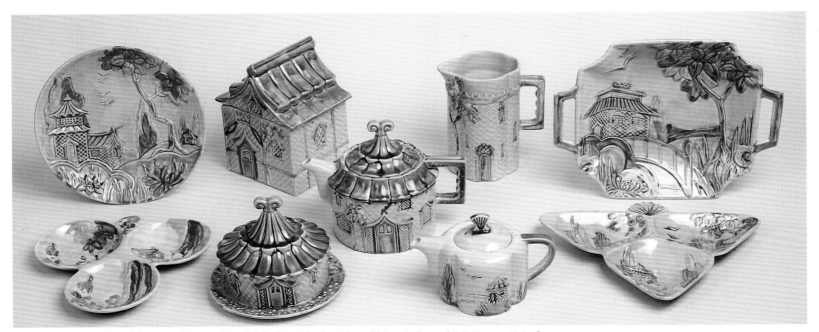

Plate XIV Pagoda tableware designed by Mabel Leigh (height of biscuit barrel 17.5 cm., 7 in.)

Plate XV Shell Ware with early Yacht vase and A.R.P. and Summerhouse nightlights (height of jug 24 cm., 9.5 in.)

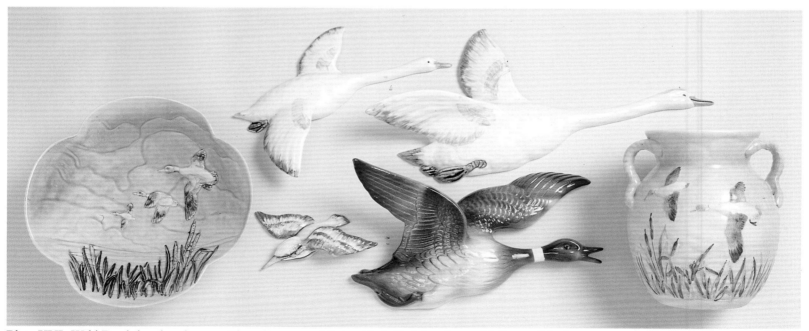

Plate XVI Wild Duck bowl and vase with wall-mounted flying birds (height of vase 20.5 cm., 8 in.)

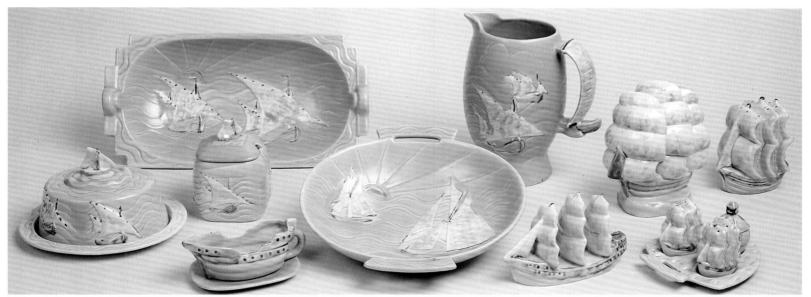

Plate XVII Yacht tableware (height of jug 20 cm., 7.75 in.)

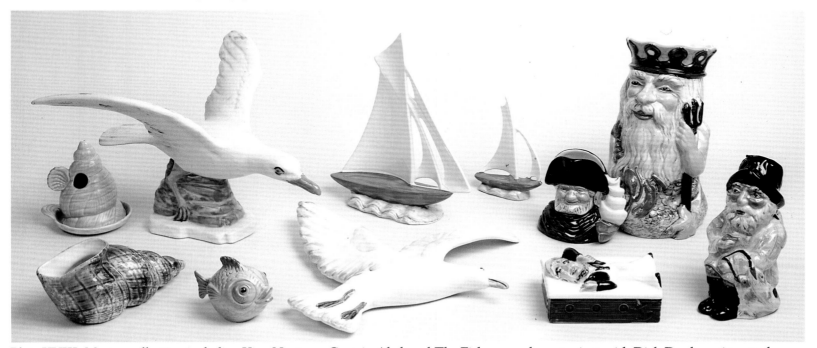

Plate XVIII Marine collection including King Neptune, Captain Ahab and The Fisherman character jugs with Dick Deadeye cigarette box
(tallest jug 25 cm., 10 in.)

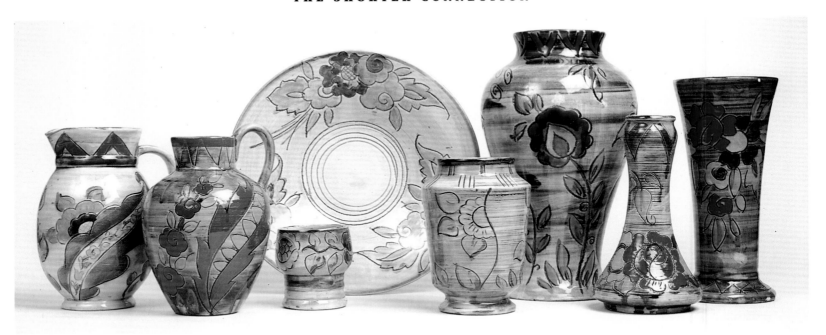

Plate XIX Period Pottery: Medina (tallest 31.5 cm., 12.5 in.)

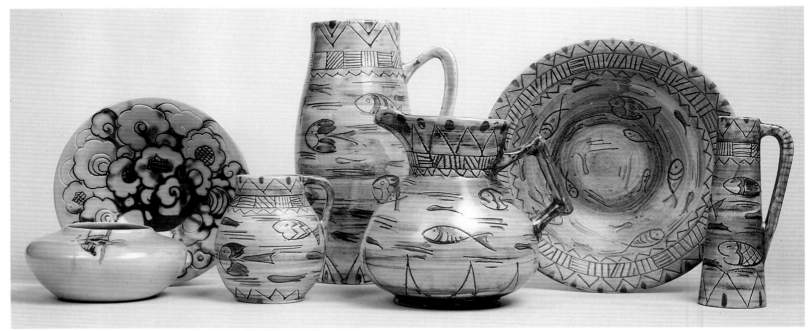

Plate XX Period Pottery: Aztec and Freya plaque and Dvina vase (tallest 32.5 cm., 12.75 in.)

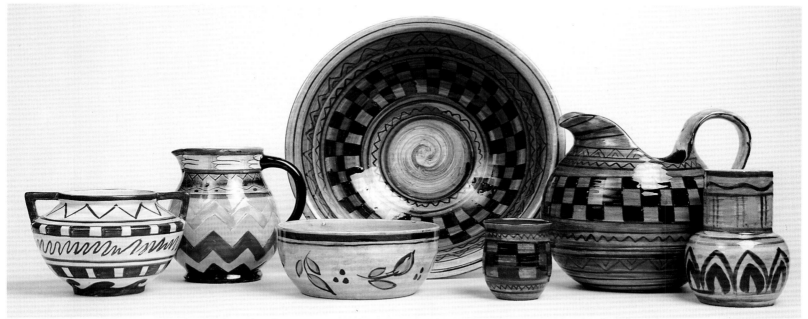

Plate XXI Period Pottery: Anglo Afrik with Algerian vase and Akaba jug (diameter of large bowl 32.5 cm., 12.75 in.)

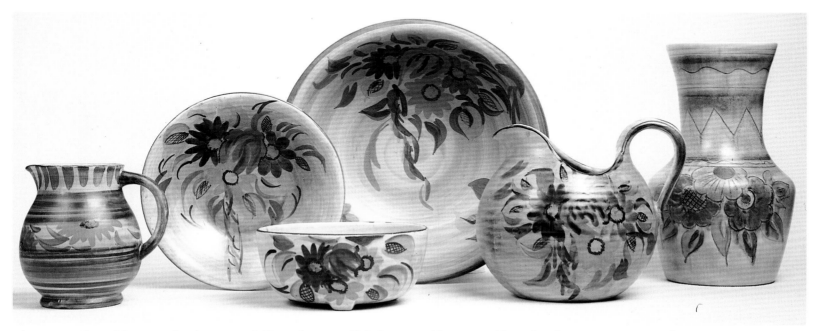

Plate XXII Period Pottery: Gardiniere with Zorayda jug and Medina vase (diameter of large bowl 32.5 cm., 12.75 in.)

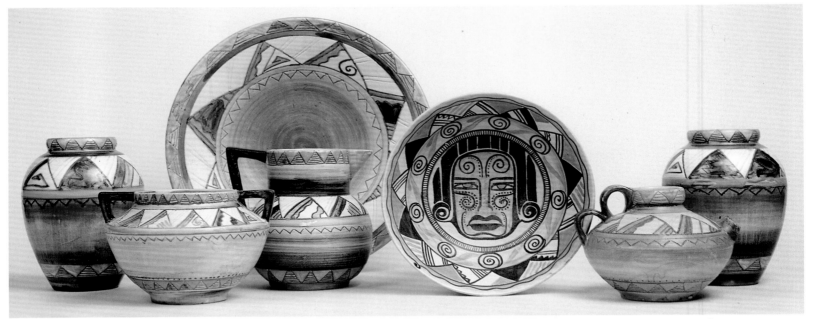

Plate XXIII Period Pottery: Khimara with Mabel Leigh's prototype for the series (diameter of large plaque 30 cm., 11.75 in.)

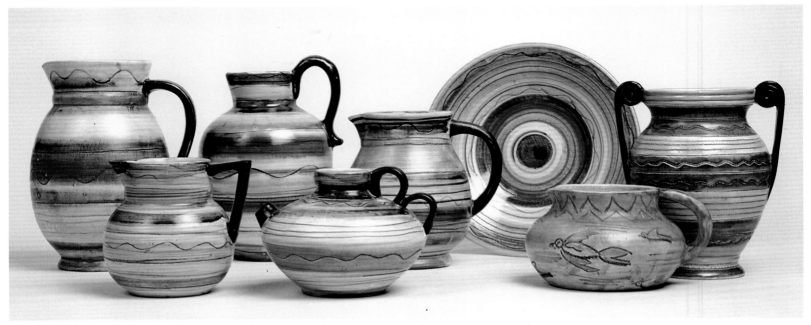

Plate XXIV Period Pottery: Moresque with Aztec bird jug (diameter of plaque 23 cm., 9 in.)

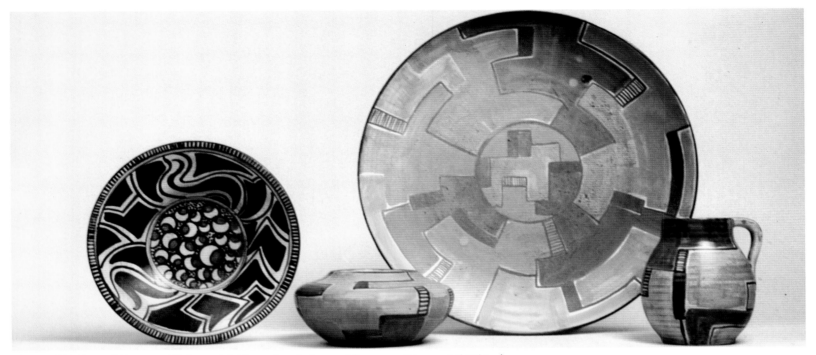

Plate XXV Period Pottery: Toltec with Samarkand plaque (diameter 40 cm., 15.75 in.)

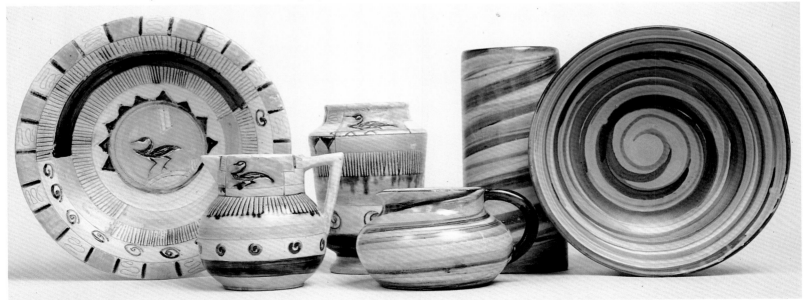

Plate XXVI Period Pottery: Milos and Espanol (diameter of Milos plaque 25.5 cm., 10 in.)

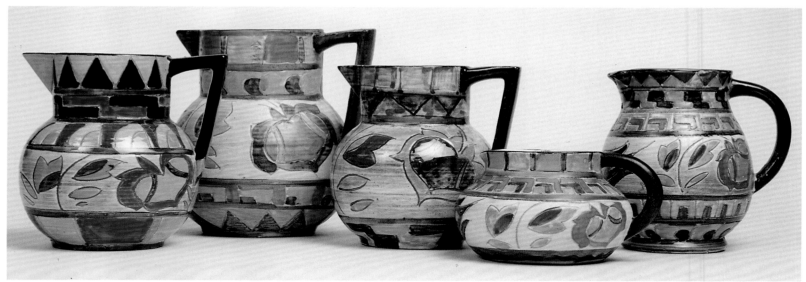

Plate XXVII Period Pottery: Basra (tallest jug 18.5 cm., 7.25 in.)

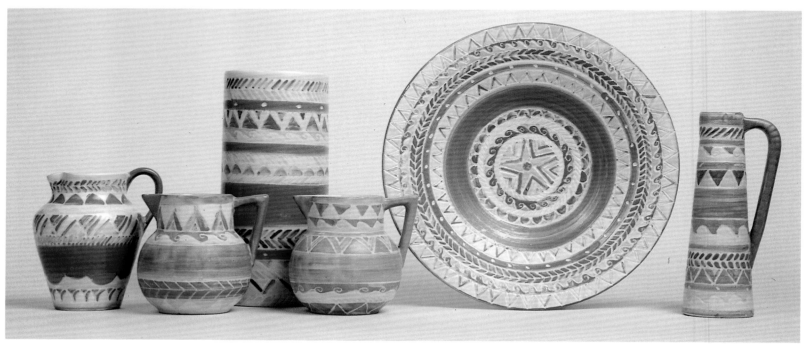

Plate XXVIII Period Pottery: Aswan (diameter of large plaque 30.5 cm., 12 in.)

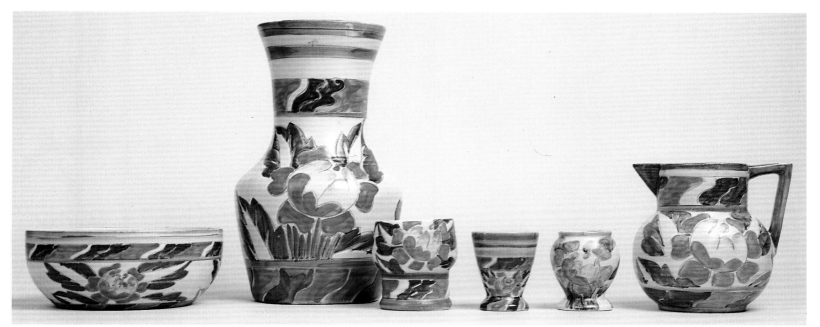

Plate XXIX Period Pottery: Malaga (tallest vase 30.5 cm., 12 in.)

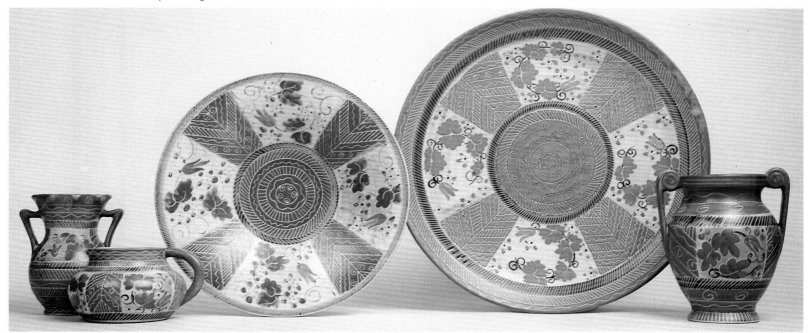

Plate XXX Period Pottery: Mecca (diameter of large plaque 39.5 cm., 15.5 in.)

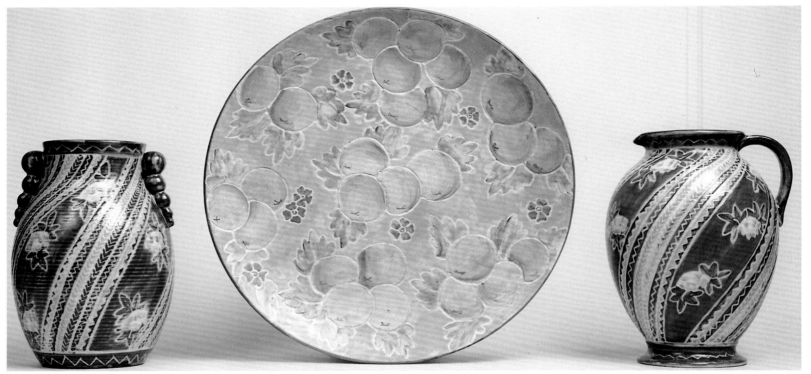

Plate XXXI Period Pottery: Kerman with Sherborne plaque (diameter 40 cm., 15.75 in.)

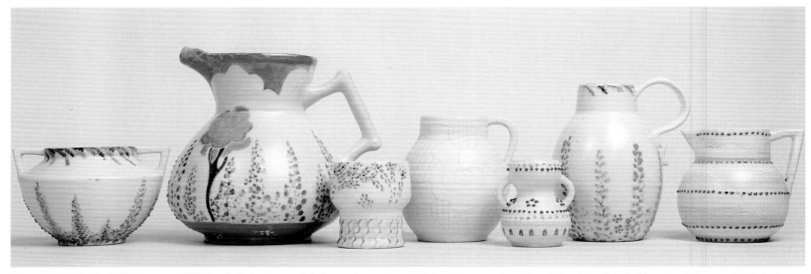

Plate XXXII Period Pottery: Old English designs with large Avon jug, White Freya and, at far right, Maribo (tallest jug 21 cm., 8.25 in.)

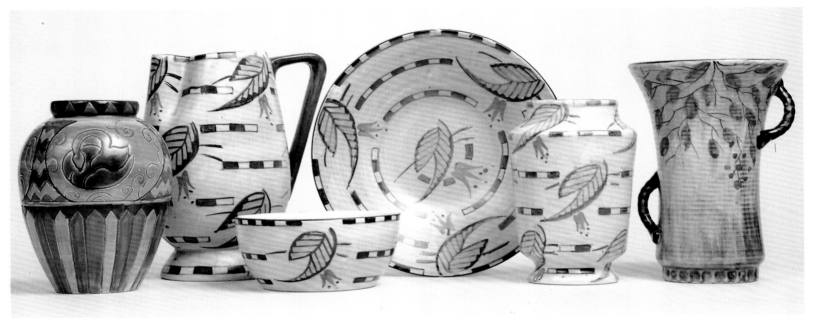

Plate XXXIII Period Pottery: Kashan with Italian No. 2 and Autumn Leaves No. 2 (diameter of plaque 23 cm., 9 in.)

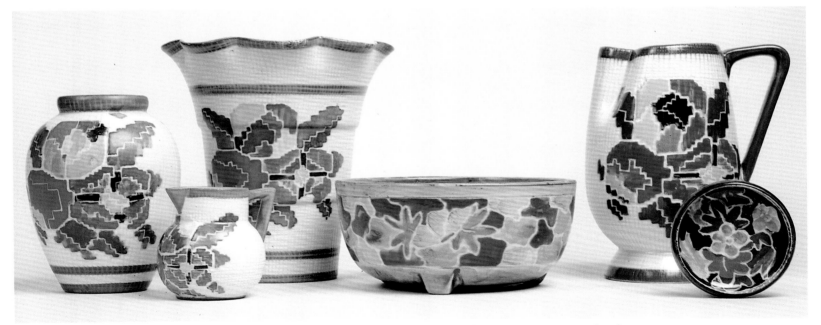

Plate XXXIV Period Pottery: Kandahar with Rayenna bowl and Clovelly tray (tallest vase 22 cm., 8.75 in.)

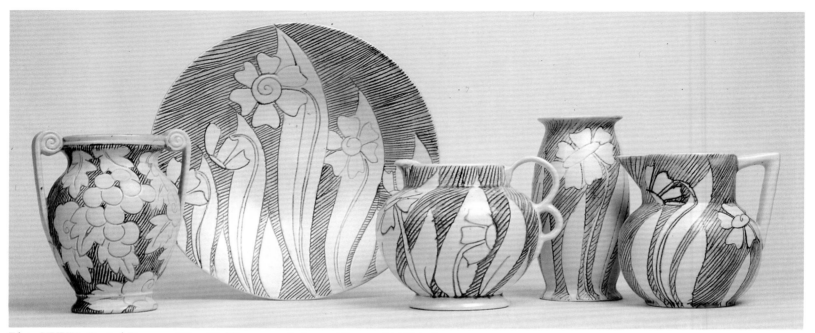

Plate XXXV Period Pottery: Wan Li (diameter of plaque 30 cm., 11.75 in.)

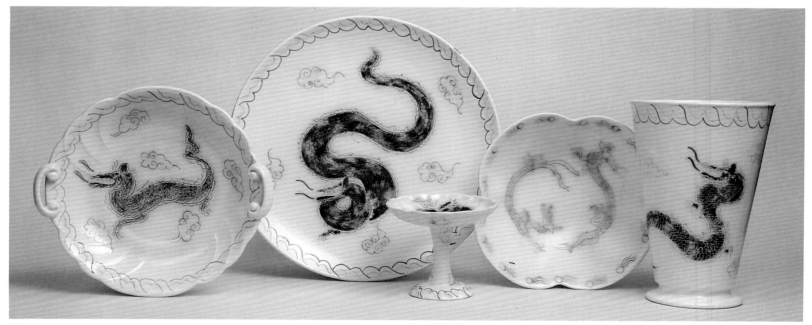

Plate XXXVI Period Pottery: Scratched Dragon (diameter of large plaque 39 cm., 15.25 in.)

Plate XXXVII Period Pottery: Mendoza (tallest jug 27 cm., 10.75 in.)

Plate XXXVIII Period Pottery: Langham Ware jugs, Medina jug, '834' bowl and vase, large '893' vase and Gardiniere plaque
(height of two-handled jug 24 cm., 9.5 in.)

Plate XXXIX Matt glazed vases from the 1940s and 1950s (tallest 30 cm., 11.75 in.)

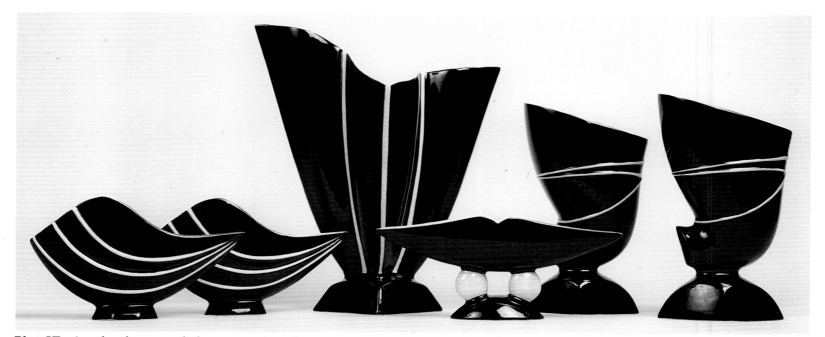

Plate XL Art glazed vases including 1960s 'Handkerchief' vase (tallest 30 cm., 11.75 in.)

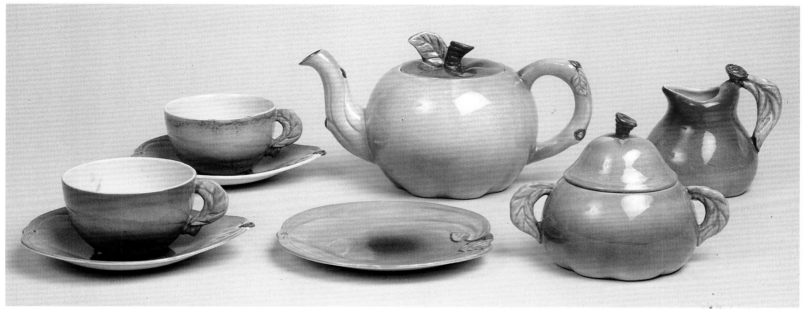

Plate XLI Fruit Ware 'Tea for Two' set (height of teapot 12 cm., 4.75 in.)

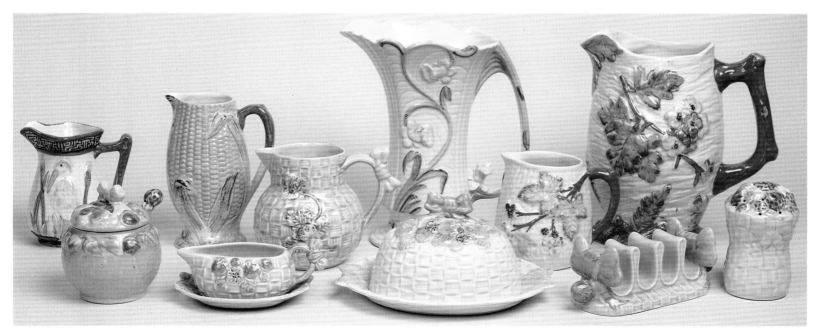

Plate XLII Pompadour tableware with Daffodil, Strauss and three smaller majolica style jugs (tallest jug 23 cm., 9 in.)

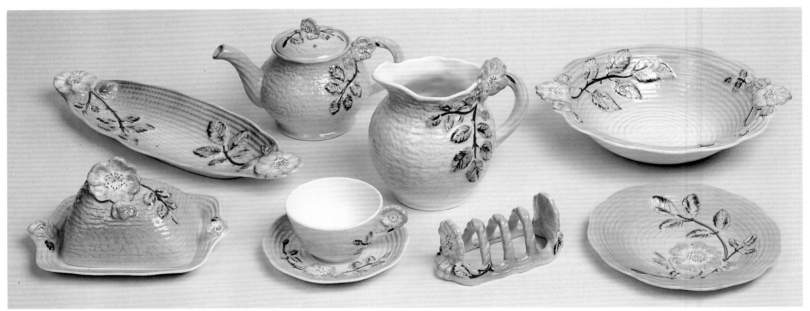

Plate XLIII Wild Rose tableware (height of jug 15 cm., 6 in.)

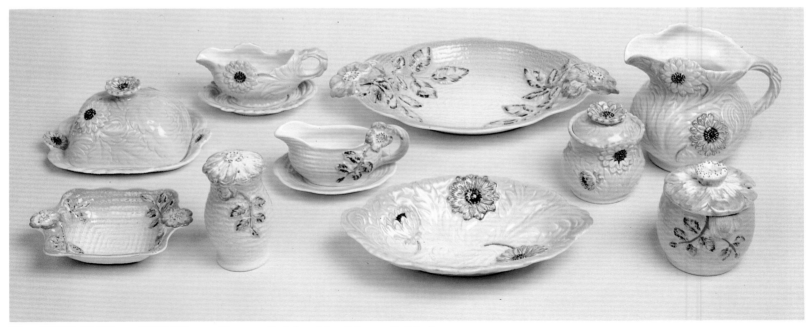

Plate XLIV Dahlia and Wild Rose tableware (height of jug 14 cm., 5.5 in.)

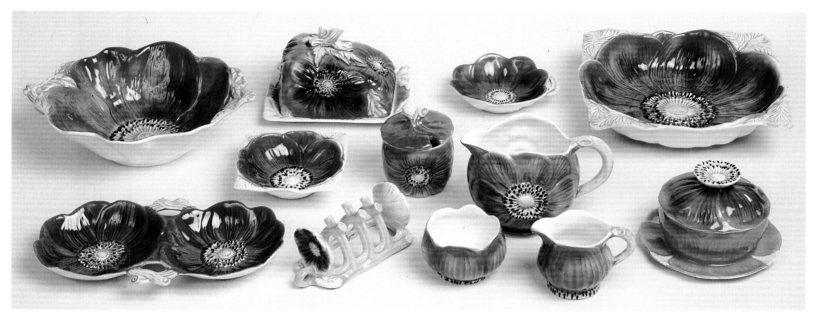

Plate XLV Anemone tableware (height of jug 11 cm., 4.25 in.)

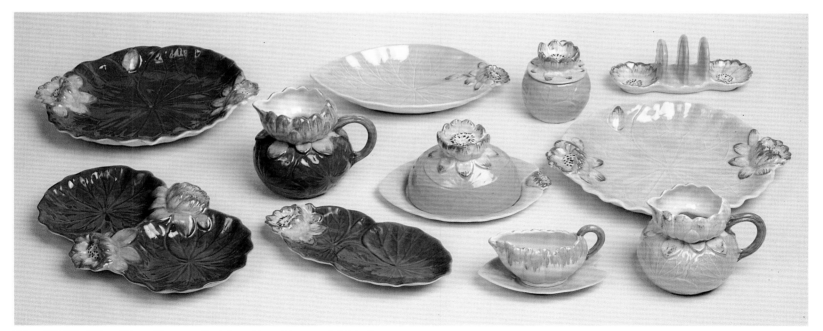

Plate XLVI Waterlily tableware (height of jug 11 cm., 4.25 in.)

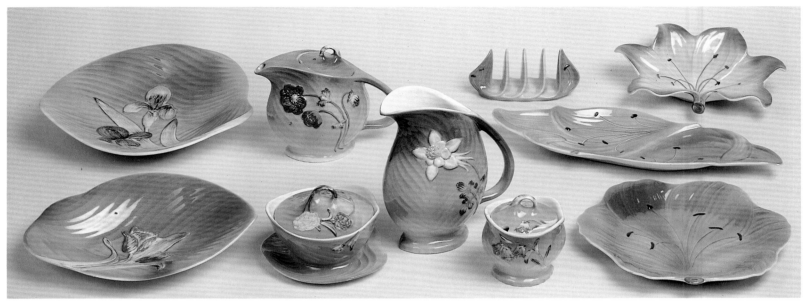

Plate XLVII Harmony and Petal tableware (height of jug 18.5 cm., 7.25 in.)

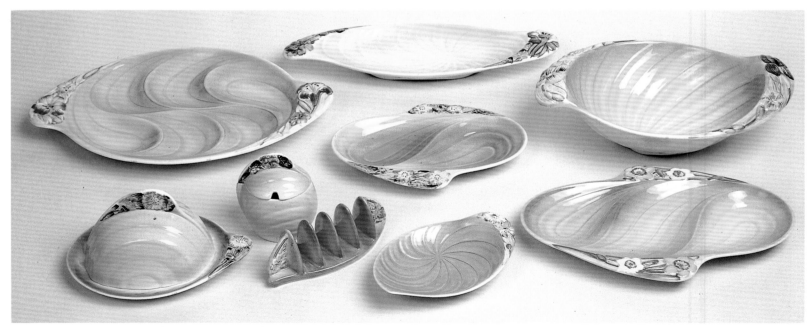

Plate XLVIII Bouquet and Rose Bouquet tableware (height of cheese dish 9 cm., 3.5 in.)

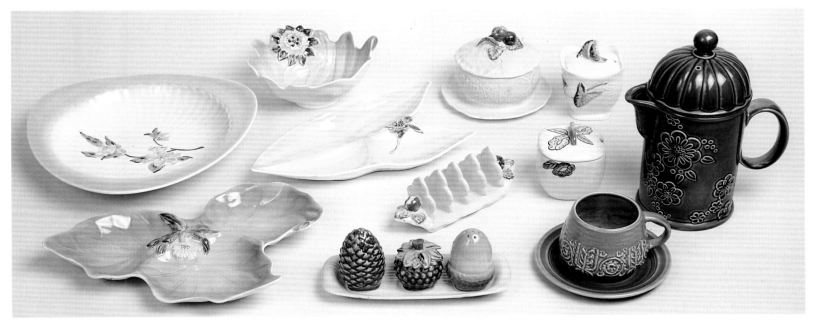

Plate XLIX Galaxy with Symphony plate, Embossed Fruit, Woodland, Linen, Rustic and Pergola tableware
(height of coffee pot 23.5 cm., 9.25 in.)

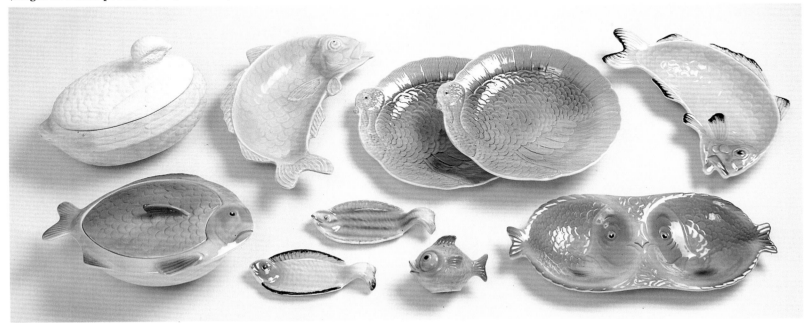

Plate L Poultry and Fish tableware (longest dish 30 cm., 11.75 in.)

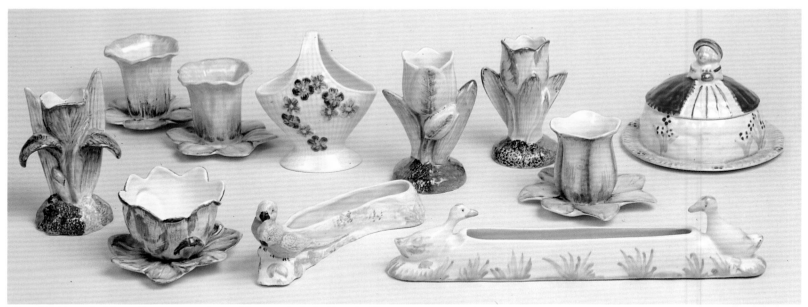

Plate LI Posy holders, flower troughs and butter dish (tallest holder 14.5 cm., 5.75 in.)

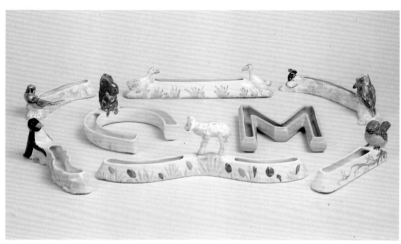

Plate LII Flower troughs (height of squirrel 10.5 cm., 4 in.)

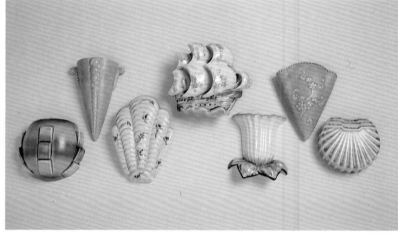

Plate LIII Wall pockets (tallest pocket 22 cm., 8.75 in.)

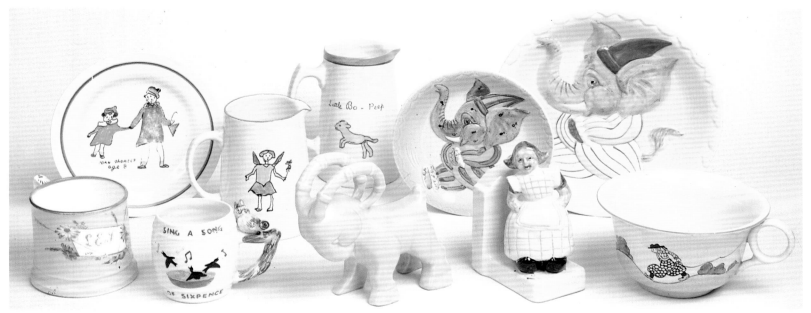

Plate LIV Children's pottery: Christening mug by Arthur Shorter, Joan Shorter ware, Widdicombe Fair and novelty items (tallest 14.5 cm., 5.75 in.)

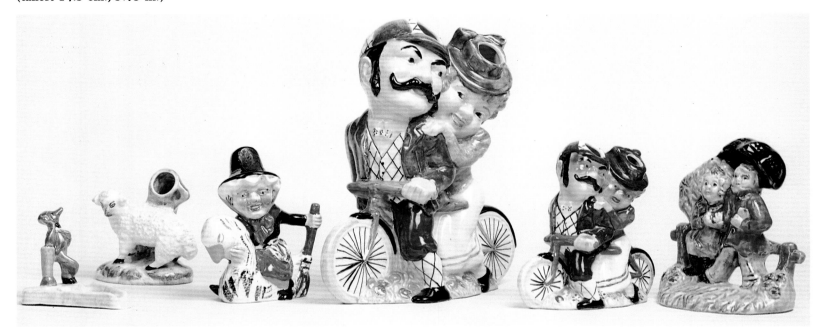

Plate LV Daisy Bell with other 'quaint' figures (tallest 24.5 cm., 9.75 in.)

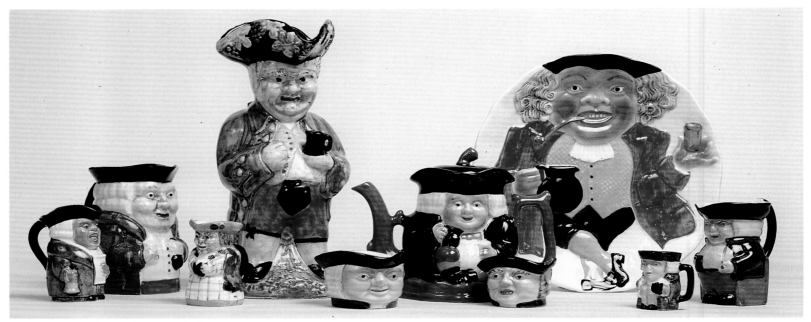

Plate LVI Traditional Tobies (tallest 27.5 cm., 10.75 in.)

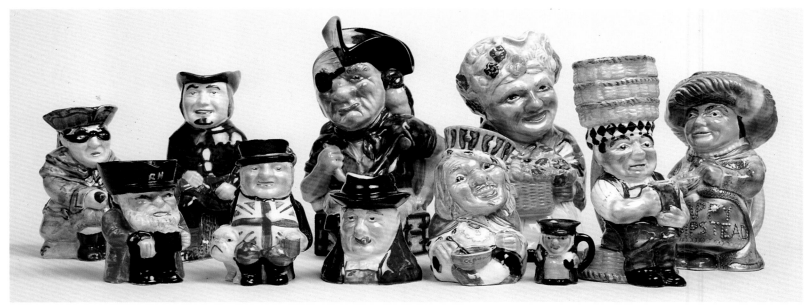

Plate LVII Character jugs (tallest 24 cm., 9.5 in.)

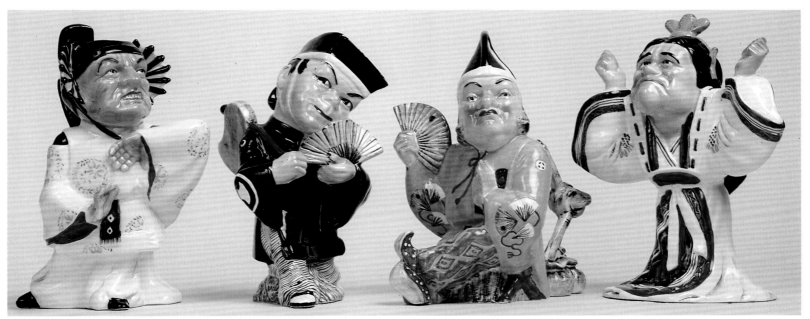

Plate LVIII Gilbert and Sullivan figurines from the 'Mikado' (tallest 25 cm., 9.75 in.)

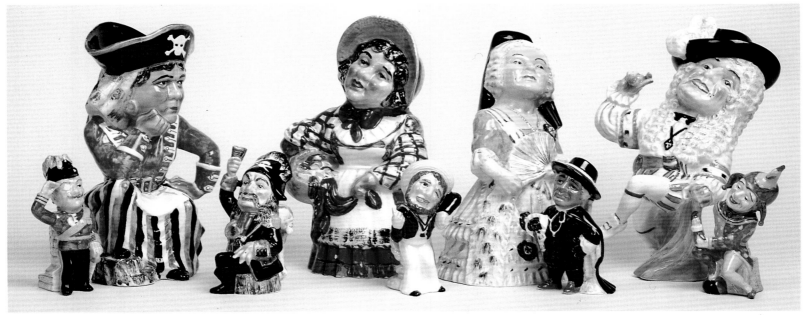

Plate LIX Gilbert and Sullivan figurines from the 'Pirates of Penzance', 'H.M.S. Pinafore', the 'Gondoliers' and the 'Yeoman of the Guard' (tallest 24 cm., 9.5 in.)

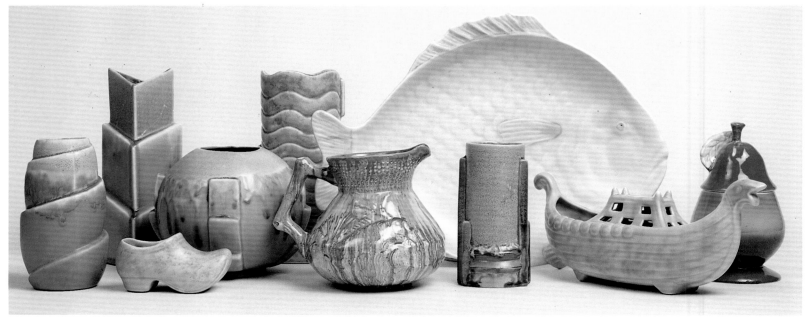

Plate LX The Clarice Cliff-Shorter connection (width of fish dish 28 cm., 11 in.)

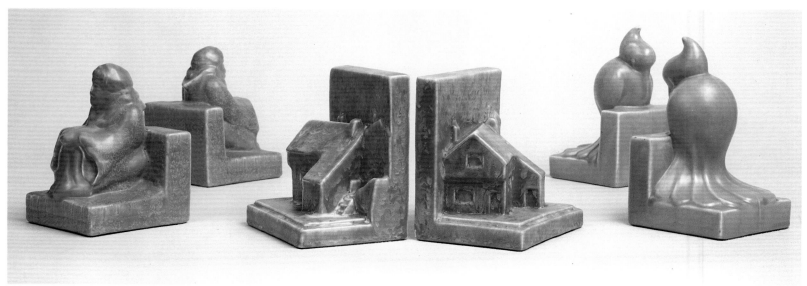

Plate LXI Shorter bookends designed by Clarice Cliff (tallest 16 cm., 6.25 in.)

THE POTTERY

Chapter Ten

EARLY SHORTER POTTERY 1874-1926

Apart from the evidence of a christening mug dated 1876, hand-painted and signed by Arthur Shorter himself, nothing is known of his early work until he went into business in 1878 with James Boulton. (Plate LIV)

SHORTER AND BOULTON

For more than half of its existence the firm specialised in the manufacture of majolica glazed earthenware. Indeed it is from this foundation and tradition that many of the later Shorter designs were developed.

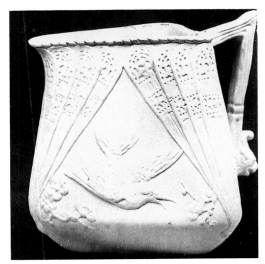

Fig. 41 Bird and Fan jug.

Their pottery was an integral part of the English Victorian majolica scene, with imaginative and often fanciful designs, abounding in colourful, extravagantly moulded flora and fauna. They specialized in the manufacture of jugs with designs ranging from fans and fish, to flowers and fruit. Some jugs are modelled as birds and animals, one has a dragon as its handle and others take the form of a tree trunk with a bark-like surface, a branch for the handle and knurled feet.

Most designs of highly-glazed, relief-modelled majolica are individually named and follow closely the traditions of Victorian Majolica. Occasionally, the name of a design was changed over the years; the Atlantic Jug appearing in later Shorter records as the Oceanic Jug. Almost identical designs were produced by different factories and it is not always possible to ascertain the origin of a piece as many were unmarked. However, some Shorter and Boulton patterns were illustrated and recorded in the official register of majolica designs — the first record is of the Dragon Jug, registered in 1879, with the Fan Jug and the Atlantic Jug appearing two years later.

Whilst multi-coloured Shorter majolica tableware celebrates such English fruits as strawberries, apples, pears and plums, the single colour majolica tableware is either moulded in the shape of a leaf or displays an overall leafy or floral embossment. Although examples of early majolica ware do exist, many of the pieces currently preserved date from the 1920s.

The first reference in the Pottery Gazette to pottery manufactured by Arthur Shorter is in the issue of July 1879 when a wide range of goods was offered under the name of Shorter and Boulton: "Majolica, green glaze etc., teapots, jugs, dessert, garden pots, garden seats and a varied assortment of ornamental goods, jet ware, teapots, jugs, dental spittoons, terra cotta gas shades etc. earthenware and stone toilet jugs, common and best." This advertisement ran for a year until July 1880 when a majolica jug decorated with a stag and a deer was illustrated. The following year reference was made, in an American journal, to a pair of Shorter and Boulton vases embossed with ducks.

SHORTER AND SON

Thirty years later the firm, now known as Shorter and Son, was still being described as a manufacturer of majolica art pottery and other fancy lines. It supplied popular ware and, in 1909, displayed a series of individually named flower pots and jardinieres. The iris and tulip vases retained their popularity for many years and were decorated in the 1930s with some of Mabel Leigh's art pottery designs.

In 1917 the Pottery Gazette reported that Shorter Toby jugs were on offer in addition to the traditional majolica ware, bulb bowls and flower pots. The original Shorter Toby Jug is a large, typical, "ordinary" seated Staffordshire Toby. (Fig. 93) A female "Toby" and a Coachman are also believed to belong to this early period. The firm's range was later extended when toy teasets and decorative fancies became part of their stock in trade.

Throughout the 1920s it continued to specialise in majolica glazed ware. In 1923 the Pottery Gazette of the day noted that the firm was exhibiting a "variety of art pottery in majolica glazes" and that, "For many years the house has specialised in these goods exclusively". Some leafy, floral, embossed tableware designs were decorated with an apple green glaze. (Plate IV)

Because of their universal appeal, many of the traditional majolica shapes continued to be reproduced at intervals throughout the firm's existence in a wide variety of glazes and colourways.

The background colour for many early Shorter majolica jugs is either a rich cobalt blue or cream. The overall impact of each piece is enhanced by the deep dusky-pink glaze with which the interior is decorated. In an expansionist phase in the late 1920s some of the traditional

Fig. 42 Pottery shapes c. 1910.

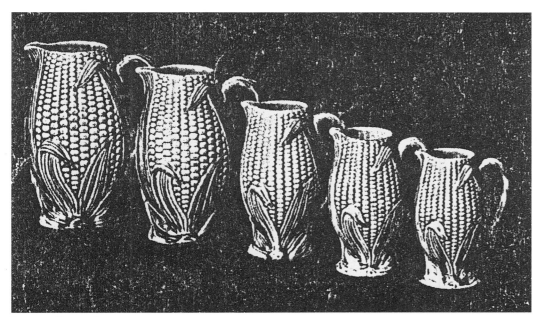

Fig. 43 Corncob jugs.

jugs were transformed when decorated in a variety of matt art glazes, whilst a series of small majolica style jugs reproduced in the 1950s is virtually identical to the early majolica ware.

Some of the majolica tableware designs had such an enduring appeal that they remained in production for most of the firm's existence — Cherry Ripe and Strawberry and Bow, later to be re-named as Pompadour, being especially popular. Designs were modified, new shapes added to the range, and new colour-ways introduced. Time and again Shorters would refer back to their majolica roots for inspiration.

Fig. 44 Violet jug.

MAJOLICA JUGS AND PITCHERS

THE DRAGON JUG *(Plate II)*
Reg. No. 336496 Parcel No. 11, June 27th, 1879

The Dragon Jug is distinctively shaped with a narrow neck and full rounded body with the handle formed by a dragon. A large sunflower with leaves is set against a lightly stippled ground.

STAG AND DEER JUG
A jug decorated with a Stag and a Deer is illustrated in an advertisement dated 1879.

THE FAN, OR BIRD AND FAN JUG *(Fig. 41)*
Reg. No. 362992 Parcel No. 9, March 17th 1881

The Fan Jug is a slightly angular jug bearing a flying bird in the triangular space made by the sides of an upright fan. Small sprays of blossom decorate the lower part of the jug.

THE ATLANTIC OR OCEANIC JUG *(Plate II)*
Reg. No. 373707 Parcel No. 13, November 23rd 1881

The full-bodied Atlantic Jug has a stippled-effect collar and is embossed with a large fish, shells, sea-weed and waves.

THE VIOLET JUG
Reg. No. 378959 Parcel No. 10, March 27, 1882

The Violet Jug is decorated with a bunch of violets, several small butterflies and a horizontal, scalloped ribbon. The background has an overall chequered effect.

STORK AND RUSHES JUG (Plate II)

The main feature of this jug is a stork, with a smaller stork standing nearby, surrounded by bullrushes, broad-leaved plants and grasses.

WILD DUCK JUG

Wild Ducks fly, in high relief, against a blue ground.

CORNCOB JUG (Plate XLII, Fig. 43)

This naturally coloured jug is incisively modelled in the shape of a corncob complete with supporting leaves. The Shorter Corncob Jug, in five sizes, was advertised and illustrated in the Pottery Gazette of 1934 as "one of many models made by us through more than half a century".

SHARKSKIN AND FLORAL BOW OR JONQUIL JUG

This textured jug is rectangular in cross-section with rounded and beaded edges. It is embossed with a vertical flower of three stylised blossoms and spiky leaves tied by a ribbon.

THE BLOSSOM JUG (Plate V)

The Blossom Jug is circular in section, with vertical sides above a rounded base. A large spray of blossom and leaves is placed diagonally on the upper part of the jug against a basketwork ground.

BLACKBERRY JUG (Plate II)

This is a barrel-shaped jug in which the surface is textured to represent the bark of a tree. It is decorated with a naturally coloured spray of blackberries, blossom and leaves.

RUSTIC OR TREE TRUNK PITCHERS (Plate II)

These jugs vary in shape, some are straight-sided, some barrel-shaped and others rounded with knurled feet. Their rough, bark-like surface, often naturally coloured, is decorated with a spray of leaves, blossom and sometimes berries. They give an appearance of age and solidity, some being proportionately larger and heavier than other Shorter majolica ware.

FIGURAL MAJOLICA JUGS (Plate IX)

Some jugs in the shape of birds and animals are rare additions to the majolica range. Known examples are a cockatoo, an owl, a pelican and doubtless other examples of both birds and animals exist.

MAJOLICA TABLEWARE

STRAWBERRY AND BOW (Plate III)

The original Strawberry and Bow design is characterised by decorative green ribbons and bows, a highly profiled arrangement of trailing strawberries, tiny flowers and leaves set against a blue or honey-coloured, basket-weave background. The lids of the teapot and sugar basin bear a strawberry-shaped finial. Later versions of this design were renamed Pompadour and the strawberry finial was replaced by a bow.

BIRD AND FAN

This design was registered in the name of Shorter and Boulton on March 17th, 1881. A pair of Bird and Fan sauce dishes bearing the English registry mark are illustrated in "Majolica Pottery" by Mariann K. Marks. They depict a half-open fan decorated with a flying bird, together with a spray of blossom and ribbons set against a cream pebbled background. The decorative features are coloured yellow, turquoise, pink and a grey-brown as are those on a matching cobalt blue, covered sugar bowl.

CHERRY RIPE (Plate III)

It is reported in the Pottery Gazette of 1934 that Cherry Ripe was reproduced from actual moulds executed over seventy years previously by Toft, a modeller who was famous in the days when the production of majolica was a thriving industry in the Potteries. Cherry Ripe would appear to have the same origin as Strawberry Fair and Embossed Fruit. With its warm colours and gently curving lines it has a timeless, rustic quality. Against a honey-coloured, basket-weave ground, cherries, plums and similar fruit are relief moulded and hand-painted. A bright green version was later produced in a limited quantity.

STRAWBERRY FAIR (Plate IV)

The surface is covered with bright green, moulded leaves and embossed with hand-painted strawberries and leaves. This design does not appear to have been produced in the same quantity as Cherry Ripe.

EMBOSSED FRUIT

With its strongly veined cabbage leaf effect, Embossed Fruit is decorated in the same bright green as Strawberry Fair. The embossed fruits, one pink, one yellow and one mauve are painted from the same palette as that used for the fruit on Cherry Ripe.

LETTUCE LEAF

In this single-coloured majolica tableware series each bright green, intricately veined piece is modelled in the shape of a lettuce leaf.

Chapter Eleven

METAMORPHOSIS 1927-1932

By 1927 the firm enjoyed a reputation for the manufacture of coloured glazed ware and of competitively priced majolica. However, change was imminent. Responding to a changing market and to the current economic climate, it began to diversify. The new ideas originating from Clarice Cliff at the Newport pottery coincided with the introduction by Shorters of their popular Fishware series, the design of which was attributed to her in press reports of the day. (Fig. 103)

Shorters' traditional majolica jugs were decorated with the latest art glazes as was a series of highly stylised art deco shapes which included the ubiquitous bulb bowls. They were producing the traditional and the ultra-modern and using new glaze techniques on both old and new shapes. One particularly successful glaze effect was named "Aura", in which a brilliant orange uranium running glaze was applied to turquoise matt glazed ware. The name "Aura" appears in the backstamp of this range. (Plate VII)

In 1928, it was reported in the Pottery Gazette that Shorter and Son ".... are chiefly manufacturers of coloured majolica", but in the same article it stated that ".... we have recently had the pleasure of seeing a still newer line of goods produced at the works of Shorter and Son, viz, a range of matt glazed ware in various attractive colourings In this new series of samples there are some wonderfully good effects, many of them quite original in type. There is, we believe, a growing tendency on the part of the public for the matt textured glazes in ornamental wares. Shorter and Son are endeavouring to cater for this demand in no uncertain measure and we should imagine they are destined to be specially successful with some of their newest lines."

It was during this period that the three associated firms, Shorter and Son, A.J. Wilkinson and the Newport Pottery, were working closely together on new designs. In 1929 Colley Shorter and Clarice Cliff were known to be experimenting with decorative glazes and she was creating new shapes and designs. In both 1930 and 1931, Shorter and Sons put on a joint display with A.J. Wilkinson Ltd. at the British Industries Fair. Shorters displayed some of her designs which are believed to have included a series of matt glazed vases in a highly original interpretation of the contemporary art deco style. (Plate VIII)

Decorative tableware based on Shorters' early majolica designs was marketed simultaneously with the latest geometric art deco shapes. Some new decorative tableware designs, with a strong novelty element, reflect the majolica influence.

Matching toilet sets, an intrinsic part of the early twentieth century life style, were manufactured in abundance. Novelty items, including book-ends designed by Clarice Cliff in 1930, became increasingly popular whilst the production of traditional Toby jugs was maintained and new figures introduced.

Fig. 45 Metamorphosis — Majolica to Art Deco.

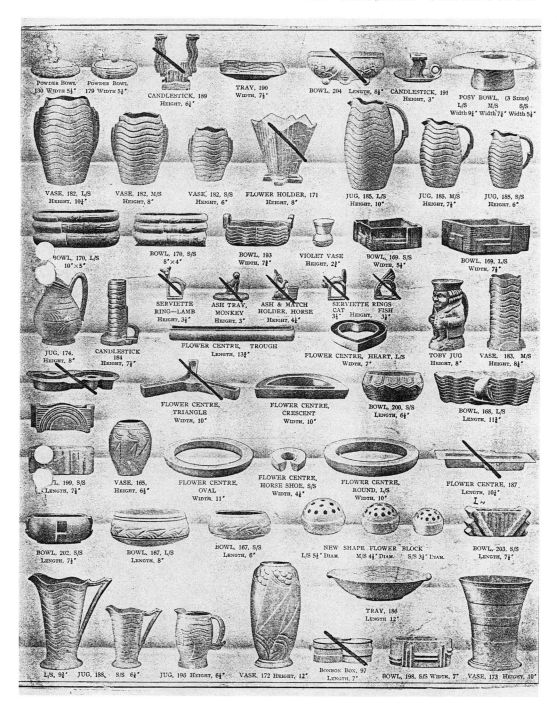

Fig. 46 Pottery shapes c.1930.

MATT GLAZED MAJOLICA WARE

A range of jugs, in three sizes, based on old stoneware jugs from the Bodley period in the mid-19th century, was marketed in 1927 and the Pottery Gazette focused attention on the Painted Dragon, the Painted Blossom and the Painted Bramble. Shortly afterwards these were presented in colourful matt glazes with a contrasting interior. A distinctive mauve proved to be an excellent foil for the pink, yellow, white and green floral decorations, whilst a successful alternative was a cool combination of a deep turquoise green with yellow and white. (Plate V)

Colourful matt glazed versions of the Oceanic and Stork jugs were produced in contrasting pink, turquoise, yellow and white whilst the same jugs were more commonly decorated in a matt turquoise green enhanced by a running crystalline art glaze in the same colour.

The down-to-earth Rustic and Tree Trunk jugs were now marketed as "Hall Boys" with distinctive matt glazes in shades of purple, mauve, clover and, occasionally, in turquoise green. (Plate V)

Striking variations in glaze and colour, including "Aura", were used on Shorter majolica shapes. (Plate VII)

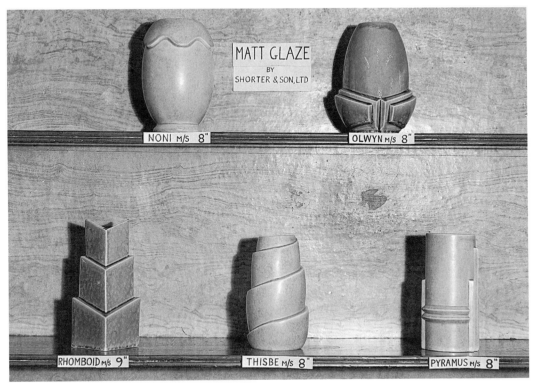

Fig. 47 Matt glazed art deco style vases.

ART DECO STYLE MATT GLAZED WARE

ORIGINAL ART DECO
MATT GLAZED WARE (Plate VIII)

This series consists of five vases, each in three different sizes. Individually named, Pyramus, Thisbe, Rhomboid, Noni and Olwen, they are quite different from any of the ware previously produced by Shorter and Son. They reflect the influence of Robert Lallemont, a French designer, as do several of Clarice Cliff's designs for A.J. Wilkinson. The architecturally styled Pyramus and Romboid effectively echo contemporary buildings of the 1920s. Two spherical vases complement this series. One, named Astrid, is decorated with tiered flanges and one, shape no. 148, with a pair of chevrons.

The vases are decorated with a variety of superior art glazes, usually with a running effect. The most widely used glaze was a matt turquoise green enhanced by a running crystalline art glaze in the same colour. Other attractive colour combinations include the vivid orange and turquoise of "Aura", matt beige, turquoise and blue, and combinations of pink, mauve, turquoise and turquoise-green. A Cerulean blue matt glaze is effective in its simplicity.

"WAVE" ART DECO
MATT GLAZED WARE (Plate IX)

Another series was in production at a slightly later date, again with typically Art Deco shapes, but with the surface distinguished by horizontal wavy lines. Decorated in original art glazes, some have the same turquoise-green glaze as that found on the five original matt glazed vases, whilst others are glazed in orange, grey, blue, green and brown or in combinations of these shades. Sometimes an overall mottled effect was created.

"BEADED" ART DECO
MATT GLAZED WARE (Plate X)

Bold curving jugs, vases and bowls have a gently ribbed surface in which either the handles, feet or the decoration consists of a row of five or six graduated beads. In the mid-1930s the distinctive shapes are reinforced by a particularly striking colour-way of green and yellow.

BULB BOWLS (Plate IV)

Bulb bowls and flower troughs were a best selling line during this period and many stylish art deco designs were complementary in both shape and glaze to the Art Deco Matt Glazed vases.

Fig. 48 Photograph in Wilkinson Archives showing "Beaded" Art Deco style matt glazed vases.

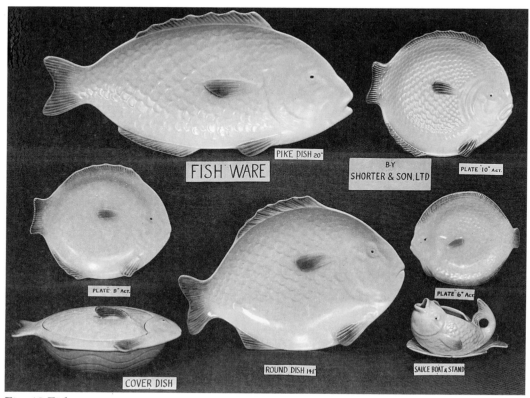

Fig. 49 Fish ware.

These early sets, which comprise a large serving plate and six medium sized plates, are matt glazed in deep cream or ivory, sometimes with the tail and fins emphasised in pale green or turquoise. The range was gradually extended.

"TEA FOR TWO" AND MORNING SETS (Plate IV, Fig. 45)

The majolica influence is apparent in traditionally based "Tea for Two" sets in which the lightly textured surface is glazed in apple green or dusky pink. The naturally coloured handles are modelled as a leafy twig and the knob of the teapot as a berry with leaves.

Stylistically contrasting sets in angular, geometric shapes are decorated with the same green and pink glazes.

TOILET WARE

The sets which include a large, rounded water jug and bowl, a covered soap dish, a beaker and possibly a chamber pot are usually glazed in apple green or dusky pink and occasionally in a deep powder blue.

DECORATIVE FANCIES

In 1929, Shorters issued the smaller version of Clarice Cliff's Viking boat, (Plate VII, Fig. 99) complete with separate flower holder and decorated in new art glazes. Her book-ends are matt glazed in a rich, powder blue. (Plates LX and LXI)

Other book-ends and bulb bowls decorated with realistically modelled animals were aimed at the juvenile market, as were some free-standing animals.

DECORATIVE TABLEWARE

ROCK GARDEN (Plate XI, Fig. 77)

Rock Garden is a range of naturally coloured tableware in which the pieces are moulded in the shape of a water-lily pond or as stone garden walls decorated with climbing flowers and foliage.

LUPIN (Plate XI)

In this lightly embossed design multi-coloured lupins, with daisy-shaped leaves, stand erect against a lattice fence.

CARAVAN WARE (Plate XI)

The fashionable gypsy theme is echoed in a tableware series modelled as Romany caravans. Hand-painted in green and yellow, wheels, windows and doors are detailed in black, brown and white.

FISH TABLEWARE (Plate VI)

It was in the late 1920s, when the Wilkinson, Newport, and Shorter group of potteries were at their most innovative, that Shorters introduced one of their most consistently best-selling lines, Fish Ware.

Chapter Twelve

THE HALCYON YEARS 1933-1939

It was in the mid-1930s that the creative momentum generated from this small factory was reaching a peak. Credit for the maintenance of this upsurge must be attributed to Harry Steele. The pot bank was teeming with original ideas and new designs. Mabel Leigh's Period Pottery dominated the Shorter scene with its originality and highly individual character. The creativity was halted by the start of World War Two and held in abeyance for almost ten years. Consequently some designs from this period such as Fruit Ware, Anemone and Daffodil were not put into production on any scale until after the war. It is believed that the conception of the Gilbert and Sullivan figures took place as early as 1939.

In 1933, when the firm exhibited in London, again in conjunction with A.J. Wilkinson and the Newport Pottery, the emphasis was on art glazes applied to art deco style shapes. Throughout the remainder of the decade the firm continued to experiment in and develop new matt glazes which they applied to a wide variety of both traditional and modern shapes.

A series of five matt glazes in pastel shades was introduced in 1936, with pink and grey proving to be especially

Fig. 50 Joint *Pottery Gazette* advertisement designed by Clarice Cliff

popular. It is recorded in the Pottery Gazette of February 1936 that: "Shorter and Sons Ltd. can lay claim to a unique knowledge and experience of the handling of coloured glazes since their factory has been engaged for over sixty years upon this special class of work. In short, they rank as specialists in connection with coloured glazes."

STAG WARE and SYRINGA are decorated in soft matt glazes in pastel shades. In Stag Ware contemporary influences were brought to bear on a traditional English design, whilst the simple floral embossment of Syringa reflects the Japanese influence seen on much Victorian majolica.

The hand-painted WILD DUCK series, believed to orginate from designs of 1880/81, is finished in either a rich matt or a soft, shiny, almost luminous glaze.

In 1937, an entirely new finish, Chenille, was shown for the first time in which the background of the glaze is of a crackled appearance, quite unlike Shorters' usual matt or shiny glazes.

Cottages, symbolising the ideal home and family, were a significant design element in the 1930s, when Mabel Leigh created two highly individual series of hand-painted, embossed cottage ware named SHANTEE and PAGODA.

Traditional majolica-based tableware maintained a following and in 1934, when Queen Mary purchased several pieces of Cherry Ripe, Embossed Fruit and Pompadour were also being marketed. By the following year, this traditional ware was being sold concurrently with two new series of decorative tableware, MODERN SALAD and YACHT WARE. In Modern Salad, a traditional Lettuce Leaf design is combined with an angular art deco shape, whilst the stylish Yacht Ware series epitomises the Thirties in subject, style, design and colour.

New shapes were added to the Fish Sets and SHELL TABLEWARE was introduced to complement and extend the contemporary marine theme.

Lupin and Pompadour continued to be re-issued and, on the eve of World War Two, a "new" Rock Garden Series was confidently launched.

The theme of birds, animals and flowers is echoed in wall pockets, flower troughs and posy holders. Daisy Bell and Mother Goose are transported by "bike and broomstick" as part of a long line of traditionally modelled English figures. Novelty and invention were the order of the day.

Character jugs, now an established part of the Shorter repertoire, were produced in abundance throughout the 1930s, culminating in 1939 with the production of a series of typically British characters, which reflected the nation's growing patriotism.

In the Thirties, there was a need for frivolity, for escapism, for change. Shorters satisfied that need.

Fig. 51
Stag ware.

THIRTIES MATT GLAZED WARE

STAG WARE (Plate X)

Stag Ware is a series of matt glazed vases in soft pastel shades which illustrates a typical 1930s leaping deer set against a background of stylised trees and leaves. A lightly stippled ground supports the precise, flat-relief design which, in later versions, is outlined in appropriate colours against a matt cream ground.

SYRINGA (Plate LIII)

A simple, relief-moulded spray of Syringa blossom is displayed on a series of co-ordinated shapes with distinctive crimped edges. It is matt glazed, usually in turquoise or a honey colour.

WILD DUCK (Plate XVI)

This beautifully modelled, naturally coloured, hand-painted ware designed in 1939 depicts scenes of ducks in full flight, against a background of clouds and above a field of bullrushes and grasses. It is reminiscent of work by Peter Scott, the painter and naturalist. A complete range of new shapes was created consisting of large flower jugs, vases, bowls, wall pockets and a twelve inch wall plaque.

Occasionally examples of Syringa and Wild Duck wall plaques, decorated with a single matt glaze are to be found bearing a backstamp which excludes the word "Ltd."

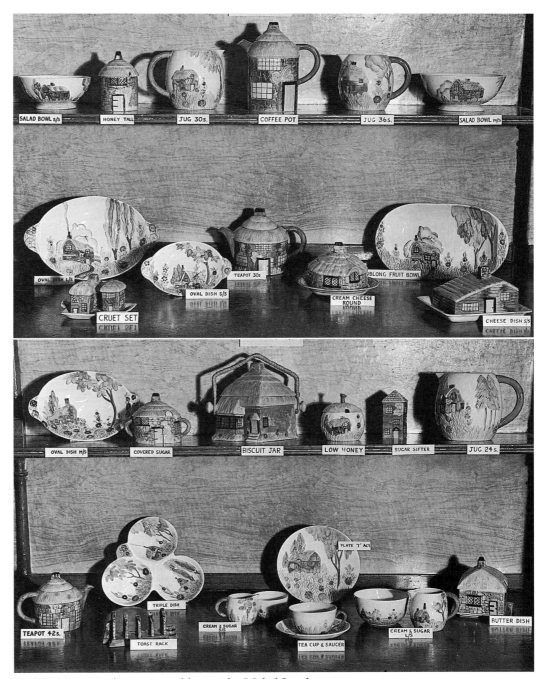

Fig. 52 *Shantee*, decorative tableware by Mabel Leigh.

DECORATIVE TABLEWARE BY MABEL LEIGH

SHANTEE (Plate XIII)

Shantee, introduced in 1933, is embossed and hand-painted in subtle, pastel shades on a glossy, honey-coloured background. The design on plates, bowls and jugs depicts a three-dimensional cottage with trees and hollyhocks. There are many variations within this theme. The containers are each modelled as a stone-built cottage with a thatched roof. The one exception is the cheese dish in the shape of a log cabin.

PAGODA (Plate XIV)

Pagoda, remarkable in both style and colouring, was only made in a limited quantity during the 1930s. Coloured from the same palette as Shantee, it is an oriental variation of the cottage theme. A teapot, biscuit barrel and cheese dish each modelled as a Pagoda, display a magnificent mauve and blue tiled roof above honey coloured walls, finely detailed doors and windows decorated with climbing roses. Plates, dishes and some containers bear finely executed scenes of pagodas, bridges and trees in which mauve and green predominate.

SARATOV

Mabel Leigh developed a range of pottery called SARATOV in which each shape is based on a curved triangle. This ware is decorated with a moulded floral and leaf pattern based on FREYA, an early Period Pottery design. It is matt glazed in turquoise, green, cornflower blue or a deep honey colour. In the turquoise version, the flowers may be coloured mauve, pink and yellow.

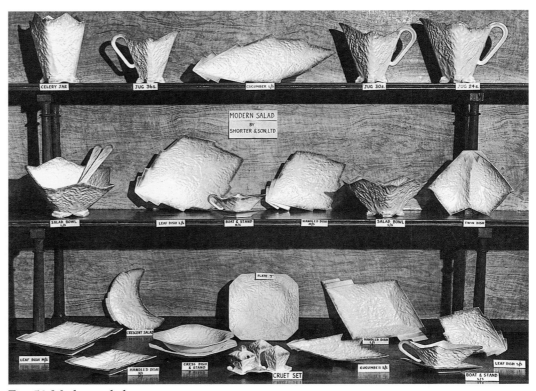

Fig. 53 Modern salad.

DECORATIVE TABLEWARE

MODERN SALAD (Plate XII)

This design represents a transition between the early traditional ware and the modern art deco style in which contemporary ideas were applied to early Lettuce Leaf shapes. A set of angular salad ware is supported on small feet and decorated with angular chevrons. The naturally leaf-veined surface is usually light green with yellow and brown chevrons. Occasionally sets were made in yellow or in pink.

NARCISSUS (Plate XII)

Narcissus is a colourful overall design of daisy-like flowers in pastel shades, relief moulded against a stippled green ground.

YACHT WARE (Plate XVII)

In 1937, a series of hand-painted art deco style tableware was produced in a soft turquoise matt glaze. The design of yachts, sunrays, waves, the colouring and individual shape of the dishes, is typical of the period. However, the jug, in which the handle is modelled as a yacht in full sail, was adapted from an earlier piece which may well have been the inspiration for this new series. (Plate XV)

FISH WARE (Plate VI, Fig. 49)

Fish Ware, introduced in the late 1920s, remained popular throughout the 1930s. A reference in the Pottery Gazette in 1935 records that a Fish Set in "....matt grey glaze, ornamented in brown", was purchased by the Queen Mother, then the Duchess of York. The following year the range was extended to include a sauce boat with stand, a cover dish and an extra-large platter known as a "Pike".

SHELL WARE (Plate XV)

In 1938, a matt glazed Shell Fish set was on display in which the shell-shaped plates, tureen, and sauce boat were modelled in fluted and sinuous lines. Eventually, a salad tray, salad bowl, flan dish and server, sweet dishes, butter dish and cruet were added to the range.

A series of flower holders in the shape of five different sea shells, in three sizes, complemented the set. Some of these have been found with an early backstamp which excludes the word "Ltd", and it is almost certain that they had been in production before 1933.

Shell Ware is decorated in a wide variety of matt glazes with some colour ways matching the Fish sets. Natural colours were most common and in 1939, an unusual mother-of-pearl effect was achieved.

ROCK GARDEN (Plate XI)

A re-launch of Rock Garden took place in September 1939 demonstrating yet again, how Shorters would reproduce a popular range with slight modifications and the addition of new items. A photograph in the Pottery Gazette includes a double dish in the form of a rock garden, with a centrally placed dove-cote, a sugar shaker in the shape of a dove-cote, complete with doves, a toast rack formed by an avenue of hedges, and a honey-pot shaped as a summer house with a cockerel perched on the roof.

UTILITY TABLEWARE

Mabel Leigh designed sets of practical tableware for Shorters, known as Utility Ware. The Pottery and Glass Record of 1935 refers to: "A whole range of matt glaze utility ware, tea, coffee, and morning sets, produced in a variety of ten to twelve colours An interesting feature is that the cups and saucers are semi-matt. There was a range of seven colours in the ribbed body designs, including a brown, blue, celadon, and attractive light toned yellow; though possibly the beige colour was the most effective". A beige and yellow-ribbed coffee set in a functional art deco shape is marked "LIASK".

DECORATIVE FANCIES

WALL DECORATIONS

In 1937 Shorters responded to popular taste by modelling a series of novelty wall pockets — a fish, a lion cub and a lion and unicorn. In company with some of their rival firms they introduced a series of hand-painted birds characterized by a real feeling of movement in flight. Flying ducks were followed in 1939 by kingfishers, geese, seagulls and swans. The flying ducks were made in sets of three, the seagulls and swans in sets of two. (Plate XVI)

FLOWER TROUGHS
(Plates LI and LII)

The firm continued the wild life theme in 1938 by producing a variety of flower troughs decorated with hand-painted models of animals and birds — rabbits, squirrels, lambs, mice, kookaburas, a very fat tom-tit and an ubiquitous pair of love birds, the latter being almost identical to a larger version designed and signed by Clarice Cliff.

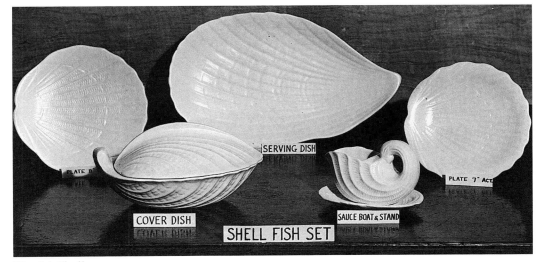

Fig. 54 Shell ware.

In complete contrast, a set of austere flower troughs formed of individual six inch units in the shape of the letters of the alphabet was reported to have been designed by Clarice Cliff. These letters could be used in a window display to spell out the name of a shop, as an advertising feature, or simply as a table decoration (Fig. 50).

A streamlined version of the early Viking Ship, designed by Clarice Cliff, marketed first by Wilkinsons and then by Shorters in the late 1920s and early 1930s, was a stylish addition to the range in 1939.

POSY HOLDERS (Plate LI)

Completely different in style are the realistically modelled and hand-painted posy holders in the shape of flower heads, approximately three inches high — a Tulip, Daffodil, Water Lily, and Canterbury Bell.

NOVELTY ITEMS
(Plates LI, LIV and LV)

Throughout the 1930s the firm responded to the public taste for novelty "kitsch" with items which range from a crinolined lady butter dish to a dashing plus-foured golfer, from a Bonzo look-alike, to a small fox in man's clothing, from an elephant embracing a bulb-bowl, to one actually modelled as a teapot. Many novelties items were created to appeal to children; book-ends displayed a Dutch boy and girl, a Scottie dog, a pony, an elephant and a cat sitting on the hearth. Egg cups were decorated with a lion or a clown. Stylized, free-standing cats, dogs, lambs and donkeys held appeal for all ages.

Two pairs of figures inspired by songs from an early hit parade, but with their roots deep in the tradition of early Staffordshire figures, joined Shorters popular Mother Goose of nursery rhyme fame. As Mother Goose sits astride her broomstick, Daisy Bell and her partner ride a "Bicycle Made for Two" and a pair of lovers coyly shelter from the rain beneath a substantial umbrella. Daisy Bell, illustrated in the Wilkinson archives, is attributed to Betty Silvester.

WAR TIME NOVELTIES

In keeping with their awareness of current trends, Shorters had on sale by October 1939, a set of candlesticks, the Canopy and New Clifton, and three nightlights, the Summerhouse, the Shell and, absolutely topical, the Anderson Shelter. (Plate XV) The latter must have been designed and in production before the war broke out in September 1939. Shorters had indeed anticipated the needs of the British public in the war-time "blackout". In 1940, the firm offered for sale a small, ration-sized butter dish.

CHARACTER JUGS

Amongst the Toby jugs issued during the 1930s was Toby seated on a barrel of nut-brown ale and a pair of Toby jugs with large hats, the woman accompanied by a cat and her partner smoking a clay pipe. The Admiral and the Soldier made a timely debut as World War Two began.

Fig. 55 Bookends. Illustration from mould maker's notebook.

MABEL LEIGH — ART POTTERY 1933-1935

PERIOD POTTERY BY MABEL LEIGH

Mabel Leigh, who joined Shorters in 1933, was a talented, strong-minded young woman, whose ideas and flair initiated the most distinctive pottery that the firm ever produced and for which it was renowned in the pottery world. Shorters' prestigious PERIOD POTTERY was created in her small studio at the Copeland Street factory.

She worked at Shorters for between two and three years producing many highly original and distinctive designs and shapes. Just as Clarice Cliff's name was synonymous with the Newport Pottery at that time, so the name of Mabel Leigh was synonymous with that of Shorter and Son. The work of the two artists, Clarice Cliff and Mabel Leigh, represent two distinctive and opposite parts of a balanced whole; Clarice Cliff's work reflecting the brightly coloured, fast moving contemporary society and Mabel Leigh's transforming the timeless and enduring quality of peasant pottery into a series of highly individual and personal designs. These ranged from MEDINA with its glowing colours and Persian influence to ANGLO-AFRIK in which

rich earth-browns and geometric patterns proclaim their origin.

Mabel Leigh created designs of peasant pottery before she began her career at Shorters. She tells us that a bowl she decorated with geometric shapes and the stylised head of a warrior is the prototype for one of her Period Pottery designs. The skilfully painted head was omitted from the Shorter version as her designs had to be simplified to ensure that the work was within the capabilities of her talented, but comparatively untrained young team, whose very inexperience gave the pieces the authentic and naive quality she required. (Plate XXIII)

Some of the work was done throughout by Mabel Leigh herself, but in most pieces the sgraffito and painting were done by members of her team under her close supervision. The pottery was signed on the base of the mould by Mabel Leigh. She had a distinctive way of signing her work whether in sgraffito or in paint, particularly noticeable being the final "GH" of "LEIGH". The work executed entirely by Mabel herself is clearly identifiable by the flowing and assured lines of the sgraffito and the accuracy and subtlety of the colouring.

Mabel Leigh's talent for design was not limited to the surface decoration of pottery as she created a whole new range of highly original and appropriate shapes to bear the ethnic patterns. It is this fusion of shape, glowing colours, naivety and freedom in decoration which makes each piece unique. Some of the early Shorter and Wilkinson shapes were also used to augment her collection. The basic shape of the Oceanic majolica jug, without its embossments, was decorated successfully with many of her period pottery designs, as was the traditionally shaped Dutch jug with its acutely angled handle. The large, rounded surfaces of the Shorter toilet sets also displayed her designs most effectively.

Some patterns, for example MARAN, SAMARKAND and TOLTEC, are rare today because they were produced in limited numbers. This was either because they were difficult to decorate, expensive to produce, or not of immediate appeal to the public. Most of these pieces were painted by Mabel Leigh. Samarkand and Toltec combine brilliantly the ethnic and art deco influences as does the popular KHIMARA.

The Middle East was the inspiration for Medina and BASRA, in which richly

coloured flowers and leaves glow against a cream or brown background. The variety seems infinite.

The popular sgraffito pattern, AZTEC, was influenced by the pottery of Central America. Although the simple fish design, set against a deep turquoise ground, allows for less obvious individual interpretation, than, for example Medina, the colour and simplicity of the design show the Mabel Leigh shapes to full advantage.

Some designs were hand-painted only, for example, the subtle, spiralling colours of ESPANOL, and the freely painted floral designs of GARDINIERE and ZORAYDA.

Mabel Leigh designed the original primitive ALGERIAN and Anglo Afrik designs, from each of which were created no less than six variations, each strongly geometric, in browns and green.

In complete contrast ASWAN is painted with very soft colours reminiscent of the wall paintings found in Egyptian tombs. This Middle Eastern influence established by Mabel Leigh, set the direction for several designs in the next series of Period Pottery. In fact, Aswan was not offered for sale until after she had left Shorters.

Individually, Mabel Leigh's designs are unique; collectively they stand as a tribute to her imagination and artistic skill.

PERIOD POTTERY, 1933-1935

MEDINA *(plates XIX and XXII) was one of the most popular sgraffito designs the firm produced in Period Pottery. It appeared successfully on the shapes designed by Mabel Leigh herself and on early Shorter shapes. Groups of simply drawn red, pink, mauve and yellow flowers with green leaves glow against a dark brown, grey brown or cream ground. The designs vary considerably, some combining freshness and precision with skilled draftswomanship and colouring, others having a more naive, primitive appearance. Within these variations two main patterns occur. In one, a large stylised, diagonally placed leaf predominates, and in the other, a group of flowers and leaves form the focal point.*

AZTEC *(plate XX). Small sgraffito fish swim in random fashion against a background which varies from a deep, rich turquoise to paler shades of the same colour*

Fig. 56 Maran — drawing by Mabel Leigh in 1988.

and cream. A deep crimson, and touches of light brown emphasise the shape of the fish. In pieces made by Mabel Leigh herself the fish are more accurately perceived and executed. Jugs and vases in Aztec have a distinctive collar in sgraffito.

AZTEC NO. 2 *(plate XXIV). In a rare variation of Aztec, flying birds are set against a rich blue matt glazed background.*

GARDINIERE *(plate XXII). Large daisy-like flowers in blue, purple, pink and yellow are supported by green leaves hand-painted freely against a grey, washed background.*

GREEN FREYA *(plate XX). An overall floral design, deeply etched into the clay, is covered by a green copper glaze which was allowed to settle deeply into the sgraffito lines. Mabel Leigh would have preferred to have had this design named "Moonflower".*

DVINA *(plate XX) bears a similar turquoise green glaze to that on Freya but is decorated with two separately placed, small sgraffito fish with waving tails and fins. The simple design is completed by bubbles and fronds of seaweed.*

ANGLO-AFRIK *(plate XXI) is decorated in two shades of warm brown and apple green under a high glaze. Six different designs appear in the pattern book, all with bold geometric shapes. They include a chequered effect, zigzag patterns and triangles arranged in different combinations. Examples exist in which leaves are included in the design.*

ZORAYDA *(plate XXII). Upper and lower borders of close concentric bands are separated by a group of freely-painted flowers and leaves in red, purple and yellow*

on a matt grey/brown ground. Dark green vertical lines decorate the uppermost part of each piece.

ESPANOL (plate XXVI) is a painted design in which the whole surface is covered by spiralling bands of colour. The colours used are combinations of orange, apple green, blue green, purple and brown.

ALGERIAN (plate XXI) is a striking design in which according to Mabel Leigh ".... the dark brown biscuit is cut through to the cream body". There are six different patterns which consist of bold geometric shapes in concentric circles, spiralling lines, triangles or an over-all star pattern.

MORESQUE (plate XXIV) is similar in appearance to Espanol but the painted bands are wider, horizontal and decorated by a few wavy lines of sgraffito. The colourways are: orange, apple green and black; orange, purple and blue; orange, purple and crimson.

KHIMARA (plate XXIII) is always found in shades of cream, grey, brown and apple green. Wide, shaded, horizontal bands of brown and grey are bordered by a simple triangular or zigzag sgraffito pattern. A broad decorative band of cream is divided into triangles, each of which is individually patterned and coloured in shades of brown and ochre. A band of apple green is placed

immediately below this pattern and the rim of the jug or vase is completed with small apple green triangles.

TOLTEC (plate XXV) combines the ethnic style with a strong art deco influence. Geometric blocks of green, ochre, brown and black completely cover the surface of each piece. This striking design is extremely rare.

BASRA (plate XXVII) bears Persian style flowers scratched and hand-painted in mauve, pink and gold, with sprays of green leaves against a deep cream ground. It is decorated with several bands of intricate and geometric sgraffito at the rim and the base of each piece. Pieces may be matt or highly glazed and any handles are black.

GRENADA is very similar in appearance to Gardiniere but with the inclusion of a pink rose in the group of flowers and a background shaded from green to yellow.

ASWAN (plate XXVIII) is painted in horizontal bands of soft turquoise, blue, green, cream and a warm, pinky brown. These bands of colour are, in turn, decorated by lightly sgraffitoed rows of scrolls, triangles and a herring-bone pattern. In a more highly glazed version the colours appear stronger and the pattern more clearly defined. Any handles are painted in deep, turquoise green.

MAGYAR The only reference to this pattern is in Mabel Leigh's notebook. It may have been used as the basis for MALAGA (MAGADOR) which was produced in 1935 or 1936.

MARAN The dark brown background contrasts with the design, etched in white, and with some pink in-fill, in which Persian "minaret" shapes encircle the vase. It is very rare.

MILOS (plate XXVI) is very strong looking pottery in a deep ochre with semi-circular bands in green, dark ochre or dark brown with scratched decoration. A deeply etched green bird is the focal point of this ware.

SAMARKAND (plate XXV). The effect of curved and angular lines is created by black, irregular shapes closely juxtaposed on a deep chrome background. These surround a central area covered with small cream spheres outlined in grey, tipped with brown. This extremely rare design brilliantly combines the ethnic and the art deco styles.

TEREK is believed to be a simple banded design of close, narrow rings in blue and sand colour.

Chapter Fourteen

THE MABEL LEIGH TRADITION 1936-1939

ART POTTERY –
PERIOD POTTERY

Mabel Leigh's influence remained long after she had left Shorters. This can be seen in the profusion of new patterns that burgeoned from the roots of her original Period Pottery. Her themes were developed and a new emphasis placed on colour and intricacy of design.

Mabel Leigh's own patterns continued to be produced with the introduction of new colour-ways, for example Freya was re-issued in pink, yellow, white and green. In 1937 her Majesty Queen Elizabeth bought two examples of Mabel Leigh's pottery, a flower vase in Aswan and a vase in WHITE FREYA, a variation in white matt glaze of the original Freya design. (Plate XXXII)

Some of the Period Pottery produced immediately after Mabel Leigh's departure was strongly influenced by her original designs. Both AKABA and ITALIAN NO. 3 display the strong colours and geometric decoration associated with Anglo-Afrik and Algerian, whilst the stylised blooms of MALAGA follow closely in the tradition of Medina and Basra.

Between 1936 and 1939, over fifty new designs for Period Ware were created by unknown designers which, whilst following in the tradition set by Mabel Leigh, show marked stylistic differences. The freedom of expression which had resulted in the naive quality of the early Period Pottery gave way to more complex and comparatively sophisticated designs finely executed by skilled sgraffito artists and paintresses.

The sgraffito work is often distinguished by a fine herring-bone pattern and by delicate curlicues. As the decoration of most of these pieces involved a skilled and lengthy process they were expensive to manufacture. Consequently, these exclusive, high quality designs were produced in limited numbers and examples are difficult to find.

Three different ITALIAN sgraffito designs, similar to Mabel Leigh's peasant ware, were introduced in 1936 bearing a distinctive antique finish in browns and greens. In complete contrast, the simple OLD ENGLISH designs, with pastel coloured flowers composed of raised, tube-lined dots against a cream ground are cool and understated.

Some of the Middle Eastern designs are particularly fine, both MECCA and

KERMAN being decorated in subtle colours with intricate sgraffito patterns scratched into the coloured glaze.

The Pottery Gazette and Glass Trade Review of April 1937, reports that many new decorations were to be seen in Period Pottery with ".... some altogether new treatments the KASHGAR pattern offered in two predominant colours, blue and green, with on-laid floral decoration in white enamel." and "The TEHERAN pattern consisting of boldly treated daisies and leafage".

In KASHAN a simple but striking design of leaves and fuchsia type flowers is set against a parchment coloured background. The same flowers are included in both KHIVA and Mecca. The very distinctive leaves are common to Khiva and AUTUMN LEAVES whilst the tube-lined dots on Mecca echo faintly the tube-lining on the Old English designs. A link is established between the Middle Eastern and English designs which indicates the hand of the same designer.

KANDAHAR simulates tapestry. The Far Eastern name belies the traditional Old English floral cross-stitch design, set on a cream woven-effect ground. The

dark green handles of jugs in Kandahar, Kerman, and Kashan confirm a common origin.

The typically Italian style MENDOZA, with its characteristic copper-green glaze and bold patterns of intricate floral and geometric sgraffito, has its origins in the earlier Italian design No 1.

Three completely different designs "890", WAN LI and SCRATCHED DRAGON, were introduced in 1939. "890" with its antique finish and tiny rosebuds is one of the new Period Pottery designs referred to, most inappropriately, by a number instead of a name. Wan Li, named after an ancient Chinese emperor, is a striking brown and cream floral sgraffito design, whilst the rare contemporary Scratched Dragon pieces bear a typically Chinese dragon.

SYRINGA with its embossed spray of hand-painted oriental blossom is listed in the Shorter pattern book with Period Pottery designs but its links are tenuous.

LANGHAM WARE is the name of a range of pottery which shows the influence of traditional English designs whilst maintaining an affinity with the Italian sgraffito ware. It includes JACOBEAN and other similar period designs which were applied to new shapes.

Aztec, Gardiniere, Medina and Khimara were re-issued but the overall style of Gardiniere and Medina is quite different from that of the early Period Ware.

Indeed when Mabel Leigh was shown later pieces of Gardiniere and Medina she neither recognised them nor accepted that they were her designs.

A significant change occurred after 1939 when the dominant influence was that of Italian sgraffito artists.

Although new shapes were modelled for the new designs some early shapes and some created by Mabel Leigh continued to be used.

PERIOD POTTERY 1936-1939

MALAGA (*plate XXIX*). (*MAGADOR*). *Against a matt cream ground a large, deep madder and pink rose is supported by dark green leaves, offset by upper and lower sgraffito borders in pink, green, brown and cream.*

AKABA (*plate XXI*). *Three zigzag bands in apple green, brown and black, outlined in sgraffito, are separated by bands of deep ochre. Two concentric bands of cream and grey have a simple sgraffito decoration. The ware is highly glazed and any handle is black.*

ITALIAN (*plate XXXIII*). *Three different sgraffito designs were produced in which shades of brown, gold and green predominate.*
ITALIAN Number 1 has an overall, intricate geometric pattern.
ITALIAN Number 2 is decorated with a swan and strong geometric borders.
ITALIAN Number 3 displays similarly bold borders but with panels containing flowers and leaves.

MECCA (*plate XXX*) *is decorated in broad bands of dusky green set on a matt cream ground. The background is enhanced by dusky pink, fuchsia-shaped flowers and green leaves. The green bands bear fine sgraffito curlicues and herring-bone patterns which expose the cream body. Mecca is also found in cream, blue and brown.*

OLD ENGLISH (*plate XXXII*). *The three matt glazed Old English designs are decorated using a "tube-line" technique, the flowers being formed by groups of raised dots.*
OLD ENGLISH Number 1. Pink, yellow and blue hollyhocks grow stiffly against an off-white background.
OLD ENGLISH Number 2. The basic pink ground is ringed by simple blue and white decorative bands and by tiny sprigs of flowers.
OLD ENGLISH Number 3. Blue and green sprays of flowers and leaves are set randomly against an off-white background.

AVON (*plate XXXII*) *is based on Old English design No. 1. In addition to the upright hollyhocks, the scene is completed by two stylised trees and two arched bridges with rounded clouds silhouetted against a bright blue sky.*

KAS(H)GAR. *The luminous blue or green background is enhanced by arching sprays of delicately enamelled white flowers and leaves, with stems in sgraffito.*

TEHERAN. *The matt dark grey or old gold background decorated with black tracery is contrasted with an overall pattern of pink and white, yellow-centred flowers with green leaves.*

KASHAN (plate XXXIII). *Against a matt parchment surface, narrow, black and parchment encircling bands are broken at intervals by a large, single, stylised green leaf and a dusky pink, fuchsia-like flower.*

MARIBO (plate XXXII). *Wide bands of soft pink are decorated with a combed effect of wavy lines which expose the cream background. Each piece is also encircled by several rings of grey tube-lined dots.*

MOSELLE *is an overall design including purple grapes, green leaves and small black scrolls.*

CLOVELLY (plate XXXIV) *consists of a profusion of leaves and flowers in pink, mauve, yellow and green including the fuchsia-shaped flowers found on Mecca and Kashan together with irregular black shapes. The cream background is exposed around the flowers and shapes.*

CAPRI. *Two broad black borders support contrasting, brightly coloured orange, yellow and purple flowers and green leaves. They are separated by a wide pink panel.*

KOTAH. *The dark green background has scratched borders with golden brown spots below them. The middle band is decorated with slip flowers and sgraffito leaves.*

CHANTILLY *displays a panelled effect with large, chequered squares of dark brown against a cream ground. The panels are separated by wavy sgraffito lines.*

LOZERE. *Golden brown and dark brown shade into each other to form the background. A central band of checks in brown and white has two bands of brown or green and grey above and below.*

WESTBURY. *Tall, dark grey panels flanked by dark green tube-lining support pink, white and yellow flowers and clusters of white slip dots against a black background.*

KHIVA *bears a marked similarity to Kashan. The parchment background is ringed by broken bands of green which are breached, at intervals, by a large stylised green leaf, a red flower, and a yellow fuchsia-shaped one.*

MANACCAN. *Fully blown roses in pink and yellow with green leaves are set in large squares which cover the whole surface. The dark grey background is scratched overall with small white scrolls similar to those on Mecca.*

MASIRA *bears the same design as Manaccan on a creamy yellow ground.*

KANDAHAR (plate XXXIV). *This pattern gives the appearance of tapestry. A group of stylised, geometric flowers in red, blue and yellow with green leaves are displayed on an ivory, "canvas-textured" background.*

AUTUMN LEAVES (plate XXXIII). *There are two versions of Autumn Leaves, both bearing stylised leaves similar in shape to those found on Kashan and Khiva.*
AUTUMN LEAVES Number 1. Comparatively few large brown leaves are set against a background shaded brown, yellow and green.
AUTUMN LEAVES Number 2. Smaller brown leaves are set against a background shaded in brown and yellow.

SHERBORNE (plate XXXI) *is characterized by its richness of colour. Yellow, crimson-tinged oranges abound amongst crimson flowers and bright green leaves on a pink ground.*

KERMAN (plate XXXI) *has a mauve background through which are cut swathes consisting of narrow stripes of yellow, blue and green. Each stripe is intricately patterned with geometric sgraffito to reveal the cream body. The mauve panels are decorated with full-blown pink and white roses which come from the same stock as those found on Manaccan and Masira. The base and rim are bordered green. Any handles are coloured green as in Aswan and Kashan.*

RAYENNA (Plate XXXIV). *This overall design consists of yellow and pink flowers and green leaves closely juxtaposed with irregularly shaped blocks of colour — blue, mauve, pink, yellow. The cream background outlines both flowers and shapes.*

JAFFA. *Sgraffito panels with flowers growing from the side are separated from the cream ground by green and brown curlicues.*

VALETTA *is a sgraffito pattern in which a group of yellow-centred flowers in purple blue and pink with long, thin leaves, climb against a simple golden-brown fence on a cream background.*

MENDOZA (plate XXXVII) *which appears to have been strongly influenced by Italian design No. 1, is characterized by its deep green copper glaze, its ornate, fuchsia or rose-like flowers, leaves and curlicues and by*

rows of intricately executed geometric borders. Usually, the yellow or pink flowers, and green leaves are arranged in panels. The bands of intricate sgraffito are coloured in pink, cream, brown, gold, green or turquoise.

TIRANA. In this sgraffito pattern two misty bands of turquoise green encircle the pinky brown background dividing it into three horizontal sections. Clusters of yellow and orange flowers with brown or green leaves are offset against the background and the turquoise bands.

CASTELLI is recognised by large, upright stylised leaves in green, brown and orange arranged in pairs and set into panels. Borders of green leaves decorate the top and base of the piece. The copper glaze has been allowed to run into and over the sgraffito.

Design NO. "890" (plate LIII) gives the appearance of having been made at a much earlier time. The parchment background, shaded to give the effect of age, is sprigged with tiny deep pink rosebuds. It is usually found on a waisted and fluted vase, shape number 509, and, occasionally, on matching wall pockets and comport.

WAN LI (plate XXXV). There are two main versions of Wan Li, both of which have a cream background, scored by fine diagonal brown lines.
WAN LI Number 1. Three variations are decorated in sgraffito with tall, upright flowers and spiky leaves outlined in brown.
WAN LI Number 2. This rare design displays a large bunch of grapes accompanied by flowers and leaves.

SCRATCHED DRAGON (plate XXXVI). One or two oriental dragons are etched in copper against a smooth cream background with a simple sgraffito border. In one version, the scales of the dragon are in lustrous purple, gold and bronze.

SYRINGA. An embossed spray of blossom is hand-painted in natural shades of pink, yellow, green and brown against the smooth cream ground of the original co-ordinated series of shapes called Syringa. Possibly the oriental quality of the blossom, when hand-painted, qualified it for inclusion in the Period Pottery series.

LANGHAM WARE (plate XXXVIII). Jacobean type floral sprays, bouquets and garlands are skilfully etched into complex, flowing patterns and hand-painted in pink, mauve, blue, yellow, brown and green. Some designs are specifically named, e.g. JACOBEAN, KNOLE, and ELIZABETHAN, and some are referred to by a number.

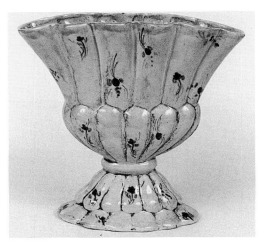

Fig. 57 Design No. "890".

DESIGNS REFERRED TO BY NUMBER (plate XXXVIII). These are hand-painted floral designs some of which are similar to Langham Ware and some of which relate to patterns previously referred to by name. The numbers do not appear to follow a logical sequence. Many pieces are numbered in the eight or nine hundreds, e.g. 834, or may have a four figure number, e.g. 4939.

RE-ISSUES OF EARLY PERIOD POTTERY DESIGNS

AZTEC appears in its original form and with a new version in which the fish are replaced by similarly styled sgraffito yachts. The yachts, and occasionally the fish, appear against a tan background, with the interior of the pot glazed green.

GARDINIERE (plate XXXVIII). The large, free-flowing painting of the original Gardiniere is replaced by a much smaller, simplified design of neat, controlled flowers and leaves. The design is completed by the addition of narrow pink, blue and green borders.

MEDINA (plate XXXVIII). The Medina pottery of this time was often produced with a dark brown ground and with the handles on jugs, vases and bowls painted maroon. This later ware is distinguished by its more sophisticated and controlled sgraffito and a more careful application of the colours.

Reference is made by number as well as name to the above designs.

KHIMARA. The difference between early and late Khimara is more difficult to detect, but the colouring and glaze of the early pieces have either greater depth and richness, or an appearance of antiquity.

Chapter Fifteen

THE NINETEEN FORTIES

WAR-TIME 1940-1945

Throughout the war-time years Shorters continued to produce and export high-quality, continental style, Hand Crafted Period Ware which was in the tradition of the early Period Pottery.

According to the Glass Trade Review of August 1940: "Important work has been going on at the Copeland Street Pottery recently in relation to incised treatments of the Sgraffito type. We learn that, of late, Shorter and Son Ltd., have been catering for a demand for quite a number of lines which were previously supplied by the Italian potters, a number of long-standing importing houses have now turned to Stoke-on-Trent for their requirements in this direction."

Shorters continued to produce Fish Tableware and to develop new glazes and glaze techniques introducing a crackle effect in 1940 and a new type of matt glaze with a satin finish in 1941. It was used successfully on Shell Ware.

The beautifully glazed Wild Duck series was marketed extensively at the beginning of the war, probably before the war-time restriction of supplies to the home trade was applied too rigidly.

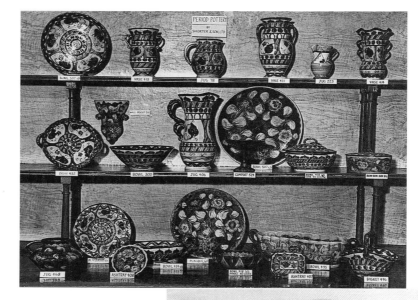

Fig. 58 Period pottery including Mendoza, Medina and Khimara.

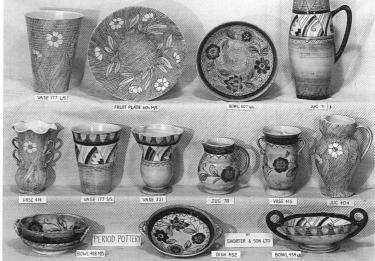

Fig. 59 Period pottery including Wan Li, Medina and Khimara.

A limited amount of FRUIT WARE was sold towards the end of the war together with the old majolica-based Cherry Ripe and Strawberry Fair series.

Some nostalgically appealing, old Staffordshire figures and animals were re-issued, to remind the beleaguered British public of its bucolic past.

Consciously or unconsciously, Shorters produced ware that provided balance and counter-balance. Harry Steele's awareness of public taste and anticipation was a major factor in maintaining the success of the firm. He predicted the increasing popularity of character jugs which became one of their most commercially successful lines.

ART POTTERY – PERIOD POTTERY

Of the four Italian designs created in the late 1930s, Mendoza was the most consistently in demand, together with the contemporary versions of Medina and Gardiniere. The Langham Ware series, with its often richly-coloured sgraffitoed and varied designs, was also aimed at the export market.

In 1941 a functional element was introduced to this highly decorative and labour-intensive ware when a series of lamp bases and covered dishes was issued.

ART GLAZED WARE

A report from the Pottery and Glass Review of 1940 states that "Three different treatments are available in the Chinese Crackle, each in matt and glossy effects."

DECORATIVE TABLEWARE

FRUIT WARE (plate XLI), first designed in 1939, consists of tea and coffee sets simply modelled in basic apple and pear shapes. Matching containers and dishes are formed as more exotic fruits such as pineapples and lemons. Naturally coloured with a hand-painted leaf and stalk decoration, it may be finished with a soft matt or shiny glaze.

DECORATIVE FANCIES

Some old Staffordshire figures and animals were re-issued together with newly modelled Old English poodles, spaniels and lambs in the traditional style.

CHARACTER JUGS

An already comprehensive range of Toby and Character jugs was extended by the addition of seven new figures introduced in 1940/1941, including Old King Cole and Long John Silver. A novelty tableware series was based on an early Toby design.

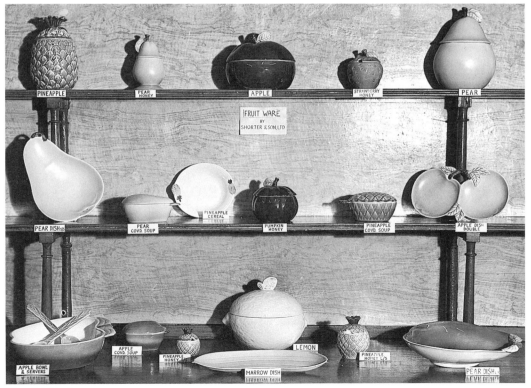

Fig. 60 Fruit ware.

POST-WAR REVIVAL

When World War Two ended, the firm continued the manufacture of Italian type sgraffito and Period Pottery.

Although a series of ".... exclusive art pottery" in which vases, jugs and bowls were decorated "....in light colourings with yellows and greens predominating", was advertised in 1947, it was not until the end of the decade that a new set of shapes was created.

Certain pre-war designs in decorative tableware, Cherry Ripe, Embossed Fruit, Strawberry Fair, Fish Ware and Shantee were re-issued. DAFFODIL, looking to the past for inspiration, was the forerunner of the range of decorative floral tableware that was to extend from the 1940s, throughout the 1950s and well into the 1960s.

The ubiquitous wall-mounted flying birds were joined by a series of humorous figures in "modern and whimsical style". The market for novelties was buoyant.

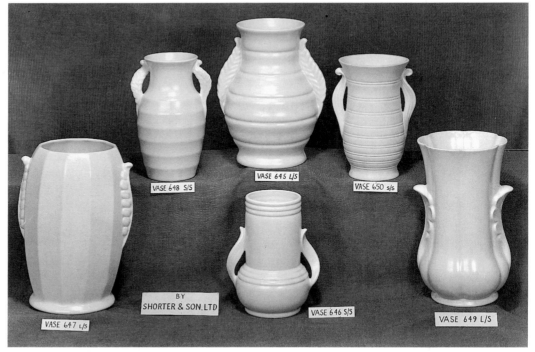
Fig. 62 Matt glazed vases 1949.

Fig. 61 Matt glazed vases 1947.

DESIGN EXPLOSION

By the end of 1948 the factory was fully recovered from the restrictions imposed during the war years and in 1949, there was a positive explosion of new ideas, with Shorters presenting the public with an incredible variety of high-quality original designs — a creative upsurge that may be likened to that witnessed twenty years previously.

In 1949 a new series of classic matt glazed vases was launched together with the first in a long-running series of moulded, embossed, hand-painted tableware with a floral motif. The influence of early Shorter majolica is reflected in some of the designs and certain of the old patterns were re-issued with modifications. The floral tableware series was to set the pattern for the direction in which the company was to develop and in which it was to be so successful.

Matt glazed vases, Wild Rose and Dahlia tableware, Strauss and Iris water sets, Widdicombe Fair comical pottery for children, posy holders, table lamps, character jugs, and the prestigious Gilbert and Sullivan figures were all part of the design explosion. This creativity culminated in the design of a second series of vases, avant garde in shape, which was produced in the 1950s.

ART POTTERY – PERIOD POTTERY

Mendoza and the Italian sgraffito designs from the war-time years continued to be produced together with Aztec, Gardiniere, Medina and Khimara.

FORTIES MATT GLAZED WARE

One of the most significant Shorter designs of the 1940s appeared at the end of the decade when a series of elegantly styled vases in matt glazes, numbered from 645 to 650, was created. (Plate XXXIX) The simplicity of each piece is enhanced by the modelling which forms an integral part of the design. The shapes are gently moulded and curved to form either vertical or horizontal bands, the shadows thus formed providing a subtle decorative effect. Each of the five vases bears a pair of moulded handles or decorative supports in an abstract leaf design. A matching bowl, number 651, together with wall pockets, shape numbers 668 and 672, complete the range.

Matt glazes in pastel shades including turquoise green, soft yellows and browns, were most widely used. At a later date, a series of the vases in a white matt glaze with a pink interior, proved to be an effective alternative to a set issued in deep ruby red.

DECORATIVE TABLEWARE

DAFFODIL (Plate XLII)

The sinuous outline of the shape and embossment are reminiscent of the Art Nouveau style of the beginning of the century. Leaves, stems and daffodils trail across a pale yellow background.

Fig. 63
Art Pottery –
Period Pottery.

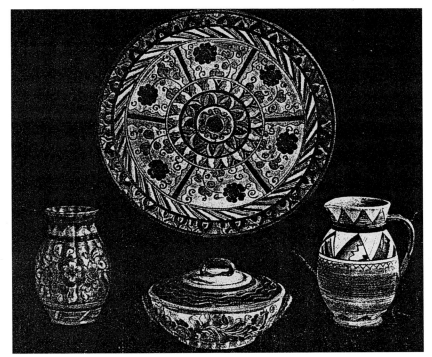

Fig. 64
Daffodil.

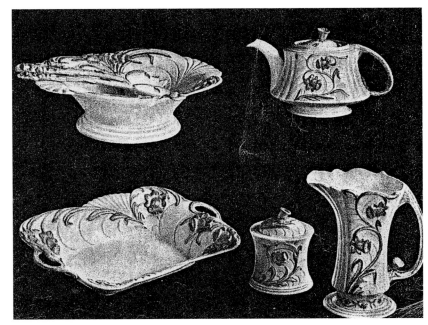

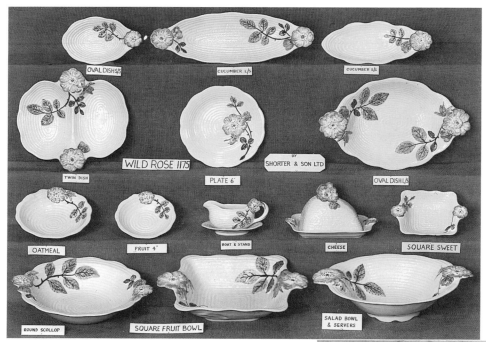

Fig. 65
Wild Rose.

STRAUSS (Plate XLII)
The pale yellow Strauss water set, decorated with a diagonal spray of pink and yellow blossoms, is based on an early majolica design. The jug has a rustic brown handle and knurled feet.

IRIS
The Iris waterset, of a jug and six beakers, is decorated with a relief-modelled flower set high on a pastel-coloured ground.

Fig. 66
Dahlia.

WILD ROSE (Plate XLIII and LXIV)
Pink roses and naturally coloured leaf sprays are relief-modelled against an apple-green, dove-grey or, occasionally, a cream, textured ground.

DAHLIA (Plate XLIV)
Several relief-modelled dahlias in pastel shades lie on a background of green, or occasionally light brown, swirling, embossed leaves which echo the shape of the jug or bowl.

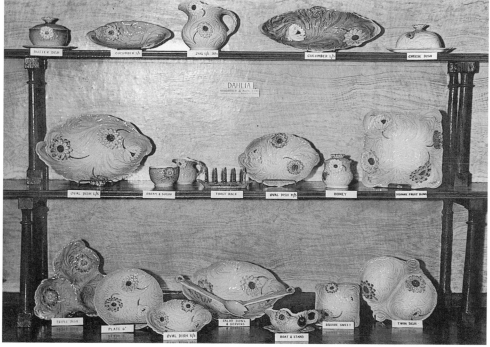

CHILDREN'S TABLEWARE

WIDDICOMBE FAIR (Plate LIV)

Further evidence of Shorters' range and diversity is demonstrated by the humorous pottery named Widdicombe Fair. Specifically made for children it is embossed and hand-painted; plates depict a happy, hatted elephant, a dancing teddy bear; bowls support a clown in striped pantaloons; a jug is a helter skelter decorated with stars and small figures; a cup with a spotted horse jumping through a hoop sports a clown as its handle. These figures are set against a vivid pink, green or cream background. Because of the ephemeral nature of children's pottery this series is now very rare.

DECORATIVE FANCIES

POSY HOLDERS (Plate LI) (Fig. 81)

A set of newly-modelled Posy Holders in the shape of a tulip, an iris and an orchid was introduced. They range in height between five and six inches, and are taller than the series produced ten years previously. The flower, leaves and stem of the tulip and iris are set into a rounded base whilst the orchid posy holder is made up of the flower head only poised on four of its lower petals.

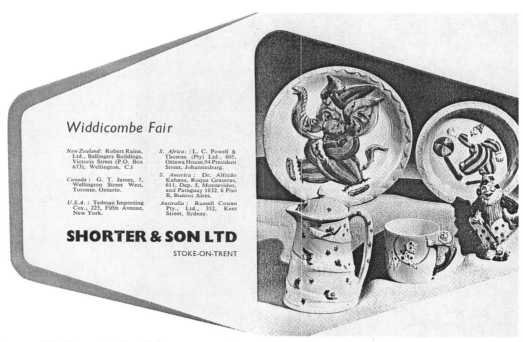

Fig. 67 Widdecombe Fair (advertisement *Pottery Gazette* 1949).

CHARACTER JUGS
(Plate LVII)

New models were added to the range of character jugs. They included Covent Garden Bill, a Fisherman and a magnificently modelled King Neptune. Some character jugs were converted into table lamps.

GILBERT AND SULLIVAN FIGURINES
(Plate LVIII and LVIX)

The production of a completely new series of figural jugs, based on characters from the Gilbert and Sullivan operas, was one of the firm's most original and indeed prestigious ventures.

Chapter Sixteen

THE NINETEEN FIFTIES

Throughout the 1950s, Shorters demonstrated their versatility and the diversity of their products. They re-introduced some early majolica shapes whilst maintaining a limited production of Period Pottery that was virtually indistinguishable from that produced in the previous decade.

Significant changes in design occurred in the early 1950s, the Festival of Britain in 1951 acting as the catalyst. A new series of WHITE MATT GLAZED vases was introduced which was quite as revolutionary in style as the Art Deco Matt Glazed designs of the late 1920s and early 1930s. The designer or designers of each of these unique series made an extreme statement on the contemporary ceramic scene.

To maintain public interest, new items, glazes and colourways were introduced to Fish Ware and Shell Ware. A highly glazed version of Wild Duck tableware was issued with a silver plated trim.

Following the highly successful introduction of the Wild Rose series, new designs in hand-painted, embossed and moulded tableware with a floral theme were produced throughout the decade. Each series consists of a new set of shapes individually designed and modelled.

Initially, designs were based on an individual flower but, eventually, styles were developed in which each piece of pottery was decorated with a variety of flowers. Sometimes, as in ANEMONE and WATER LILY, a series would pay homage to Shorters' majolica past, whilst other series, such as HARMONY and BOUQUET, reflect the influence of contemporary design.

In 1958 two new designs were on display, the floral-based PETAL series and SALAD DAYS with its more prosaic design of salad vegetables. It is at this point in time that the romantic floral patterns were beginning to be replaced by designs more related to the current life style.

This imaginative tableware must have made a tremendous impact on a public which had been starved of colour, luxury and extravagance during the war-time and austerity years.

Fruit Ware was re-issued in 1950, and the traditional Lettuce Leaf and Rock Garden were promoted in 1951 and 1953 respectively. Shantee was revived with a light cream background.

The firm continued to produce novelty items, constantly looking for new ideas which would appeal to the public.

The output of character jugs during this decade was prodigious. In 1950 a highly successful and widely publicized launch of King Neptune and a concentrated and imaginative marketing of Gilbert and Sullivan character figures, both at home and abroad, focused attention on the Shorter factory.

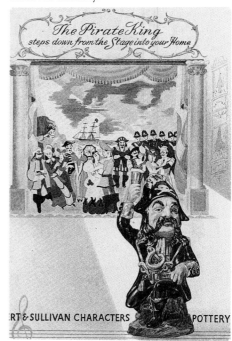

Fig. 68 Gilbert and Sullivan advertising leaflet.

MAJOLICA STYLE JUGS

Some of the old majolica jugs were reproduced using obviously modern colours and glazes, whilst others, including Strauss, are decorated in a rich cobalt blue, majolica-type glaze complete with a deep pink interior which would be virtually indistinguishable from the early ware but for the backstamp. (Plate XLII)

MATT GLAZED WARE

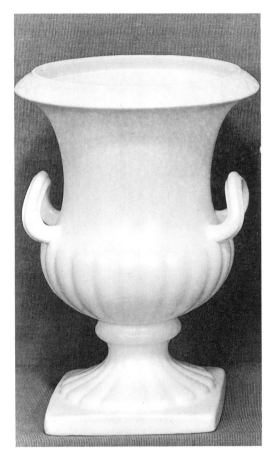

Fig. 69 The Firm's best selling vase – the white matt glazed Grecian Vase No. 446, first produced in the 1930s.

VASE 681 S/S VASE 681 L/S VASE 688 S/S VASE 688 L/S

BY SHORTER & SON, LTD

BOWL 682 L/S BOWL 682 S/S BOWL 684 S/S BOWL 684 L/S

BOWL 687 S/S BOWL 687 L/S BOWL 685 L/S BOWL 685 S/S

Fig. 70 Matt glazed vases .

FESTIVAL MATT GLAZE

The diversity of shapes within this series is remarkable. Numbered from 681 to 690 the ware is futuristic, streamlined and, metaphorically, broke the mould of British pottery design. Shape number 689 with its three-pointed tubular sections is reminiscent of the lines of the Skylon which was the focal point of the Festival Exhibition on the South Bank of the River Thames. Vases numbered 684 and 687 anticipate the design influence of the Space Age. (Plate XXXIX and XL)

The shapes both symmetric and asymmetric, are with one exception, supported on a base, some designs appearing to be almost poised for flight. In design number 684 the body of the piece balances on a small sphere which, in turn, balances on the base, whilst in design number 686, two spheres intervene.

Bowl number 703 was designed to complement vase number 681 with shapes number 715, 716 and 717, being introduced at a slightly later date to extend the range. The series was first produced at the beginning of the decade with a white matt glaze and later in a variety of coloured matt glazes. A highly glazed series in black with the embossments featured in yellow and white provided a dramatic contrast when marketed in the late 1950s or early 1960s.

Fig. 71 Anemone.

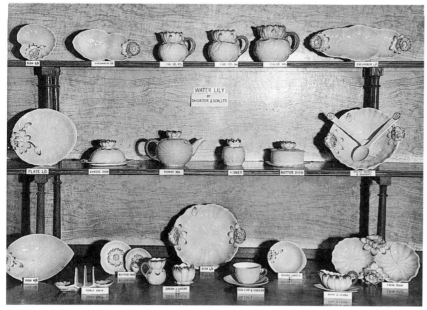

Fig. 72 Water Lily.

DECORATIVE TABLEWARE

ANEMONE (*Plate XLV*)

In 1951 one of the most distinctively modelled and coloured designs called Anemone was marketed. Its deep-shaded maroon, purple, and mauve flowers with contrasting centres of apple green and black form the basis of each pot. Anemone is sometimes found in green, yellow, and black, occasionally in cream, maroon and black.

The first designs for Anemone were executed in the late 1930s.

WATER LILY (*Plate XLVI*)

Water Lily, designed in 1949, was marketed in 1953 with either a dark green or a light apple green foliage. Delicately veined leaves support a relief-modelled, pink-shaded water lily which is incorporated into the pottery either as part of a jug or bowl or, in its entirety, forming a cover or lid. A few examples exist with a cream ground.

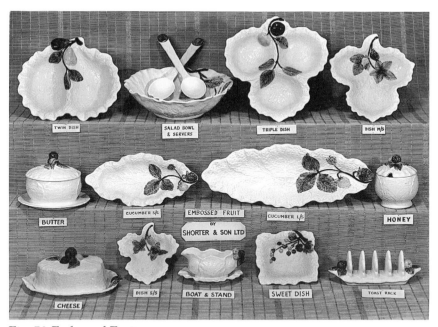

Fig. 73 Embossed Fruit.

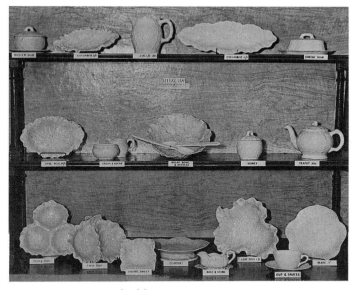

Fig. 74 Lettuce Leaf tableware.

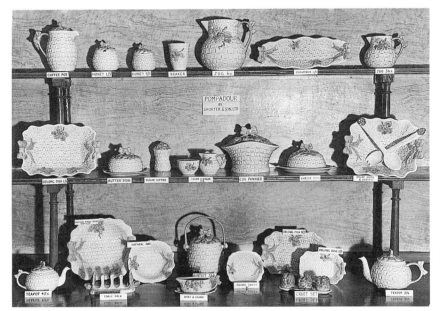

Fig. 75 Pompadour.

EMBOSSED FRUIT (Plate XLIX)
Based on a traditional Shorter pattern the Embossed Fruit ware of 1956 has a lightly leaf-veined background in ivory, blue or grey supporting a long spray of leaves and fruit in pastel shades.

LETTUCE LEAF
This is a modified version of the early majolica ware.

POMPADOUR (Plate XLII)
Pompadour demonstrates the way in which Shorters modified their early majolica styles to fit the contemporary market. New pieces were introduced with a modification to their overall shape, the bowls and dishes becoming more rectangular. The pale cream basketwork ground supports relief-modelled strawberries, pastel-coloured flowers and leaves. The characteristic bow is in pink.

Fig. 76 Rock Garden (advertisement *Pottery Gazette* 1953).

ROCK GARDEN (*Plate XI*)

A "new" Rock Garden series, with an affinity to the 1930s Cottage ware theme, was issued in 1939. Based on the early Shorter design, the novelty element introduced then was continued in the 1953 version, in which the influence of majolica ware is still evident.

Fig. 77 Harmony (advertisement *Pottery Gazette* 1956).

HARMONY (*Plate XLVII*)

Asymmetric, sinuous and inter-related lines form a harmonious whole with the shape emphasised by the gently ribbed surface lines which follow the contours of each piece. A realistically modelled and hand-painted spray of flowers in natural colours decorates each item of pottery. The spray may be of roses, iris, tiger lilies, daffodils, tulips or corn flowers. This series is usually aerographed in grey, turquoise or maroon. Sometimes two contrasting colours are merged into one another.

BOUQUET (*Plate XLVIII*)

Bouquet, first made in 1957, represents the Fifties floral tableware series at its best. The smooth asymmetric outlines, typical of Fifties design, are echoed by the compartments of the bowls and dishes which flow into each other and are emphasised by the rim or handle of embossed, brightly coloured garden flowers. The background may be pink, blue, yellow or maroon, or aerographed in two colours which blend into each other as in the two, rich pink tones of ROSE BOUQUET.

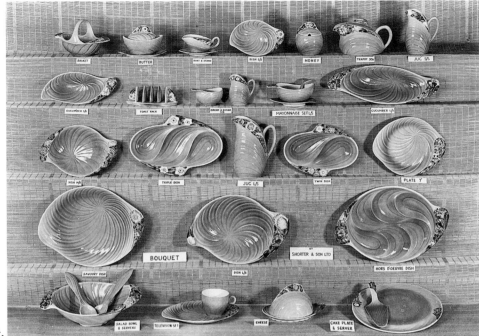

Fig. 78
Bouquet.

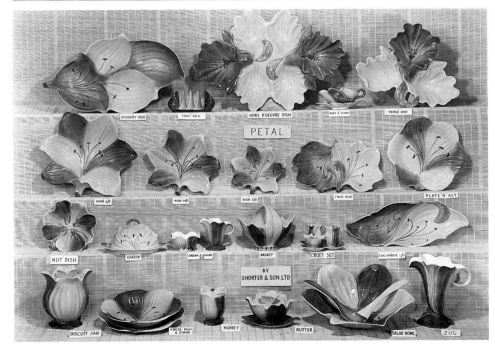

PETAL (*Plate XLVII*)

The Petal series is moulded in the form of large petals with sinuous asymmetric lines and boldly defined stamens. The petals are aerographed in colour combinations of pink and grey, pink and green, or green and yellow, arranged alternately and following the contours of each piece.

Fig. 79
Petal.

SALAD DAYS

Shapes similar to those used for Harmony are cream-glazed and embossed with brightly coloured salad vegetables such as a tomato, carrot, mushroom or spring onion, arranged singly or in small groups.

WOODLAND (Plate XLIX)

Woodland is characterised by bold rectangular shapes, with rounded corners. Large, realistic, embossed leaves in autumnal colours are scattered over the cream-textured background.

NEW SHAPES IN FISH TABLEWARE (Plate L)

The Fish Ware range was extended considerably and, by 1950, included a curved crescent salad dish, and circular plates in two sizes. A salad bowl with servers, a wavy-edged hors d'oeuvre dish with a fish-shaped sauce pot were later additions, to be followed in 1957 by a double serving dish in which two fish confront each other nose to nose and a pair of comical fish on a wavy tray dispense salt and pepper. The last addition to the range was a double dish in which the fish swim side by side. A high glaze and unusual colour combinations in turquoise, mauve, grey, green or yellow, sometimes striped, are typical of 1950s Fish Ware.

DECORATIVE FANCIES
(Plates LIII and LIV)

Wall pockets, which echoed the 1949 series of matt glazed vases, were introduced together with one which matched the Daffodil posy holder. A novel, cream-coloured, whistling mug bears an embossed design in brown, gold and black, illustrating the nursery rhyme "Sing a song of sixpence" as the blackbird escapes from the pie.

CHARACTER JUGS

New character jugs including Captain Ahab, Pedro and the Sheik were issued, together with a set of three military figures called "The Queen's Men".

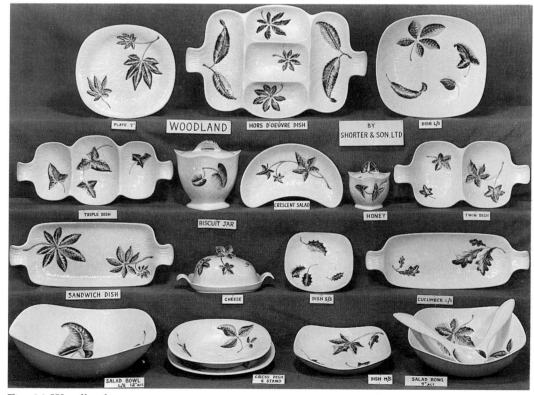

Fig. 80 Woodland.

Fig. 81 Orchid posy holder.

THE NINETEEN SIXTIES AND ONWARDS

THE LAST YEARS AT COPELAND STREET 1960-1964

During this period, Shorters continued to produce new designs and glazes.

Period Pottery remained on the Shorter agenda with advertisements in the Pottery Gazette featuring Wan Li in a new "harmonious colour scheme of pale green and rustic brown" and Medina.

A new series of contemporary vases in a white matt glaze was introduced and the firm's commitment to the creation of new glazes maintained. Metallic glazes in black, bronze and gilt were applied to both old and new shapes. New colour combinations enlivened the Fish Ware series and an austere white satin matt glaze dramatically emphasised the unusual shapes of Galaxy.

With the exception of GOURMET and ELITE, new designs of decorative tableware elaborated the floral theme.

Responsive as ever to current market trends, the firm expanded production to include designs in oven-to-tableware.

A few new animal figures were modelled together with a new Beefeater character jug. Traditional Toby and character jugs retained their popularity and the Gilbert and Sullivan figurines were re-introduced in the early 1960s.

SIXTIES MATT GLAZED WARE

A group of distinctive Free Form Vases epitomises the style of the nineteen sixties. The asymmetrical vases, shape numbers 747, 795 and 797, are supported by symmetrically shaped vases numbered 794, 800, 803 and 825 in the same series.

In these pieces a sculptural effect is created by the deeply moulded contemporary shapes.

The original White Matt Glaze series is in direct contrast to ware highly glazed in black, highlighted in yellow and white. This change of glaze and colourway completely alters the character of the designs. (Plate XL)

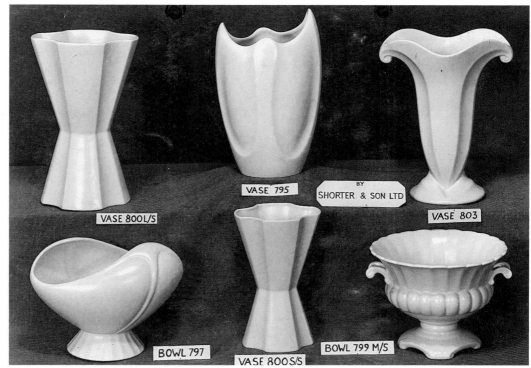

Fig. 82 Matt glazed vases.

DECORATIVE TABLEWARE

SYMPHONY (Plate XLIX)

The basic shape of Symphony is a curved triangle in which the rim is aerographed in a pastel shade and surrounds a cream base embossed with radiating lines and a floral spray.

GOURMET

In 1960, Gourmet tableware was produced on shapes similar to those of Harmony and Salad Days. The cream ground is moulded to represent a fishing net and embossed with lobster, crab and other shell fish, hand-painted in browns and greens.

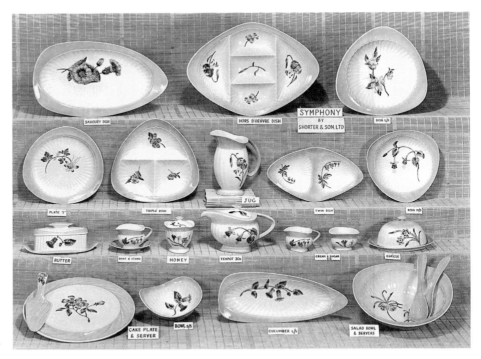

Fig. 83
Symphony.

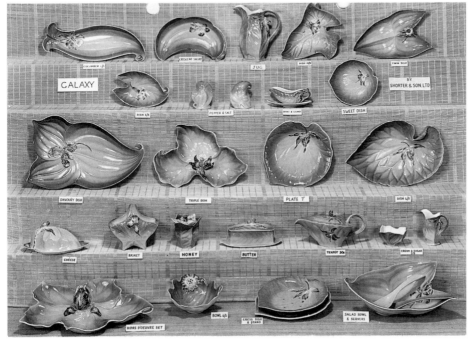

Fig. 84
Galaxy.

GALAXY (Plate XLIX)

Galaxy, marketed in 1960, consists of asymmetric shapes based on a wavy-edged leaf design. There is a great variety in the size and overall shape of each piece. A single colourful embossed flower decorates the pastel background which is shaded in two colour combinations of mauve, green and peach.

SHRUB

Shrub, issued in 1962, consists of a series of rounded, asymmetrical shapes bearing a colourful embossed flower on a plain pastel ground.

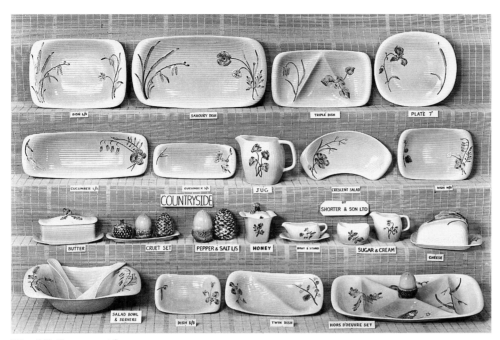

Fig. 85 Countryside.

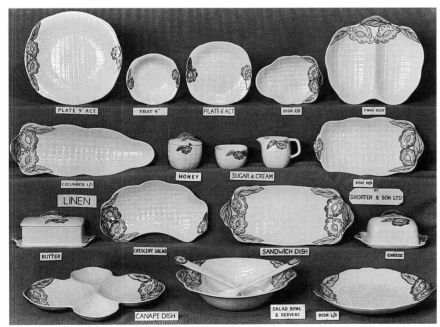

Fig. 86 Linen.

COUNTRYSIDE

Countryside, issued in 1961, consists of rounded, differently proportioned rectangles. Simple embossed sprays of country flowers, such as poppies or catkins, decorate the ribbed background, which is shaded in two pastel colours.

LINEN (Plate XLIX)

Linen, issued in 1962, has gently curved edges and an ivory, linen-textured background. The applique-style flowers in pink and blue are outlined in black.

ELITE

Elite, produced in 1963, is based on a design for "utility tableware" by Mabel Leigh in which concentric bands provide a decorative ribbed effect. This pastel-coloured ware is distinguished by contrasting black lids, handles and saucers.

JACKPOT

Jackpot, introduced in 1963 is a bold, oven-to-table range in black and white, decorated with a brightly coloured, stylised vegetable motif.

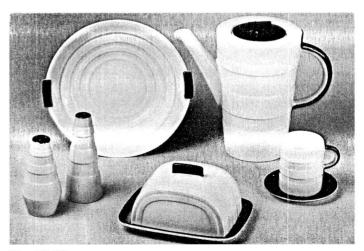

Fig. 87 Elite.

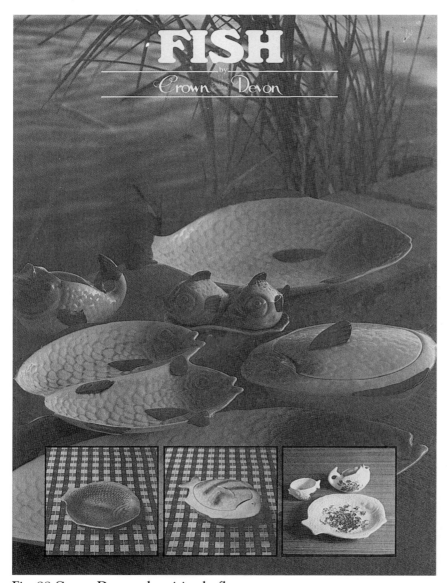

Fig. 88 Crown Devon advertising leaflet.

THE CROWN DEVON CONNECTION 1964-1974

When Shorters merged with Fieldings in 1964 and production moved to the Crown Devon factory, the creative element, so strong in previous years, was considerably diminished. The exception that proved the rule was the superbly moulded POULTRY TABLEWARE. Having survived the trauma of the move to Crown Devon, the firm proceeded to issue this original, high-quality design, the ornithological equivalent of their famous Fish Ware. Who designed it? Was it a new design or an old one that had not previously been in production? Why should this maverick set appear in the middle of the 1960s? Why should Shorters model and market this design which was stylistically and qualitatively at odds with most of the other ware they were currently issuing?

The jewel in the Shorter-Crown Devon connection was produced concurrently with the well-established Shorter Fish Tableware, both designs being marketed in a variety of superior glazes.

Crown Devon featured Fish Ware in an advertising leaflet in 1970 and the Shorter designs may be found with the Crown Devon backstamp.

Fig. 89 Jackpot.

In 1965 both Shorter and Son Ltd and Crown Devon exhibited in London as part of the Fielding Group Potteries. New glazes were in evidence in colours quite different from those previously used by Shorters — dark green, dark blue, a gold lustre and a bronze finish with crackle effect. A modified version of Embossed Fruit, several generations removed from its majolica antecedent, was re-issued in ivory, dark green or mustard yellow with similarly dark-coloured fruit. It was marketed simultaneously with functional, single-coloured tableware, that was both contemporary and rustic in design.

Two new tableware designs, RUSTIC and PERGOLA, were first marketed in the 1960s and continued in production into the 1970s.

The Jackpot Oven-to-Tableware was revitalised in orange and in yellow.

The output of Shorter Toby jugs was maintained, and such was their quality that when Shorters finally ceased to operate as an independent organisation, Crown Devon continued to use the original Shorter moulds and issued identical figures with their own Crown Devon backstamp.

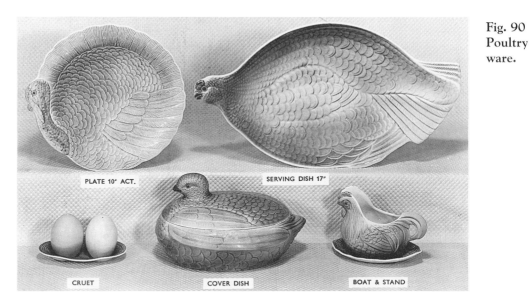

Fig. 90 Poultry ware.

PLATE 10" ACT. SERVING DISH 17"

CRUET COVER DISH BOAT & STAND

TABLEWARE

POULTRY TABLEWARE (Plate L)
Poultry Dinner Ware, sets of plates and serving dishes realistically modelled as game birds, was introduced in 1965. The subtle shades of brown, grey, and blue are enhanced by a high glaze which emphasises the detailed modelling of the feathers.

CAPRICE
Caprice is one of a series of simple, stylised, free-hand-painted designs which were used in 1966 on CLARION, a modern, triangular shape with windswept lines. It decorates fancy tableware, coffee sets and, in the early 1970s, a set of kitchen ware.

RUSTIC (Plate XLIX)
Rustic, issued in 1966, is most appropriately named. It is decorated with a simple raised geometric design and is matt glazed in strong colours including a deep blue and a rich turquoise.

PERGOLA (Plate XLIX)
Pergola one of the last in the series of tableware designs, is glazed in green or other dark colours. The fluted base of the cups, bowls and jugs supports a broad hand of embossed, stylised flowers, whilst the plates and dishes are marked with radiating lines, edged by a floral rim.

Fig. 91 Clarion.

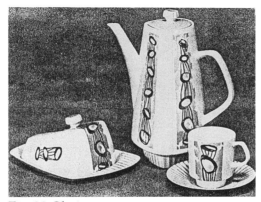

Fig. 92 Clarion.

Chapter Eighteen

TOBY JUGS, CHARACTER JUGS AND FIGURINES

TOBY JUGS AND CHARACTER JUGS

Toby jugs and character jugs were in production throughout most of the firm's existence. The first reference in the Pottery Gazette to their "quaint Toby's and Tubby figures" is in 1917. The original Shorter Toby, 12$\frac{1}{2}$ inches high, wears a red greatcoat, yellow stockings, black breeches, shoes and tricorn hat. It is based on the design of a large, early "Ordinary" Toby by Hollins of Hanley (1794-1820). Other early Toby jugs are thought to include several versions of a Coachman, a female Toby and a paired Punch and Judy.

Fig. 93 Original Shorter Toby.

A sinister Coachman with a high winged collar and a stock, smiles his way from the 1920s through to the 1960s as his colouring becomes progressively brighter. An extra large head and shoulders version of the Coachman leers on a grand scale. An early, cloaked female "Toby" with her hair in a bun under a tricorn hat stands clasping a tankard of ale firmly in both hands. A wary, long-nosed Punch grasps his stick and crouches uncharacteristically, whilst a beruffled, seated Judy smiles enigmatically.

Old Toby jugs were a popular line in 1932 when Harry Steele took over the management of the firm. In the mid 1930s, a pair of Mr and Missus Tobies with large hats were produced, she with her cat and he with a long pipe and a foaming tankard. In another version, Toby sits on a barrel marked "Nut Brown Ale". Towards the end of that decade, twenty of the old designs were revived and a new series of character jugs in three sizes, and in miniature, were modelled. Four new characters, The Admiral, Highwayman, Soldier and Queen of Hearts were introduced in 1939 and marketed together with the Beefeater, Chelsea Pensioner, Flower Seller, Gardener, Guardsman, Policeman, Sailor, Scottie and Punch with Judy.

Old King Cole, Long John Silver, South American Joe, a Red Indian, King Henry VIII, Parson John and Dick Whittington made their debut at the beginning of the Second World War. Although slightly grotesque, they are highly individual, full of character and finely modelled. Amongst the Wilkinson papers are illustrations of a Pirate with a parrot, and a Red Indian by Betty Silvester who is known to have designed some of the Gilbert and Sullivan figurines.

In 1941 the Pottery Gazette reports that ".... a particularly striking range of Toby jugs were launched in many scores of different characters and in various sizes down to miniature."

In order to extend the appeal of character jugs, Shorters made them functional as well as decorative. By the end of the war some of them had been converted to table lamps.

Toby was adapted to form a novelty tableware series in which he was modelled as a teapot and unkindly flattened to form a plate. The Lord Mayor, the Judge and Old King Cole were modelled as teapots, whilst some characters appeared on wall plaques, cigarette boxes, ash trays or as a pair of pepper and salts.

Highly traditional and typically British Character Jugs were on offer throughout the war years, it being reported in 1944, that fifty different subjects were available.

In 1949, one of Shorters most productive years, an extensive range of British Character Toby Jugs was marketed in three sizes with the small jug modelled as a head and shoulders version of the full-length figure. The new characters were Covent Garden Bill with a tall wicker basket on his head, a Sou'Westered Fisherman, a Highwayman with pistols at the ready, a Huntsman with hound and whip, Irish Mike with a shamrock in his hat and King Neptune complete with trident and seahorse. In 1950 Neptune was spotlighted in a blaze of typical Colley Shorter publicity.

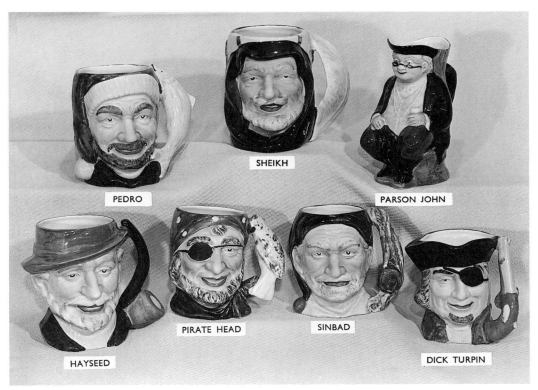

Fig. 95 Character jugs .

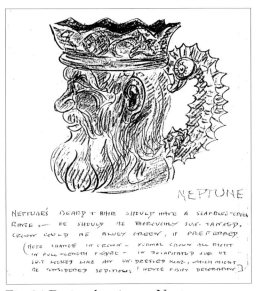

Fig. 94 Design drawing — Neptune.

A series of table lamps was modelled on earlier character jugs including Old King Cole, Long John Silver, Scottie, a Guardsman and a Beefeater, together with the Pirate King from the Gilbert and Sullivan series and Daisy Bell.

Later, a series of finely modelled portrait character jugs was issued in which the handle forms a significant feature of the design when viewed from the front. Captain Ahab is symbolised by a full-blown sailing ship, the Sheik by his plumed head-dress and Hayseed by his rustic pipe. Dick Turpin and Sinbad display the tools of their trade, a flintlock and a coiled rope respectively, whilst the Pirate sports his parrot and Pedro the Fisherman a large example of his catch.

The Outrider, the Royal Volunteer and the Trumpeter complete a military set entitled "The Queen's Men", on parade in full ceremonial dress uniform.

The majority of character jugs to be found today date from the 1950s. In the early 1960s a new Beefeater was modelled and by the end of the decade, Shorter Toby and character jugs were appearing with the Crown Devon backstamp.

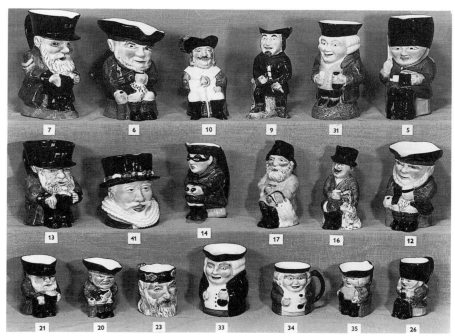

Figs. 96 and 97.

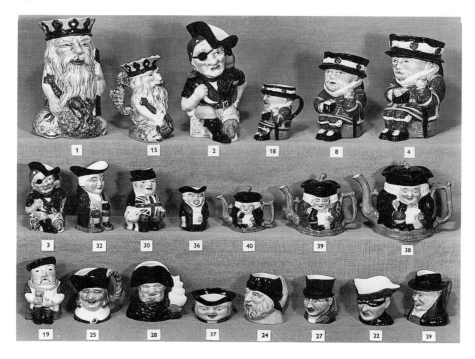

SHORTER TOBY JUGS AND CHARACTER JUGS

Abraham Lincoln	Mountaineer
Admiral	Old Bill
Beefeater	Old King Cole
Beefeater Gin Jug	Old Toby
Butler	Outrider*
Captain Ahab	Parson John
Cavalier	P.C. 49
Chelsea Pensioner	Pedro
Clown	Pearly King
Coachman	Pearly Queen
Covent Garden Bill	Pirate
Dick Turpin	Punch
Dick Whittington	Queen of Hearts
Fisherman	Red Indian
Flower Seller	Robin Hood
Friar Tuck	Royal Volunteer*
George Washington	Sailor
Gardener	Santa Claus
Guardsman	Scottie
Guy of Gisborne	Sheikh
Hayseed	Sheriff of Nottingham
Henry VIII	Sir Walter Scott
Highwayman	Sinbad
H.M.S. Cheerio	Soldier
Huntsman	South American Joe
Innkeeper	Squire
Irish Mike	Tasmanian Tudor
John Bull	Toby
Judge	Totem Mug
Judy	Town Crier
King Neptune	Trumpeter*
Long John Silver	Uncle Sam
Lord Mayor	Winston Churchill
Mac	(*Queen's Men Series)
Mr Farmer	
Mrs Farmer	

GILBERT AND SULLIVAN FIGURINES

Shorters extended the concept of character jugs when, in 1949, they issued entirely original figurines based on actors in the Gilbert and Sullivan operas. (Plates LVIII and LVIX)

They obtained permission from the D'Oyly Carte Opera Company to model fourteen character jugs from five of the Gilbert and Sullivan Operas; The Mikado, The Gondoliers, H.M.S. Pinafore, The Pirates of Penzance and The Yeoman of the Guard.

This series is quite different in style from any Shorter character jugs manufactured previously. The characters are posed and caught in mid-gesture, each wearing an exact copy of their stage costume.

An article in the magazine "Far East Trade and Engineering", of August 1949 confirms that: "Artists from the firm visited the players in several of the main cities. There, all the stars were interviewed and asked to pose in costume in the attitude most representative of their part. The stars played their parts willingly in the intimacy of their dressing rooms where they were photographed and colour notes were made It will not be long before they are seen in all the departmental stores of the Far East Their sale in America has already been phenomenal."

It is understood that Clarice Cliff, as Art Director, was responsible for the design of the Gilbert and Sullivan series. Betty Silvester, modelled the Duchess of Plaza Toro, the Pirate Maid and the Pirate King. Examples bear her incised signature.

Although designed about 1940, the Gilbert and Sullivan figures were not marketed until after the war, when an extensive advertising campaign was master-minded by Colley Shorter in 1949. They featured prominently when he and Clarice Cliff-Shorter toured Canada and the United States on a publicity tour in the same year.

The Gilbert and Sullivan Character Jugs were made in two sizes: large, 10 inches high, and small, 5 inches high. Both sizes bear a scrolled backstamp.

In addition to the figurines, small rectangular wall plaques, cigarette boxes and ash trays bearing embossed figures from the Operas supplemented the range.

The figurines were re-issued by Shorters in 1961.

In the mid-1980s, a very few sets of the small figures were issued, impressed "Rockingham", by an individual who owned the moulds for a short period.

A limited number of the small figures was issued with the new Shorter backstamp by Sherwood China during the late 1980s. They are very slightly reduced in size.

GILBERT AND SULLIVAN FIGURINES

THE MIKADO
* The Mikado
** Katisha
Ko Ko
Pooh Bah

THE GONDOLIERS
* The Duke of Plaza Toro
** The Duchess of Plaza Toro
Don Alhambra

H.M.S. PINAFORE
* Dick Dead–Eye
** Buttercup
Sir Joseph Porter

PIRATES OF PENZANCE
* Pirate King
** Pirate Maid
Major General

THE YEOMAN OF THE GUARD
Jack Point

* *modelled on cigarette boxes*
** *modelled on ashtrays*

Chapter Nineteen

DATING SHORTER POTTERY

Information from the Public Records Office, the Shorter shape book, the Shorter pattern book, the modeller's notebook, the salesman's photographs and trade magazines has helped to date Shorter pottery.

It is difficult to be precise in dating as the firm's few surviving records rarely include a definitive date. Although a reference in a pottery magazine of the day may create the impression that a design is on the market for the first time, this has not always proved to be the case. Some designs were not marketed immediately after they were created. The advent of World War Two was a major factor in effecting such delays.

Over the years, Shorters continued to re-issue identical versions of their successful ware. New shapes might be added to a range, variations made in the overall shape of a design and new glazes or colour-ways applied to old shapes. It is essential to assess all the relevant factors and to consider the general impression and overall style of a particular piece of pottery before attempting to date it.

Most but not all Shorter pottery is back stamped. This plays a useful but not always definitive part in dating a piece.

POTTERY SHAPES

The capital letters LS, MS and SS impressed on to the base of a pot indicate its size — large, medium or small.

Some of the earliest known Shorter shapes are the majolica jugs referred to by name; the Atlantic, Bramble, Stork, and the Corncob, which remained in production for almost a hundred years.

Some early twentieth century shapes had individual names, for example, a gardiniere is named Mostyn, a flower pot, Turin, a bulb bowl, Rhine, and a vase, Tulip. The Bowness, Clifton and Eden jugs and the Cauldron bowl were early Shorter shapes which were also referred to by name on the Wilkinson shape sheets used by their salesmen in the 1930s.

Traditional shapes which had been in production for some time are the first numbered items illustrated in the Shorter Shape Book which is believed to have been introduced by Harry Steele when he joined the firm in 1932. In this shape book, reference is made to the Tulip and Iris vases and to their new shape numbers, 3 and 4 respectively.

Mabel Leigh designed new shapes for her Period Pottery which are referred to by number, and include shape numbers 60 to 78. In practice, however, shapes number 61 and 66 were also referred to according to their function, namely a pitcher and a ewer. The Period Pottery range was extended by the inclusion of some early shapes — the Iris vase and shape numbers 24, 29, 47, 48, 49, 50. There is a tendency for early pots to be slightly heavier than later pieces in the same shape and design, and for the colours to be richer and deeper. In 1939, a series of complex shapes, 404 to 419, was created for the new Italian Style Period Pottery.

Many of the Shorter shapes were designed as a related series.

The Wild Duck series designed in 1939 and issued in 1940 was numbered 520, 529 to 532 and 534 to 542. This run of numbers was interrupted by designs for a wall mask, book-ends in the shape of a dog, an elephant, a goat, a Dutch boy and girl, and, most incongruously, by number 533, a jug in the form of a bear.

A homogeneous group of matt glazed vases issued in 1949 and numbered 645 to 650 was followed shortly afterwards by the equally distinctive, but stylistically different, Festival Matt Glazed series numbered 681 to 690, 703, 715 to 717.

During the 1950s and early 1960s groups of both contemporary and classic shaped vases and bowls were decorated in art and matt glazes. These shapes were numbered between 700 and the early 800s. By 1964 the shape numbers extended beyond 900.

It must be emphasised that shape numbers indicate only approximately when a piece was first produced as some low-numbered shapes continued to be re-issued over a long period of time.

Tableware designs usually bear neither name nor shape number on the base, relying on their highly individual shape and embossed decoration for identification.

MARKS AND BACKSTAMPS

Many pieces of Shorter pottery bear an impressed mark "SHORTER ENGLAND", a shape number, the size and a backstamp of which there are several variations. This information plays an important but not necessarily decisive part in helping to date the pottery. Some inconsistencies and anomalies occur but, in general, a piece marked "SHORTER AND SON" or "SHORTER AND SONS" is pre-1933, whilst one with a backstamp including the abbreviation "LTD" is always post-1933.

Although some of the earliest Shorter majolica designs are marked with the English registry diamond, it is possible that some may be marked "Shorter and Boulton". In common with much of the majolica ware of the period, many pieces

have no mark at all but they are identical to marked pieces made by Shorters in the 1920s.

Many of the majolica jugs found today bear the blue copperplate backstamp "Shorter and Son (or Sons)", of the 1920s (A).

Most pottery produced between 1906 and 1933, the year in which the firm became a limited company, is marked "Shorter and Son" (B). However, for a brief period in the mid-1920s, the firm was referred to as "Shorter and Sons" and it's pottery similarly marked (C).

Between 1924 and 1927 reference is made to the name "Shorter and Sons" in the ledgers of A.J. Wilkinson Ltd, and in a major article in a Pottery Gazette of 1927.

Highly glazed, embossed jugs, bowls and plates in apple green usually bear the "SHORTER AND SONS" backstamp as do some characteristic designs to which no reference is found in the pottery journals or the Shorter Shape and Pattern Books until the mid-1930s. For example, in Fish Ware, Shell Ware, Rock Garden and Lupin the backstamp serves to confirm the earlier production date suggested by the overall style and glaze of the designs.

Before Shorters became a limited company in 1933 three main backstamps were in use.

One version, in blue copperplate, occasionally grey or black, is found on majolica or the early art deco matt glazed designs.

The use of the word "SON" or "SONS" is the only difference between the other two backstamps which are printed in blue or black capital letters.

When pieces of this period are decorated in a vivid, orange running art glaze, the name "Aura", in copperplate, is added to the backstamp (D).

From 1933 two new backstamps were issued in either dark blue or black capital letters, one in an oval (E) and one including "Great Britain" (F).

A later stamp reads, "Shorter and Son, Ltd., Stoke on Trent, England" (G).

In the 1940s, a new backstamp was introduced which includes the words "GENUINE STAFFORDSHIRE HAND PAINTED" (H).

When the words "AUSTRALIA, Regd." are included in a backstamp it indicates that the ware was originally intended for the Australian market or that the designs had been so registered to prevent reproduction in Japan.

A contemporary logo was commissioned by John B. Shorter in 1964 (I).

It must be stressed that the backstamp should not be used as the sole criterion in the dating of Shorter pottery, as ware has been found with backstamps which do not conform to the known production date of the piece. Occasional variations are to be found in the wording of the backstamps. Some pieces that were obviously made by Shorters are merely stamped "MADE IN GREAT BRITAIN", "MADE IN ENGLAND" or have no mark at all.

PERIOD POTTERY — INSCRIPTIONS AND BACKSTAMPS

Early Period Pottery often has a crudely finished base inscribed in various ways; sgraffito, hand painted, or impressed. Information on the base may include Mabel Leigh's signature, the initials of the decorator, the name of the design, the shape number, the size and the name of the firm. Each piece may or may not bear one of two backstamps; in an oval, "SHORTER AND SON LTD, MADE IN ENGLAND" (J) or "SHORTER AND SON LTD., STOKE ON TRENT, MADE IN GREAT BRITAIN' (K).

As the base of each piece of Period Pottery is marked individually either by the sgraffito artist or the paintress, there is a wide variation in the marking of this ware, including spelling mistakes and the occasional thumbprint and designs wrongly named.

Many of the Period Pottery designs produced after Mabel Leigh had left Shorters have a typically smooth cream-coloured base with a slightly crazed surface. The ware is usually backstamped "SHORTER AND SON LTD, STOKE ON TRENT, GREAT BRITAIN" and often has details, including the pattern name, either scratched into the base, or hand-painted in large, elongated, freely-drawn capital letters (L,M). These sgraffito marks are often etched very lightly and need to be angled against the light to enable the name to be deciphered. Some designs with an Italian influence, for example Mendoza, have a rough, boldly sgraffitoed base, as in the early ware.

Much of the Period Pottery produced during the 1940s and 1950s bears a hand-painted inscription "PERIOD WARE, HAND CRAFT BY SHORTER AND SON" (N) or may include the name of the design and the term "HAND CRAFTED" together with the GENUINE STAFFORDSHIRE HAND PAINTED stamp.

On late reproductions of early Period Ware designs, the name of the piece is indicated in small, hand-painted, capital letters together with the GENUINE STAFFORDSHIRE HAND PAINTED backstamp.

TOBY JUGS, CHARACTER JUGS AND FIGURINES – BACKSTAMPS

Many Toby and character jugs are impressed "SHORTER, ENGLAND" and include the name of the character. Those from the 1930s may include the words "OLD STAFFS TOBY"(O) but variations occur. The majority are marked with the later "GENUINE STAFFORDSHIRE, HAND PAINTED" backstamp.

GILBERT AND SULLIVAN FIGURINES

The name of the character and that of the firm is impressed onto the base of each piece together with a backstamp indicating that the figure was: "REPRODUCED BY PERMISSION OF THE D'OYLY CARTE OPERA CO." (P)

BACKSTAMPS AND MARKS ON SHORTER SHAPES ISSUED BY OTHER FIRMS

CROWN DEVON

The Crown Devon backstamp appears mainly on Shorter Toby Jugs, Fish Ware and some tableware designs, such as Embossed Fruit, which were issued in the 1970s.

"ROCKINGHAM"

Shortly before the moulds were bought by Sherwood China, a very limited number of small Gilbert and Sullivan figures, impressed only with the character's name, were issued by a firm using the name "Rockingham".

SHERWOOD CHINA

This factory produced Shorter pottery from original moulds in the mid and late 1980s. It is marked with a double circle enclosing an oak tree (R). Character jugs are marked with a sharp, clear "SHORTER AND SON" printed on a curve (Q). Each named piece is signed or initialled by its decorator. The backstamp on the small Gilbert and Sullivan figures includes the name of the character and the opera. Each signed piece is numbered or dated.

BACKSTAMPS

Shorter & Son, Stoke=on=Trent, England.

A

SHORTER & SON,
STOKE-ON-TRENT,
ENGLAND.

B

SHORTER & SONs,
STOKE-ON-TRENT,
ENGLAND.

C

"..."
BY
SHORTER & SONS,
ENGLAND.

D

MADE IN
SHORTER
& SON LTD.
ENGLAND

E

SHORTER & SON LTD
STOKE-ON-TRENT
MADE IN
GREAT BRITAIN

F

SHORTER & SON LTD.
STOKE-ON-TRENT,
ENGLAND.

G

H
GENUINE
STAFFORDSHIRE
HAND PAINTED
SHORTER & SON LTD.
ENGLAND.

H

SHORTER
& SON LTD
MADE IN ENGLAND

I

MEDIIVU
MADE IN
SHORTER
& SON LTD
ENGLAND

J

ESPANOL
by MABEL
LEIGH
SHORTER
ENGLAND

K

RAVENNA

L

SHORTER ENGLAND
SON
STOKE-ON-TRENT
KALHAN

M

PERIOD WARE
HAND CRAFT
BY
SHORTER & SON
ENGLAND.
MEDINA

N

OLD STAFFS TOBY
SHORTER & SON LTD.
STAFFORDSHIRE.
MADE IN ENGLAND.

O

REPRODUCED BY
PERMISSION OF THE
D'OYLY
CARTE
OPERA Co.
SHORTER & SON LTD
STAFFORDSHIRE
MADE IN ENGLAND

P

SHORTER & SON
LTD
ENGLAND
Little Buttercup
"H.M.S. Pinafore"

Q

SHORTER & SON LIMITED
ENGLAND

R

Chapter Twenty

THE CLARICE CLIFF-SHORTER CONNECTION

The fact that Clarice Cliff was married to Colley Shorter, the Managing Director of the group of factories that included Shorter and Son Ltd., and worked with him for many years, must give rise to the question: "What influence did Clarice have over the designs of that factory?"

The authors have given this question the most detailed consideration and have reached the conclusion that there is an overwhelming body of evidence that suggests that Clarice Cliff not only influenced much of the Shorter output but actually designed a significant number of pieces bearing the Shorter backstamp.

Shorters were part of the group of three associated potteries which, from 1926, were led by a joint management team consisting of Colley and Guy Shorter, later to be joined by Harry Steele. In the late 1940s references are made to Clarice Cliff as the Art Director.

Between 1927 and 1933, when Clarice was making such a strong impact at the Burslem factories, remarkable changes were taking place at Shorters in Stoke, both at management and design level. Original designs of high quality were being produced and decorated in a wide variety of art glazes, by a firm that had, until then, specialized in traditional majolica ware.

As the factories operated conjointly, it was inevitable that discussions on market trends took place and that design ideas were exchanged. There are recorded instances of the group transferring funds and products between Wilkinsons and the Newport Pottery in 1929, for tax purposes, and no doubt there were times when the Shorter factory was similarly involved.

EARLY CONNECTIONS

Examination of the pottery itself indicates that there was some interchange at production level. Some of Clarice Cliff's early designs from the 1920s were issued bearing the blue, copperplate Shorter backstamp of that time.

Shorters issued Clarice Cliff's Arab, Bird and Cottage book-ends in a blue matt glaze and in "Aura" (Wilkinson shape numbers 414, 415, 409 and 416). (Plates VII AND LXI)

The flower bowl in the shape of a Viking ship that was almost certainly designed for Wilkinsons by Clarice Cliff in 1927, was followed two years later by a smaller

Fig. 98 Clarice Cliff Viking boat decorated in Gibraltar c. 1930.

edition, identical but for the foot supports, and marketed under the Shorter name in a variety of art glazes, including "Aura". (Plates VII and LX)

A further link, but with a difference, occurred in 1928 when Clarice produced a series of Children's ware for Wilkinsons based on drawings by Colley Shorter's younger daughter, and which bore the inscription, "Joan Shorter, aged 8" (LIV).

It is known that Clarice Cliff decorated some of the old Newport Pottery shapes with her "Bizarre" designs. However, in a contemporary photograph, from the Wilkinson collection, Clarice Cliff is poised to paint a Wilkinson charger whilst a decorated Shorter Dragon jug is prominently displayed in the foreground.

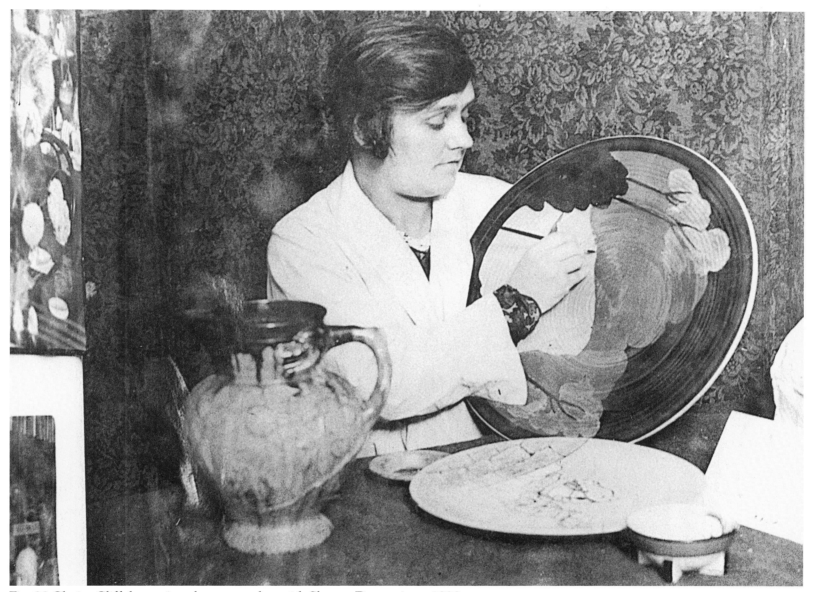

Fig. 99 Clarice Cliff decorating plaque, together with Shorter Dragon jug c.1930.

Shorter's unique "Dragon" jug is to be found decorated with the running glazes of "Delicia" which Clarice introduced in 1930. Rare pieces may be seen decorated with a hand-painted landscape. The Shorter "Oceanic" jug was also decorated in Delicia and in the Windbells pattern of 1933. (Plate LX)

The large Shorter vase, shape number 29, pictured in the advertisement for the original Delicia series in 1930, is identical in shape to that of shape

number 386 on the Wilkinson shape sheet. Three years later, the same vase was chosen by Mabel Leigh for her Algerian, Aztec, and Medina Period Pottery.

By a reciprocal arrangement, Wilkinson shapes were used for some of the Shorter Period Pottery designs. For example, shape number 14 was decorated in Medina, shape number 357 in Khimara and Rayenna and shape number 264 in Wan Li. Both Clarice Cliff and Shorters decorated the Wilkinson Sabot, Clarice with many of her inimitable designs, and Shorters in a variety of coloured glazes. The three factories and their pottery were inextricably linked. (Plate LX)

THE DESIGN REVOLUTION

A series of named, art deco style, matt glazed vases decorated with running art glazes and bearing an early Shorter backstamp led the authors to wonder why, amidst the production of highly traditional, mainly majolica ware, Shorters should suddenly introduce such a "maverick" series. After much research, they came to believe that the advanced style of art deco ware produced at Shorters in the 1920s was almost certainly the work of Clarice Cliff.

Information from the Clarice Cliff "scrapbook", contained amongst the A.J. Wilkinson papers held in Hanley library, has helped to confirm this theory, but readers must apply their own expertise to the evidence, which is sometimes circumstantial, and make their own judgement.

EXPERIMENTAL GLAZES AND ART DECO SHAPES

The blue, copperplate backstamp on many Shorter art deco matt glazed vases indicates a production date that coincides with Clarice Cliff's experimental work, in conjunction with Colley Shorter, on new glazes and glaze techniques, and with the creation of some of her most avant-garde geometric shapes. Two of her successful designs for the Newport Pottery, "Inspiration" in 1929 and "Delicia" in 1930, displayed such new glaze techniques. Simultaneously, Shorters were featuring new glazes, including "Aura" on both art deco style and traditional shapes.

It was reported in the Pottery Gazette of March 1928 that Shorters had presented a: ".... still newer line of goodsa range of matt glaze ware in attractive colourings wonderfully good effects, many of them quite original in type".

This is believed to be the series of art deco style matt glazed vases that includes the named "Noni",."Olwen", "Pyramus", "Rhomboid" and "Thisbe" in which an entirely different concept in design is presented. The angular, tiered and spiralling pieces are in total contrast to any ware that Shorters had produced previously. Who or what inspired this conversion? (Plates VII, VIII and LX)

Fig. 100 Clarice Cliff tableware, two tiered candlesticks and Thisbe. "Town and Country Homes" November 1930.

THE CONTINENTAL INFLUENCE

The three associated factories were working very closely together at this time. They shared showrooms in London and, in January 1930, exhibited jointly at the British Industries Fair. It was during this period that Clarice Cliff was at her most creative and productive.

Her work for the Newport Pottery had been influenced by continental designers, with whose work she had become familiar following her visit to Paris in 1927. She subscribed to the French journal "Mobilier et Decoration" which contained illustrations of work by Robert Lallemont whose designs were created in severe spherical or cuboid shapes and were often characterised by a tiered effect.

The tiered design of the Shorter "Rhomboid" may be compared to several shapes created by Clarice Cliff in 1929, and numbered 366, 367, 368 and 369 in the Wilkinson shape sheet. Shorters' spiralling "Thisbe" is another tiered design. Several photographs of "Thisbe" are included in the Wilkinson scrapbook, the earliest one being illustrated in a cutting from the November 1930 edition of "Town and Country Homes".

Both Wilkinsons and Shorters produced almost identical spherical vases. Those made by Shorters about this time, Astrid and shape number 148, have the same basic shape as that of shape number 370 which Clarice Cliff is known to have designed for Wilkinsons in 1929 (LX).

Another photograph in "Mobilier et Decoration" of 1929, shows a vase by Gudrun Bandisch, executed by the Vienna Werkstatte, which bears a marked similarity to "Pyramus" in the Shorter art deco style matt glazed series.

A Shorter vase and two matching candlesticks in the art deco style, shapes number 183 and 184, are similar in concept to a table lamp, designed by Lobel in 1929, and illustrated in the same journal. (Plate IX, X and LX)

The Wilkinson scrapbook contains a cutting from "Australian Women's Homemaker" of February 1936 in which a photograph of pottery attributed to Clarice Cliff includes the Shorter vase shape number 182 in the same series.

Even more conclusive evidence of the connection is contained in the Pottery and Glass Record of March 1931 in which a report states categorically: "In conjunction with Messrs A.J. Wilkinson, Messrs Shorter and Son were showing some of the latest designs of Miss Clarice Cliff, chiefly decorated in greens and browns, but with a vase of circular shape in turquoise." Unfortunately the article does not illustrate the vases described.

Shorter vases 289 and 290 are illustrated in the Wilkinson archives. The Shorter bowl, shape number 294 and the Daffodil bowl, shape number 475 designed by Clarice Cliff for A.J. Wilkinson, have the same basic oval shape with pointed ends and similarly placed decorative features. (Plate X)

The three-footed Clarice Cliff vase, shape number 452, is akin to her vase, shape number 734, in the "My Garden" series of 1934. Both these vases are similar in design to Shorter vase, shape number 289, which, in turn, echoes the overall shape of the "My Garden" vase, shape number 701.

Even if it is not possible to prove conclusively that Clarice Cliff personally created the new Shorter designs, they were certainly influenced by her and bear the hallmark of her talent.

Fig. 101 Applique Lugano c.1930.

In the Spring of 1930, Clarice Cliff created Applique, a design based on a landscape with mountains and trees, inspired by the French designer, Edouard Benedictus. The water mill on Applique Lugano is identical to the house with mill wheel which she modelled for Shorter book-ends, number 416 on the Wilkinson Shape Sheet. (Plate LXI)

Fig. 102 "The Quiver" 1936.

FISH WARE

One of the most popular designs associated with Shorter pottery has always been the Fish Sets which first appeared in the late 1920s or early 1930s. No less than six separate photographs and cuttings relating to Fish Ware are included in Clarice Cliff's scrapbook. The most significant, from "The Quiver" of December, 1936, pictures a Shorter Fish Set and informs its readers that:

"The fish set illustrated, designed by Clarice Cliff, is an example of today's interpretation of what was once a very colourful series. This one is in a delicious matt cream glaze in pottery and has only softly subdued turquoise fins as colour accent." (Plate VI and LX)

No reference has been found in any Shorter papers to any design for the original Fish Sets.

FLOWER TROUGHS

In an extract from the Evening News of February, 1937, in the Wilkinson scrapbook, the design of Shorters' flower troughs in the shape of individual letters of the alphabet is attributed to Clarice Cliff. (Plate LII) She designed a joint Wilkinson and Shorter advertisement featuring these troughs which was published in the Pottery Gazette of May 1937. The Shorter flower trough decorated with a pair of love-birds is almost identical to a much larger version she produced for Wilkinsons.

FRUIT WARE

The similarities in design between Shorter Fruit Ware and a series of decorative tableware designed by Clarice Cliff in 1938 for Wilkinsons are worthy of note. Although Fruit Ware was almost certainly designed in 1939, it was not until 1949 that it was marketed extensively. On a visit to Canada in that year, a local newspaper refers to an interview in which she had ".... Some new pieces in the shape of fruit, pears, apples and pineapples. There is a big jar Miss Clarice Cliff suggests it's for dry cereal on the breakfast table (the bran would never be served from a box on the English breakfast table). Maybe out of a pear or a pineapple it would be more enticing". (Plate XLI and LX)

Was Fruit Ware one of Clarice Cliff's designs, or was she merely promoting it?

Fig. 103 Fruit Ware, Jack Point and Mendoza 1949.

Fig. 104
Press reports—
Canada 1949.

"Clarice Cliff" Visits Eaton's

English Ceramics Designer Draws Heavily on Women's Fashion

Mrs. Colley A. Shorter, better known in the world of ceramics as Clarice Cliff, was a recent visitor to Eaton's, Winnipeg. Accompanied by her husband, Lt.-Col. Shorter, who is president of three pottery and semi-porcelain factories in England, Mrs. Shorter was making her first trip to Canada.

To find out what Canada and the United States prefer in ceramic designs is what brought Lt.-Col. and Mrs. Shorter to Canada. Mrs. Shorter has found that many Canadian women are demanding a modern design which was popular in England 15 to 20 years ago. Many of her ideas for pottery designs come from women's fashions and the materials from which their clothes are made. She says: "The mid-century look is toward the traditional so we find the modernized reproduction of the traditional in pottery is most popular."

This is Mrs. Shorter's first trip to Canada although her husband has visited several times, this being his third since April. Clarice Cliff has been in the pottery business since she was a young girl of 15, and she loves her work. As her husband says, "You never can tell what she is going to work into a design. It may be a leaf, a tree, anything that gives her the idea."

"Jenny Lind" is one of the "Shorter" patterns of semi-porcelain which is carried by Eaton's.

Twenty-Seven

GILBERT AND SULLIVAN FIGURINES

In 1940, Clarice was actively involved in the production of character jugs of a particularly high quality for A.J. Wilkinson Ltd. The firm had created a series representing First World War Allied Commanders and Clarice was given the honour of completing it by modelling a figure of the Prime Minister, Winston Churchill, in full naval uniform. In the same year, Shorters, acting under franchise from the D'Oyly Carte Opera Company, arranged for the design of fourteen character jugs representing characters from the Gilbert and Sullivan operas. (Plates LVIII and LVIX)

An office worker from Shorters has recounted to the authors that Clarice Cliff was personally involved in the creation of the Gilbert and Sullivan figurines, making copious drawings from some of the operas whilst they were in performance. This report is confirmed in an article in "Far East Trade and Engineering" in August 1949. Clarice was assisted in this project by Betty Silvester who was one of the skilled designers and modellers employed by Colley Shorter and who worked at the Newport factory in the late 1930s.

It was not until 1949, however, that this range was launched with much publicity. In that year, Colley Shorter and Clarice Cliff-Shorter went on a sales promotional tour of America and Canada.

The Winnipeg Tribune in November 1949 records that: "D'Oyly Carte Gilbert and Sullivan characters are being made now by the Shorter potteries from Clarice Cliff's designs."

Clarice preserved a cutting from the Australian Women's Weekly of May 1950 which featured a photograph of these figurines and one from the Pottery Gazette of December 1950 showing Mr Alec Cowan from Shorters' Australian agency making a presentation to the cast of a local production of the "Mikado" in Stoke-on-Trent. Also included amongst the Wilkinson documents is a glossy photograph of an advertising display.

Both Colley Shorter and Clarice Cliff-Shorter played a major part in the promotion of the Gilbert and Sullivan character jugs with a contemporary photograph showing Colley presenting one of the figures.

Mrs Charlotte Shorter, the wife of John B. Shorter, has told the authors that she had been given several figures from the Mikado by Clarice Cliff herself. It had seemed obvious to Mrs Shorter that they were the prototypes for the final products as the painting appeared to be experimental.

John Shorter of Shorter House, Sydney, Australia, Colley's cousin, knew Colley and Clarice Cliff well, and stayed with them in the late 1940s and early 1950s., During a visit to England in 1991, he was examining a collection of Shorter pottery when he noticed a group of Festival Matt Glazed vases. He immediately pointed at them and said, "Clarice Cliff". Although he has no definite information which links Clarice Cliff with the designs, his instinctive reaction was that they were her work. This is the first tenuous lead that may establish a link between Clarice Cliff and yet another Shorter design.

Almost the last entry in Clarice Cliff's scrapbook is a tiny photograph of a Shorter poultry tureen.

All the evidence, from the pottery itself, from newspaper reports, from the Pottery Gazettes and from Clarice Cliff's own scrapbook and the Wilkinson archives, points to the conclusion that she did indeed design for Shorter and Son Ltd. It is impossible to believe that this talented, strong-minded woman, who played such a significant part in ceramic design should not have directly influenced the pottery designs produced by the three associated factories of which she was Art Director.

Fig. 105 Advertising photograph in the Wilkinson Archives.

A PERSPECTIVE ON SHORTER POTTERY

From a study of Shorter shapes and designs, it became evident that the firm had made a small, but significant contribution to the history of British ceramics. It was a quintessential small family pottery operating in Stoke-on-Trent during the nineteenth and twentieth centuries. Three generations of Shorters ran the pottery without a break for almost a hundred years. Close family links with two other companies ensured that, together, the three factories covered virtually the whole market for domestic ceramics. The output of the firm was so wide-ranging that it could be said that the Shorter story epitomises the history of popular ceramics over that period.

For the first fifty years it was a majolica factory. As public taste for the extravagance in form and colour of Victorian majolica waned, a metamorphosis took place. The firm severely curtailed its output of majolica and went on to reflect in its pottery designs the rapid changes that were taking place in contemporary society. From the late 1920s, Shorters was often in the forefront of contemporary trends and developments, although echoes from its Victorian majolica past were never entirely absent. Their colourful decorative tableware designs from the

1930s, 1950s and 1960s are evidence of this.

After their majolica period, during which time the art nouveau influence was sometimes evident, a new dynamism was generated and radical, art deco forms were created. Subsequently, their designers would echo every stylistic trend that was currently in vogue. Most significantly, the modernist influences resulted in the creation of several series of sculptural vases with an emphasis on style, form and art glazes. One such series coincided with the Festival of Britain.

In the nineteen thirties, Shorters explored the pottery of primitive cultures, and, from a small studio within their factory, Mabel Leigh evolved highly individual art pottery based on ethnic designs. This unique, hand-crafted pottery with its timeless quality, introduced a simple, fundamental element into an increasingly sophisticated society.

Tradition and innovation appear to have been twin strands in the history of Shorter pottery. Perhaps it is the decorative fancies which were produced in such abundance by the firm that most

comprehensively encapsulate British popular taste in the nineteenth and twentieth centuries. Their Staffordshire figures and Toby jugs form part of a long line of moulded, hand-painted decorative items which have enhanced the homes of British working people from the 18th century onwards. Paradoxically, it is these rustic figures with their, naive, folkloric quality that have a strong appeal for today's collectors. At the other end of the scale, the kitsch figures and animals produced during the firm's later years, are awaiting the benediction of time.

A case could be argued for presenting the "Daisy Bell" figures as symbolic of the Shorter production policy. The firm ran, "in tandem", traditional designs and designs in the vanguard of fashion. If the British nation of garden-lovers wished to buy a rustic teapot, reminiscent of the one that had graced granny's tea table, then an up-dated, majolica version would be on offer, but if the preference was for flowers, foliage or fruit on the latest, streamlined shapes then these too would be available from Shorter and Son Ltd.

A nation that had been at war for ten out of the thirty years between 1914 and 1945 was especially receptive to the

patriotic and nostalgic appeal of the traditional Toby and character jugs. Having had so many references to "the British", it is as well to recall that a large proportion of the firm's pottery was exported to our former Empire where it was probably bought by nostalgic ex-patriates and perhaps even made some small contribution to the Anglicisation of "foreign parts".

The success of the firm lay in an ability to predict market trends and to manufacture pottery that the British public would buy. Whilst many of their designs were aimed at the popular market, some lines, especially the more expensive art pottery, were directed at the section of the public that had more awareness and appreciation of aesthetically pleasing and avant garde designs.

The strength of the firm lay in the varied abilities of the family; Arthur Shorter, the artistic businessman, Colley, the visionary salesman, Guy, the sound administrator and, finally, John, who had inherited his father's business acumen. Other essential elements in its success were the innovative management of Harry Steele, the inspired designs of Mabel Leigh and a skilled, conscientious and loyal workforce.

To study the Shorter family and their work is, therefore, to study the history of popular British pottery over the last hundred years. To examine their wares is to examine popular British taste in pottery over that period.

Although Shorter pottery is not as well documented as we would wish, it has been possible to trace it from a number of authentic sources. Early Shorter and Boulton majolica designs of 1881 are registered in the Public Record Office; there are references in the Pottery Gazette from as early as 1879 which are brief and sporadic until the nineteen thirties onwards when they become more frequent and comprehensive. A pattern book and a shape book are still in existence, as is a well-thumbed mould-maker's notebook. Our information has been supplemented by a number of black and white photographs that were used by travelling salesmen and coloured advertising leaflets for Period Pottery and the Gilbert and Sullivan character figures.

From these sources, and from the memories of dozens of talented people who worked for or with the firm, we have been able to create the Shorter story, a hundred years of popular British pottery in microcosm.

INDEX

This index is in alphabetical order. Where there is more than one reference, the main reference is in bold, eg Pagoda **82**. Roman numerals refer to colour plates, eg Khimara XXIII.

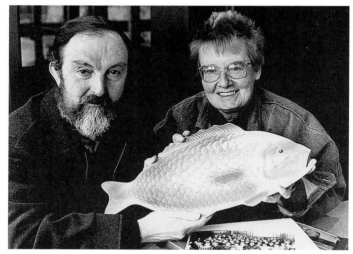

Gordon and Irene Hopwood

As something of an antidote to too many years dedicated to education and government service, the Hopwoods have adapted their enthusiasm for social history and antiques to the arcane world of pottery research. Their first major project has been the exploration of the under-rated and under-documented pottery of Shorter and Son Limited. With its long history and the amazing variety of its ware, this has become "not so much a project, more a way of life". Their collection of Shorter pottery has left little space in their old Cotswold farmhouse for two cats and two people.Interests in industrial relations and local government have given way to developing valuable relationships with the generous people of the Potteries and visiting their outstanding libraries and museums. "How will it all end?" they ask themselves, as they wonder if they dare seek another obscure firm to investigate.